THE BORSCHT BELT

It was my good fortune to land in the Borscht Belt in the summer of 1933. It had an active Jewish community and a bucolic countryside, in many ways similar to the shtetl life familiar to me in Lithuania. My cousin Seymour Cohen and I visited every major hotel in the area and carefully compared what they had to offer. I was introduced to some of the owners. I think I even met the legendary Jennie Grossinger. But all good things eventually end.

 Al Jaffee, 95-year-old journeyman cartoonist

Susan Sontag observed that "all photographs testify to time's relentless melt." One could scarcely imagine a more poetic testimony than Marisa Scheinfeld's eerie photographic record of the remains of American Jewry's mid-century Xanadu, the Borscht Belt. Her melancholic images of ruins, detritus, and festering vegetation are haunted by an unseen and undefined presence—a visual meditation on abandonment and absence.

 Maya Benton, Curator, International Center of Photography

In New York's Catskill Mountains, a party began in the 20th century that lasted decades. Party pictures filled thousands of scrapbooks—but now, the party's over, and the guests are gone, never to return. Enter Marisa Scheinfeld, whose camera finds profound eloquence in the silence that remains and hope in new life emerging from the ruins. This story was already ancient when Shelley penned "Ozymandias": that all things grand eventually fall. But Scheinfeld's work is all the more moving, because these things are ours, now.

 Alan Weisman, author, *Countdown* and *The World without Us*

My mother spent childhood summers at the Tempel Inn at Shandelee. My father was a counselor at Camp Ranger in Bethel. My sisters and I were taken to the Laurels and the Nevele, and I first picked up a camera in Roscoe. Years later my husband and I decamped to Beaverkill when our eldest daughter was born. *The Borscht Belt* captures that sweet spot between the exquisite pain and the beauty of decay. Brava to Marisa Scheinfeld for giving us this skillfully composed archive of what remains of the splendors of the Catskills past.

 Laurie Simmons, artist

These photographs are beautiful and at the same time terrible. And by that I mean, having spent 40 years in many of these hotels, to see them again is wonderful but at the same time brings heartache. All in all, this work is fascinating and will linger in my memory.

Freddie Roman, comedian

One winter I went with other teenagers to a convention at Grossinger's and remember my excitement at discovering the indoor swimming pool and the deep heat of their sauna. I recall that the whole place seemed to offer a wonderland of new experiences. I went to the convention again the next year, but I never went back after I left New York. There is a stark difference between my memory and the shell of a resort that exists today. But the past can be given form and detail by photography, and that is what Marisa Scheinfeld's photographs do. Visualizing the past this way can actually take the form of memory. Old and new pictures help us to experience any change that has happened, and I have found change to be the truest measure of time.

Mark Klett, photographer

In photographing the ruins of the great Jewish resort area, Marisa Scheinfeld taps our memories of the great Golden Age of the Catskills and fills our hearts with recollections. In their whirlwinds of color, these photos sing the history of the hotels and bungalow colonies, putting us at ease by the pool, at sport on the handball courts, and always at the table in the dining room. It's a joy to step into these vivid images and relive such an important historical phenomenon.

Phil Brown, Founder and President of the Catskills Institute

Lord Acton famously wrote that history is not a burden on the memory but an illumination of the soul. That sentiment comes alive in the photographs of Marisa Scheinfeld. This collection tells the fascinating story of the history of the once vaunted Catskills resort industry that at its peak included more than 500 hotels and 50,000 bungalows. This is the story of a paradise lost, and these photos are an invaluable tool in preserving the past for those who were not fortunate enough to have experienced it.

John Conway, Sullivan County Historian

THE BORSCHT BELT

REVISITING THE REMAINS OF AMERICA'S JEWISH VACATIONLAND

PHOTOGRAPHS BY MARISA SCHEINFELD

ESSAYS BY STEFAN KANFER AND JENNA WEISSMAN JOSELIT

CORNELL UNIVERSITY PRESS

ITHACA AND LONDON

Epigraph is reproduced from *The Works of Love* by Wright Morris, by permission of the University of Nebraska Press. Copyright © 1949, 1951 by Wright Morris.

First published 2016 by Cornell University Press

Printed in China

Design by Scott Levine.

Library of Congress Cataloging-in-Publication Data

Names: Scheinfeld, Marisa, 1980- photographer. | Kanfer, Stefan. Echoes of the Borscht Belt. Container of (work): | Joselit, Jenna Weissman. In the frame. Container of (work):
Title: The Borscht Belt : revisiting the remains of America's Jewish vacationland / photographs by Marisa Scheinfeld ; essays by Stefan Kanfer and Jenna Weissman Joselit.
Description: Ithaca : Cornell University Press, 2016. | Includes bibliographical references.
Identifiers: LCCN 2016006302 | ISBN 9781501700590 (cloth : alk. paper)
Subjects: LCSH: Resorts—New York (State)—Catskill Mountains Region—Pictorial works. | Abandoned buildings—New York (State)—Catskill Mountains Region—Pictorial works. | Catskill Mountain Region (N.Y.)—Pictorial works. | Jews—New York (State)—Catskill Mountains Region—Social life and customs.
Classification: LCC F127.C3 S29 2016 | DDC 974.7/38--dc23
LC record available at http://lccn.loc.gov/2016006302

Cornell University Press strives to use environmentally responsible suppliers and materials to the fullest extent possible in the publishing of its books. Such materials include vegetable-based, low-VOC inks and acid-free papers that are recycled, totally chlorine-free, or partly composed of nonwood fibers. For further information, visit our website at www.cornellpress.cornell.edu.

Cloth printing 10 9 8 7 6 5 4 3 2 1

In the dry places, men begin to dream. Where the rivers run sand, there is something in man that begins to flow. West of the 98th Meridian—where it sometimes rains and it sometimes doesn't—towns, like weeds, spring up when it rains, dry up when it stops. But in a dry climate, the husk of the plant remains. The stranger might find, as if preserved in amber, something of the green life that was once lived there, and the ghosts of men who have gone on to a better place. The withered towns are empty, but not uninhabited. Faces sometimes peer out from the broken windows, or whisper from the sagging balconies, as if this place—now that it is dead—had come to life. As if empty it is forever occupied.

Wright Morris, *The Works of Love*

CONTENTS

PROLOGUE Marisa Scheinfeld

1

ECHOES OF THE BORSCHT BELT Stefan Kanfer

15

IN THE FRAME Jenna Weissman Joselit

21

PHOTOGRAPHS

29

NOTES ON THE PHOTOGRAPHS

177

ACKNOWLEDGMENTS

185

BIOGRAPHIES

187

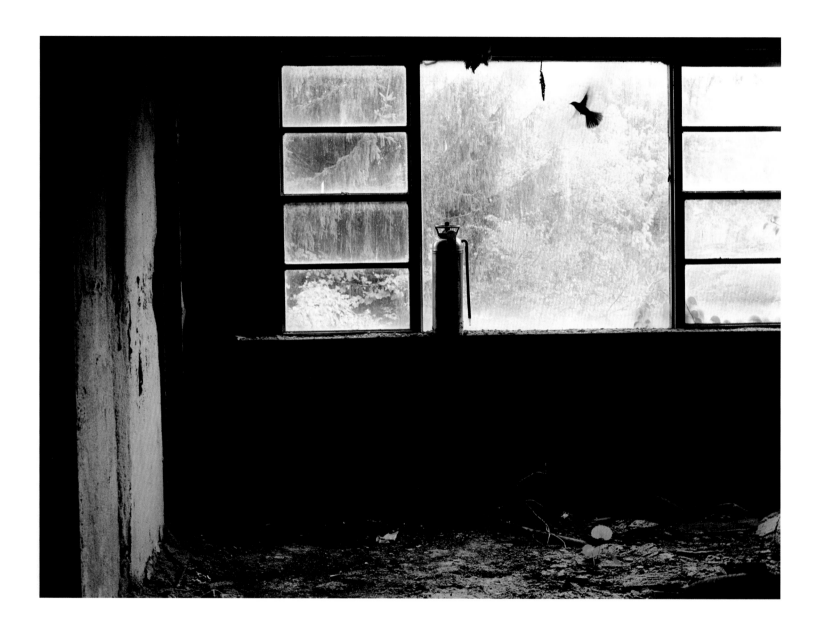

PROLOGUE

MARISA SCHEINFELD

SCATTERED ACROSS SULLIVAN AND ULSTER COUNTIES, NEW YORK, ARE THE physical remains of the Borscht Belt. Structures of various sizes and diverse forms lie vacant, abandoned. Overcome by entropy and engulfed by their natural surroundings, these former resorts, hotels, and bungalow colonies are now decaying in a disused landscape, casting a gray shadow over a vibrant past. For some people, these structures signify economic stagnation and cultural loss. For others, these former vacation destinations are eyesores, blights upon the land. Manicured compounds have been pillaged. Their lobbies, once elaborate, are adorned with graffiti, their foundations cracked and buckling. Insulation plunges from ceilings, moss cultivates the carpets, and swimming pools have become shallow ponds tinted green with algae. But to me, these discarded places are artifacts of time, evidence of change, and settings of intrigue. The remains of the Borscht Belt evoke something great that is no longer.

On the deserted grounds of these former retreats I have found an enchanting solitude—a seclusion that is empty and uncontrolled. Yet the stillness is deceptive. What appears to be abandoned is actually full of life and activity. One act of animated history has ended, but, as any visitor to these sites quickly learns, new acts have begun. Some sites have become free-for-alls, zones for scrappers, squatters, skateboarders, and paint-ballers. Each group leaves a mark on these places of past extravagance. Nature has also made her lush return. Guest rooms have become sanctuaries for birds. Leafy ferns have pushed their way through foundations and floors. Overgrown shrubs and tangled weeds have swallowed staircases. An

aroma of mildew and damp decay permeates the entryways, hallways, and showrooms of the buildings as they slide further into a state suggestive of a post-apocalyptic time.

Not all of the Borscht Belt's former resorts, hotels, and bungalow colonies are decayed and dilapidated. Many have been repurposed as meditation centers and rehabilitation facilities, whereas scores of others have been purchased by and developed as vacation and study destinations for Orthodox Jews. The Catskills, after all these years, still entices people in search of community and leisure. Voyagers and seekers continue to arrive from the congested streets of New York City, escaping the high costs of living in metropolitan areas. I suspect that in time even more will arrive, for the Catskills has been made and remade as economies and populations wax and wane. As we move deeper into the twenty-first century, this ebb and flow is likely to continue. Even in places where the casual visitor or the nostalgic seeker finds the Borscht Belt to be lost, the pulse of the past continues, and new life emerges.

I grew up in the hamlet of Kiamesha Lake, in the town of Thompson in Sullivan County, and in the heart of the "mountains" and "the country." Family, friends, and neighbors uttered these words as if no other mountains or country existed anywhere else in the wide world. My family was a small part of a cultural and demographic movement that, particularly in its heyday in the 1950s and 1960s, made the Borscht Belt the place to be. For the several generations of American Jews who made their way to the southern tip of the Catskill Mountains to escape, whether for a week of vacation or year-round living, the resorts of the Borscht Belt represented leisure, fueled the local economy, and facilitated countless and enduring social bonds. The mere mention of the Borscht Belt or the "Jewish Alps," as it was also known, elicits recollections and myriad warm and humorous stories from those who lived, worked, or vacationed there. That has been true for me, too.

When I began, in 2010, photographing the ruins of the Catskills, my aim was to document the history of the Borscht Belt. I wanted to capture what remained from the golden era, to create an archive. I read many books and memoirs recounting the glory of the era but did not come across anything about the physical condition of the sites. This project was also to be a homecoming for me because it required that I return to my hometown from sunny

San Diego, where I was living at the time. Inspired by the guidance of my mentor and friend, Arthur Ollman, who told me "shoot what you know," I began to plan my work. I booked a flight to New York. I studied published anthologies of documents and photographs, public collections of artifacts, and my own family's boxes of images and ephemera. I immersed myself in the shared memories and meanings of the Borscht Belt: as a place that held all things pleasant and entertaining, that served as a testament to growing affluence, and that became a social and cultural center for generations of people.

My fascination with the Borscht Belt was not just about its place in American history or its role in Jewish American life; it was always personal. The places, people, and folkways of the Borscht Belt were part of my everyday and inextricable from my family history. My father's parents met while my grandmother and her sister were hitchhiking the woodsy roads of Sullivan County one summer. They spent their summers at bungalow colonies such as East Pond, Walter's, and the Irvington Hotel. Later, my grandparents owned a condominium at Hidden Ridge, a community adjacent to Kutsher's Hotel in Monticello. My maternal grandparents went to the Nevele Grand Hotel, close to Ellenville, for their honeymoon and vacationed at two bungalow colonies, Wawarsing and Rosmarins, from then on. Both my mother and father spent summers during their childhoods and teenage years in the Catskills. In the mid-1980s, when my father was fresh out of his medical residency and looking for a job, two positions were available, one in Sullivan County and another in Connecticut. My father chose the job in Sullivan County, and I believe he did so because of his attachment to the Catskills and his desire to create a whole new set of memories in "the country" with his own growing family.

As a young child, I would visit hotels such as Kutsher's or the Concord, in Kiamesha Lake, on weekends with my family. Although we were not guests at these hotels, we strolled in as if we were. At the time, Kutsher's and the Concord experienced a mere fraction of the foot traffic they had once accommodated. I've heard stories of having to sneak into the popular, fully booked hotels by sliding underneath a metal gate, but by the time I was a child it was simple to walk into these establishments and spend an afternoon. I can still recall my

Grandpa Jack camped out in the card room at the Concord. To a small girl, the card room seemed massive—a space redolent with the scent of cigars, ringing with the brassy voices of older men triumphant with a winning hand of gin rummy. On a typical summer afternoon, after a visit to the card room to greet my grandpa, I would sit in on a game of bingo or jump feet-first into the icy-hot tub, known to most as the cold plunge, with my Grandmother Ruth. In the fall, I would swim in the indoor pool at Kutsher's until my fingertips shriveled up; when I close my eyes I can still smell the potent chlorine inside that large blue room. Afterward, my grandmother and I would meet with my grandpa and go to the coffee shop for a grilled cheese sandwich. In the winters, ice skating at Kutsher's was a favorite pastime of mine, as was pumping quarter after quarter into the video games lined up in a row in the dimly lit game room. I looked forward to taking a canoe out on the lake in the spring. I still remember gazing into the murky pond at Kutsher's, watching bass's eyeballs pop out of the water as they looked to make a meal of a buzzing dragonfly. My grandfather would row, and occasionally he would stop to grab my nose with fierce gentleness as he pretended to snatch it off my face. My memories of those days of fun and family, in all of the seasons, are full.

The cozy quality of childhood faded, but the Borscht Belt continued to be important to me as I grew into adolescence. (One of my first jobs was as a lifeguard at the Concord's outdoor pool the summer before it closed in 1996.) The Catskills was always home. When I returned as an adult with a camera slung over my shoulder, I was on familiar ground.

Soon after arriving from San Diego in the fall of 2010, I visited the hotels that I had frequented during my childhood as well as other sites that I discovered in my research, un-expected conversations, and the serendipity of long, aimless drives. On my first excursions I went by myself, but I soon learned that, although I prefer to shoot alone, I had to bring a friend. Getting close to the resort and bungalow sites sometimes required that I slither un-der a fence. Once on the grounds, I found ditches, where it would be easy to turn an ankle, and metal fragments and glass shards that, with an innocent fall, could lacerate. So a friend often accompanied me, and usually that friend knew someone who could open a gate or had the key to a padlocked door. We would carefully make our way onto the grounds of one of

the old hotels or bungalow colonies. I carried the lightweight, foldable tripod and medium format Pentax camera that I found most useful on uncertain terrain, in variable light or odd spaces. We would wear steel toe boots to protect our feet and ankles and long-sleeved shirts to protect our skin from noxious materials that, flaking off old buildings, would fall on us.

These preparations and precautions suggested to me that I was not just on an archival adventure into the past but also on a journey into an unruly present and future. The hunt for artifacts from the golden era quickly led to my fascinated observation of a dilapidated, un-usual, and vital contemporary landscape—into places that were close and treacherous or vast and unobstructed, in rooms sated with light or tucked away in absolute darkness. Each time I set out with my camera—whether walking up an empty driveway, leaping over a chain-link fence, or entering with the official say-so of a family member, a friend, or, at times, a strang-er—the remains of the Borscht Belt revealed themselves in unexpected and fascinating ways. Seemingly deserted rooms were engulfed by grass and foliage, red carpets were interwoven with brown earth and mud, lobbies had turned into wild forests. In its apparent death, amid an environment of architectural remnants and relics, the Borscht Belt has generated new life.

The Borscht Belt was the preeminent destination for tens of thousands of predomi-nantly east coast American Jews from the 1920s through the mid-1960s. Located ninety miles northwest of New York City, it was known internationally as a summer retreat for entertainment and leisure, though the tourism industry operated year round. For more than forty-five years, the Borscht Belt reigned supreme in the American Jewish experience, exerted a strong influence on the cultural and economic landscape of New York State at large, and shaped popular American culture and imagination. First and second generation Jewish immigrants held on to many of their Old World European and Russian traditions in the Borscht Belt while simultaneously dedicating themselves to the pursuit of new Amer-ican practices. Those who visited the hotels and bungalow colonies year after year forged social connections and cultural bonds, many of which have lasted to the present day. Those employed by the vacation industry were able to pay their bills and finance a greater life for themselves and their children, assured as they made their life plans that the seasonal guests

would return, year after year. Those who lived year-round in the region welcomed the economic and cultural boom, and they embraced the lively activity that brought a touch of the cosmopolitan to the country.

The transformation of the Catskills countryside into a resource and then a resort for city people began in the nineteenth century. The early industrial development of the region was based on lumber, tanning, and agriculture. When Sullivan County was split off from Ulster County in 1809, it was a mountainous and rugged terrain abundant with timber and coal—resources at the time in high demand. After the building of the Delaware and Hudson Canal, these raw materials were easily transported to the New York metropolitan area. The mid-1830s saw the decline of the lumber industry and subsequent rise of the tanning industry. Tanning, a process for treating animal hides that uses the bark from trees, was a necessary part of the production of boots and a whole host of leather goods. In the middle of the nineteenth century the Catskills, rich in hemlock trees and their bark, produced more tanned leather than any region in the United States. But by the late 1880s, its surplus of trees was depleted. The physical landscape of the region was wholly altered by the time the tanneries closed—mountain slopes were denuded and villages depopulated—and the local economy crashed.

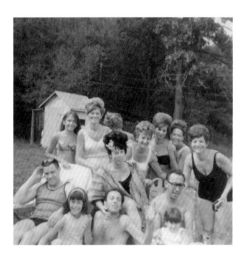

The cleared landscape, however, lent itself to a new economy—less centralized but also less intensive—based on dairy and chicken farms. Farms employed and lodged individuals for work, and most farms and rural hamlets had some capacity to board those passing through for a harvest season or just for a day. The marginal nature of farming on such depleted land gave rise to a hybrid economy that turned to sporadic tourism and steady business travel as a source of income. Very quickly, regional farmers realized the lucrative opportunity for supplemental income. Several agrarians became entrepreneurs and began to make boarding visitors and guests their primary enterprise. In turn, many of the original farm and boarding houses expanded to become bungalow colonies or small hotels. The rudiments of a tourist economy had been put in place.

With new railroads and better-paved highways traversing the region, by the late nine-

teenth century Sullivan and Ulster Counties were well linked to New York City. Local residents and outside investors put their money first into expanding accommodations for travelers and then into advertising that would entice them to come up to the mountains. Fishing enthusiasts and nature lovers were followed by writers and painters who had heard of the region's natural beauty. (American Jews were certainly among these early visitors, but they did not play an important role in this first iteration of Catskills tourism.) Entrepreneurs in the early twentieth century looked to turn the healthful character of the country into a medical resource. Pockets of the Catskills region, acclaimed for its fresh air and clear streams, were transformed into sanatoriums for the treatment of tuberculosis. This new field of business, however, dampened the enthusiasm of the average tourist and local alike. The businessmen had clearly overreached, and by 1915 many of the once magnificent hotels had closed, along with the sanatoriums. Criticism from the proprietors of the established resorts, as well as from the local residents, whose livelihoods depended upon the young resort industry, proved of little avail. Tourism fell off sharply, and the local economy faltered again.

Around this time, another transition occurred that would lead to an expansion in Jewish tourism and to the rise of the region's third economic epoch, the tourist and entertainment business that was emblematic of the Borscht Belt. Recognizing a growing Jewish immigrant population that wanted to experience an American lifestyle but whose members often found themselves locked out of hotels, Jewish investors began to purchase properties in the area. The anti-Semitism that flared nationally in the 1920s was the push that helped create the resorts and colonies of the Catskills. The pull was to be found in the social, cultural, and religious connections that inclined American Jews to vacation among themselves. Major businessmen like Asher Selig Grossinger bought or expanded properties to create the first resorts that welcomed Jewish families from the New York City region and provided the right mix of extravagance and comfort. Twin forces of forced and voluntary segregation permitted traditional daily habits to remain intact even while they made space for adapting to American life. Early financial success like that seen at Grossinger's led others to follow suit, and the established tourism industry in the Catskills quickly remade itself to offer a haven

for American Jews looking for a summertime getaway. Sullivan and Ulster Counties rapidly became prime resort locales as well as work destinations for many Jews hailing from New York City and its surrounding areas. A total of 538 hotels and more than 50,000 bungalows were built in Sullivan and Ulster Counties—a tremendous amount of construction in a short period and within the footprint of a modestly sized region.

In the post–World War II era, Jews from working-, middle-, and upper-middle-class neighborhoods all along the east coast flocked to the Borscht Belt. They enjoyed relaxation, entertainment, and a sense of social and economic recognition in a place where they were welcomed and accepted. Other Jews, and non-Jews, made their way to Sullivan and Ulster Counties to work in the resorts as waitresses, musicians, busboys, and comedians. For working and vacationing Jews, the area created a feeling of belonging in a world where historically they had experienced much prejudice. The small society fashioned in the Catskills region embraced Jewish history and tradition while adopting a modern desire for acculturation into the wider culture and participation in a middle-class standard of living. These events helped to mold the identity of post-war Jewish-American life, which in turn influenced contemporary American culture, particularly in the realm of entertainment.

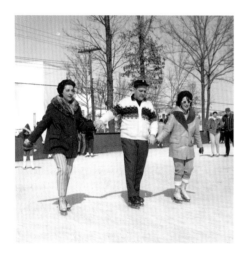

Entertainers put the Catskills on the social and cultural map for the part of America that did not have regional, ethnic, or religious affiliations to the Borscht Belt. Numerous nationally recognized entertainers, singers, and comedians got their start on the stages of the resorts. These performers created and then popularized the quintessential Catskills mix of banter and self-deprecation distilled in catch phrases such as Henny Youngman's "Take my wife . . . please" and Woody Allen's "Eighty percent of success is showing up." Youngman and Allen, representatives of two different generations of entertainers, were joined by a cohort of future stars—including Mel Brooks, Jerry Lewis, Jackie Mason, Lenny Bruce, and Joan Rivers—who drew crowds from around the United States and who were featured on television broadcasts beamed to all fifty states. For a time, the Borscht Belt could rival New York and Los Angeles as a site of headline entertainment that pleased audiences and at the same time pushed the boundaries of what was considered funny or even acceptable.

This period, identified by historians as the Golden Age of the Borscht Belt, lasted until 1965. Many factors played a role in the decline of the Catskills resorts. Newly affordable airfares to Europe and the Caribbean began to steal away crowds of tourists. Railways decreased service to the Catskills, the post-war economic boom waned, tastes in entertainment shifted away from the burlesque-style that typified the offerings on the Catskills stages, and the younger generation of American Jews chose to explore new destinations. The pull of the Catskills had lessened and measurably so. The push from American society had also changed. Many Jews became more Americanized and felt less of a need to be in segregated locales. Most Jewish entertainers did not need to start in Jewish-only establishments and were rapidly making their way onto mainstream television shows and theater stages.

By the mid-1960s, and into the 1970s, many resorts and bungalow colonies were in a general state of deterioration as their popularity declined. As the 1980s progressed, deterioration led to a series of key collapses. In 1988, the Brown's Hotel filed for bankruptcy, and in 1990 even Grossinger's Hotel and Country Club filed its Chapter 7 paperwork. As had happened in the past when the principal industry in the Catskills failed, the regional economy faltered. By the early 1990s only a handful of the larger hotels remained open. Their cultural influence was virtually nonexistent and their economic impact negligible as the larger regional tourist economy had declined with the principal resorts. The large numbers of people who would drive up to Liberty for a weekend show or who would book a weeklong vacation in Ellenville had vanished. The Borscht Belt had had its day.

By 2011, I was awash in history, memory, and emotion from these stories of the Borscht Belt. But as I went deeper into this project I became more and more enchanted with the living and fluctuating state of the ruins themselves. The growth, flowering, and exhaustion of places and of things, as well as their subsequent regeneration, provided me with potent opportunities for observation and making photographs. I found spaces whose intended uses and moods had been transformed by natural forces and human action: a stage repurposed as a ramp for a skateboard park and a dining room now used as a paintball battlefield. I gazed not at ruins but at tableaux of color that cycled with the seasons, of texture and odd

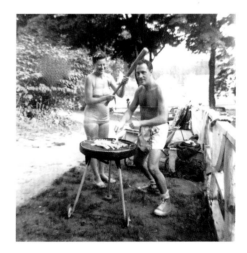

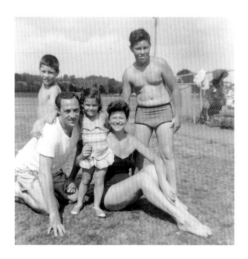

juxtapositions like a coating of moss vertically commandeering a stucco wall. Amid these settings—a complicated mix of old and new, memory and history, the made and the natural—I felt compelled to make regular and seasonal returns to compose more photographs. Each visit presented me with a new still life of sorts, a scene arranged by nature, will, and chance.

What I set out to discover and photograph on any given day was often not what I would find. Scenes of neglect and reuse, of decay and birth, were ubiquitous. A chaotic collection of objects and their random placement might be changed in a day by a passing rainstorm, a band of skateboarders, or a crew of graffiti artists. During specific times of the year, things appeared suddenly while things that had once been there disappeared or were obliterated. My role as photographer was to see, observe, and record. I did not move or adjust anything. Many of these sites were in such a chaotic state that all I needed to do was adjust myself and my camera angle in order to capture a dynamic variety of scenes. Often I could not tell where what was manufactured ended and nature began; the two had formed an amalgam joined by time and decay, by stubborn and, yes, prevailing organic life.

By the fall of 2012, I had fully embarked on what would become a five-year journey searching for relics of this former era while also seeking to capture visually its peculiar beauty. Using my research into the past as a starting point, my excursions with my camera took me to the locations of roughly forty abandoned hotels or bungalow colonies in various states of ruin, in all four seasons; some of the sites had been abandoned for over twenty years and others for just a few seasons. The seasons themselves played an important role in the project, since the constant changes of weather alter the ruins. In addition, my childhood experiences of the region were shaped by its four seasons, and my intention was for the imagery to convey the sensation of change. As a result, I coordinated each trip with the turning of the seasons. For a photographer, the cycles incited an attentiveness that provided increasingly diverse visual layers, colors, and textures to the photographs. The standing ruins of the Borscht Belt have been shaped by the many forces that have beaten them apart and the recent marks of people or of nature. These sites have withstood time and are still active powers, collapsing and regenerating with each season.

Upon arriving at a specific location, I looked for remnants, searched for recent activity, and found unexpected items and scenes. All the while the affective dimensions of these sites were not lost on me. Venturing to places such as the Concord Hotel, now just a pile of metal and concrete, would leave me speechless, thrown back on myself. Arriving at the gates of the Concord, located in my hometown of Kiamesha Lake, I immediately recalled my days there as a child and a teenager. The history I had returned to document was often poignantly personal. Strong emotions of connection and loss were waiting to be released by a new perspective on a landscape, an empty pool, or a stray deck chair. Memories resting below the surface of my consciousness would surface when I came face to face with a lobby's corner nook that once contained a pool table I played on in my youth. Now absent that pool table, the space itself was bewitching. I felt myself not exactly nostalgic but longing for the simplicity of the past while at the same time excited to see the commotion of what came after.

The emotional jolt of those moments when I would return to my personal history made it clear that I was not just searching for the past or immersing myself in the aesthetic experience that proximity to ruins can produce. I also wanted to reconnect to myself. From the research to the image making to the final edits on the photographic prints, each return to the ruins of the Borscht Belt reveal an outer landscape continually changing. I found that same relentless change unfolding in my own life. My work as a photographer forced me to look at my life, taking into account what has been lost, what has been gained, and what possibilities and transformations lie ahead.

What remains materially will eventually be no longer. Many of these vacant properties will be demolished in the end, and new structures will be built on these sites. This series serves as both an archive and testimony to the Borscht Belt while demonstrating the processes of time, particularly on the built environment. Time arrives with its inevitable persistence, modifying and transforming the landscape and us. While the photographs I've made contain a sense of pathos for what was, I see most clearly in them the traces of hope, growth, and possibility.

HOTELS AND BUNGALOW COLONIES OF THE BORSCHT BELT

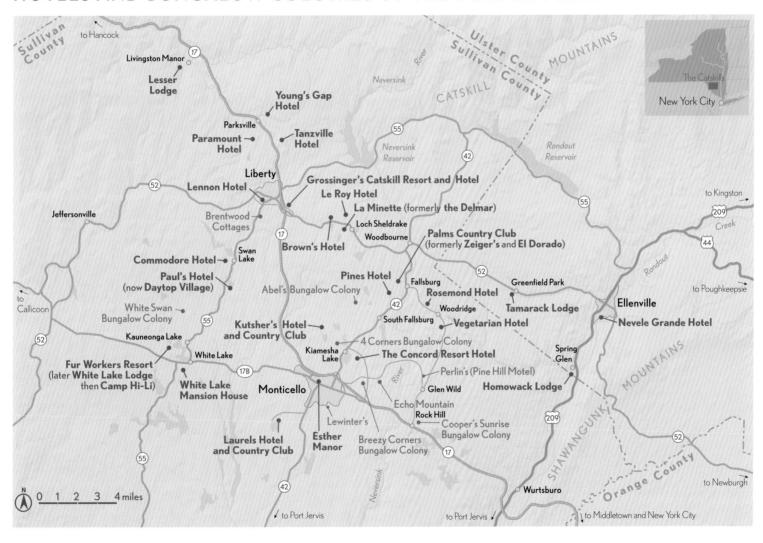

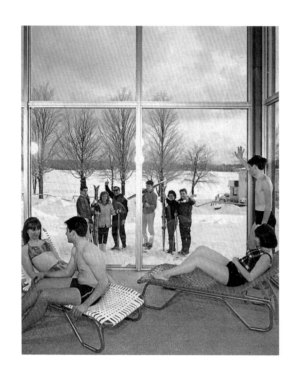

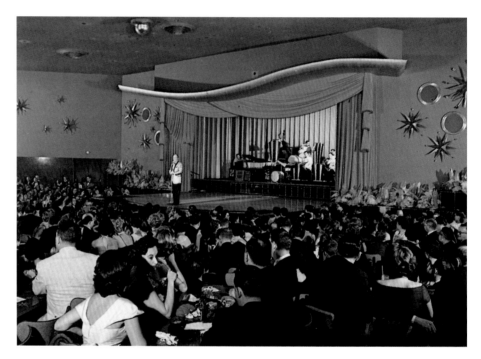

ECHOES OF THE BORSCHT BELT

STEFAN KANFER

GAZING AT THE ORPHANED OBJECTS OF MARISA SCHEINFELD'S PELLUCID LENS, it seems hard to believe that they were once the evidence of immigrant triumph. They were part of a place dubbed the Borscht Belt, a loose confederation of some thousand resorts, nestled in the Catskill Mountains of New York. An Eastern European Jewish clientele, accompanied by its children and grandchildren, thronged those resorts from the 1920s to the early 1970s. They filled the rooms with laughter and rumor, wandered the greenery in search of rest and recreation (and mates), all the while consuming four Lucullan meals a day, including a generous midnight snack. In between they cheered the tummlers, a Yiddish word for the manic, all-purpose entertainers who were the mainsprings of these summer palaces.

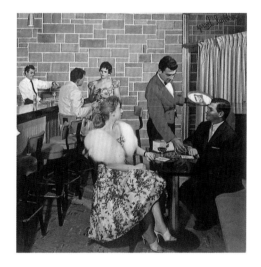

The performers, like much of their audience, formed a nation of refugees: David Daniel Kaminsky, Aaron Chwatt, Joseph Levitch, Milton Berlinger, Joseph Gottlieb, Eugene Klass, Jacob Pincus Perlmuth, Morris Miller. Each was better known by his marquee name: comedians Danny Kaye, Red Buttons, Jerry Lewis, Milton Berle, Joey Bishop, actor Gene Barry, Metropolitan Opera stars Jan Peerce and Robert Merrill.

It had all begun decades before, when the Statue of Liberty was new. A few of the early immigrant families, unhappy with the urban struggle, had gone west of Manhattan to try farming on the Catskills' harsh soil. Vegetables would not grow in abundance, but debts and children did, and the Jewish farmers were obliged to take in boarders. By the turn of the twentieth century, the old houses had become inns, many offering kosher

IT'S ALWAYS
Fun Time
AT THE

Hotel
ZEIGER

THE *Smart* HOTEL
AT
FALLSBURG, NEW YORK

cuisine yet, ironically, displaying names that suggested a yearning for assimilation. The vast and cryptically named Nevele, for example, was only eleven spelled backward, in honor of a group of guests. Ratner's had large Rs in the wrought iron fencing. The new owner called it the Raleigh.

But Grossinger's, the greatest of all resorts, kept its name and its proprietors. Along with her recessive husband, Jennie Grossinger grew her little hotel into an 800 acre estate with its own post office. During the good years, the walls of its playhouse were festooned with ecumenical snapshots: Jack Benny, Senator Robert Kennedy, Jackie Robinson, Terence Cardinal Cooke, Yogi Berra, Governor Nelson Rockefeller, U.N. Ambassador Ralph Bunche.

Alas, it was not meant to endure. The Borscht Belt was slowly but thoroughly undone by a series of factors. First, the overheated, overcrowded ghettos of the Lower East Side became livable thanks to the newfangled air conditioner—no need to escape the mephitic city weather by fleeing to the mountains anymore. Then came television, with new tummlers every night to amuse an entertainment-hungry public.

Most significant, there came acceptance. The greenhorns who overflowed Manhattan's Lower East Side until it was more crowded than Bombay, who peopled the sweatshops six-and-a-half days a week, turning out garments for others more fortunate, who suffered from anti-Semitism in school and in the workplace, but who kept at their lessons and at their work, finally realized their dreams in the Promised City. Teachers came to recognize that the youth of the ghetto were often the lodestars of the class. Many of those kids would go on to occupy corner offices in the private and public sectors.

Only now have historians come to realize that there has never been a domain like the Catskills. Summers ago a whole world was here, a place of unparalleled vigor and humor—and sometimes of conspiracy and crime. The thugs of Murder Inc. could be spotted around certain lake fronts; bigtime gamblers got their starts by fixing local basketball games. Still, these were only a sideshow. The center ring was the one that hired youngsters to wait on tables, to flatter the customers (in the case of pretty girls it was an easy assignment), and to

give them their money's worth of diversion. Willy-nilly the Catskill graduates influenced the humor of a nation in New York and Hollywood; other more serious patrons and employees shaped the progress of the country as attorneys, judges, politicians, physicians, bankers, Wall Street traders, musicians, educators, merchants.

Therein lay the seeds of destruction. For once these ambitious men and women arrived at higher stations, they tended to regard the Catskills as old news—an embarrassment they would rather not remember. To them the Borscht Belt smacked of naïveté and a lack of worldliness. If they wanted to meet the opposite sex there was the water cooler, the singles bar, the nightclub. If they wanted diversion, there was Broadway. If they wanted a vacation, the airlines offered attractive package deals to Miami, Las Vegas, Europe, or even Israel. If they wanted a superior education for their own children, private schools abounded, provided parents could come up with the fees. As for higher education, City College used to be referred to as the Harvard of the Poor. But to the post-Catskills generations, an authentic Ivy League sheepskin was not beyond their aspirations.

And so, one after another, the resorts folded. Today, small towns that once seemed as Hebraic as prewar Lublin, and as roiled and noisy as Tel Aviv, are quiet, shrunken little hamlets with empty storefronts and pensioners pushing aluminum walkers down the undisturbed streets. The forsaken hostelries have become reminiscent of festivals after the celebrants go home, leaving a lawn scattered with rinds and paper plates.

As Scheinfeld demonstrates in her evocative and haunting pictures, nature is green in tooth and claw. Vegetation has come to reclaim its turf. Weeds grow out of the cracks in empty swimming pools—surely the most poignant of all ruins. Indeed, John Cheever based his classic short story, "The Swimmer," on such an image. A once-prosperous executive, in the throes of a nervous breakdown, decides to take a dip in every neighbor's pool on the way to his lush suburban home. A series of disappointments awaits him. At the Welchers', for example, the pool is unfilled, the deck chairs stacked away, and the bathhouse locked. At the front of the house he finds a For Sale sign. But hadn't he and Lucinda dined there last week? "Was his memory failing, or had he so disciplined it in the repression of unpleasant

facts that he had damaged his sense of the truth?"

Not far from another pool—that empty one in the Catskills—moss covers the sides of old recreation halls and wisteria vines pull down proud old hemlocks. In one of Scheinfeld's most memorable works, a row of bar stools awaits customers who will never return, at the edge of a counter long since removed by jobbers or vandals. The seats recall the foreground of an Edward Hopper painting enveloped in a clamorous silence.

Another image shows a kind of benign sabotage—in an old dining room, kids have done battle with paint guns, generously splattering tables and walls. The colors add some life to a moribund arena.

My favorite photograph inspires all sorts of imaginative reflections. In the middle of deserted acreage, an elevator shaft thrusts upward into the sky. But there are no passengers, no hostelry, no recreation hall, no dining room. And, in fact, no elevator. A fire has taken them all away, leaving only a ghost—the vertical path that leads to nowhere.

But it does lead the viewer to wonder—who took that elevator on its last day in a long-ago summer? Was it a housewife stranded with the kids, waiting for a husband who came up only for weekend visits? Was she accompanied by a waiter working his way through college and hoping for a tryst? Or was it a family newly arrived in the Catskills, on its way to rooms with a superb view of the hills and valleys, an unpolluted horizon, the breezes wafting in the open windows, redolent of new mown hay, flowers, and toasted garlic bagels?

Or did it contain someone very young but also very motivated? Someone who dreamed of recording the Borscht Belt experience with a paintbrush, a typewriter, or, best of all, a camera? I like to think that at one time Marisa Scheinfeld, the Catskills scholar, rode that elevator, vowing to preserve it for all time. That she has done, in her own unique and aesthetically provocative way—the way of all important artists. Let your fingers do the walking through this exhibit of ruins. You will not be the same person as the one who first opened this magical volume.

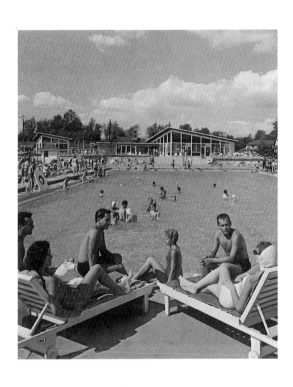

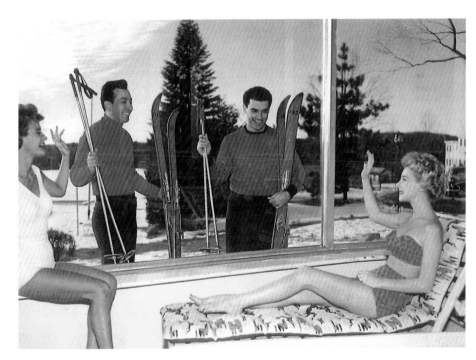

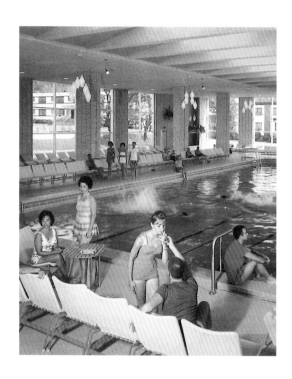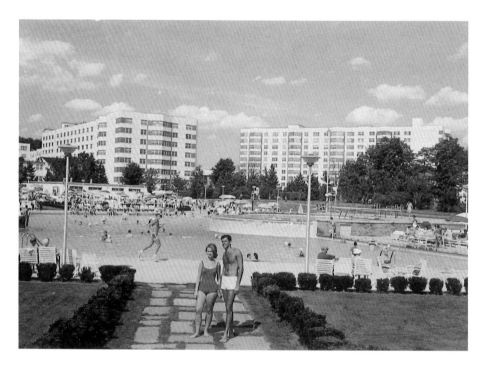

IN THE FRAME

JENNA WEISSMAN JOSELIT

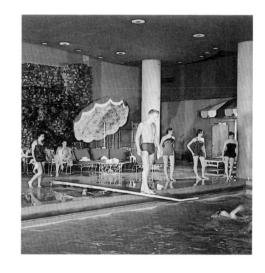

THE CHAIRS. OH, THOSE CHAIRS. ONE FLOATS IN THE WEEDS OF A LOCAL watering hole, bringing to mind the baby Moses adrift in the bulrushes; another stares out the window. Three or four lounge chairs seek shelter from the sun under a billowing yellow and white canvas, which seems as if it is about to take off. Elsewhere, they form a straight line or huddle in a circle. Amid the welter of detail that characterizes Marisa Scheinfeld's portfolio of arresting and artful images, my eye seizes on the chairs. I can't get enough of them, which is a good thing, since so many turn up in her photographs, where each and every one figures as the visual equivalent of a found object. Lest you think Scheinfeld rearranged the furniture for maximum effect, think again. She photographed these items just as she found them—here, there, and everywhere.

The chairs come in multiples: in wood and in plastic, in hot pink and in various shades of green; tufted, woven, slatted, upholstered. Some were intended for indoor use only, in the lobby, the coffee shop, and the guest room; others were intended for the great outdoors, around the pool, by the lake, or in the shadow of a great big tree. All of them have now lost their moorings; they're no longer where they're supposed to be. These chairs are out of place, decontextualized. They turn up where you least expect them, occasioning both a sigh and a chuckle. Piled atop one another, helter-skelter, their fabric soiled and torn; decapitated, legless, armless, the chairs—I catch myself anthropomorphizing these inanimate constructions of metal and wood and fabric and need to stop. But how can I resist? In contrast to everything else around them, the chairs of the Catskills are so alive.

Much of their appeal is ocular. Thanks to the way Scheinfeld captures their liveliness, they're good to look at, even in their diminished state. Sculptural presences, studies in volume, the chairs occupy space, defy space, even memorialize space. They stake their claim to the Catskills. The chairs are extremely tactile, too. Paint peels from the frame of an Adirondack chair, the chrome of a bar stool has tarnished to a fare-thee-well, while the plastic slats of a once proud chaise longue sag and droop like an aging body.

But there's more here than visual provocation. There's history, too. Whether clustered in a group or isolated in a field, the chairs tell stories. Some of those stories have to do with loss and absence. Others have to do with pleasure and the thrill of anticipation. Every one of them tells of a time, some fifty to sixty years in duration, when American Jews, largely from the East Coast, ventured to the Catskills, to its hundreds of bungalow colonies and equally large number of resorts, for fun and games, for a respite from the summer heat and the pressures of daily life. But that's all gone now and what remains are Scheinfeld's canny images, which bear witness to both change and stasis. Her artistry makes us see that the past doesn't vanish so much as startle. Just when you think there's nothing left from an earlier era, you happen upon something that stops you in your tracks, some quirky detail that puts you in mind, ruefully, perhaps, of the odd juxtaposition of human and natural history.

The presence of so many chairs in Scheinfeld's chronicle of the Catskills is no accident, no artifact of her aesthetic imagination. It reflects one of the most characteristic of all Catskills experiences: sitting. American Jews came to the mountains, as they called the Catskills, not to hike or bike or develop their musculature. They came to sit. No, it wasn't laziness or physical limitations that contained them so much as their avid, and collective, pursuit of conversation. Over the years, as the Catskills came into its own as a destination, enterprising hotel proprietors augmented their facilities with tennis, racket ball, and basketball courts, with golf, swimming, boating, and games of Simon Says, all of which were designed to get the guests out of their chairs and on their feet, up and about, moving. They did, but only up to a point. Nothing held a candle to sitting and chatting. The latest amenities were nice, to be sure: a welcome bonus, even a source of distraction. But talk, not movement, was the coin of

the realm. Verbosity rather than physical activity greased the wheels of Esther Manor and Breezy Corners, the Concord and Grossinger's. These resorts were of a piece, merely a geographical sleight of hand, with the cafes that once dotted the Lower East Side, where "bright talk" flowed as thickly as the coffee which, reported the *New York Times*, was "made with wise economy from sound berries."[1] Vacationers sat around the pool, on the veranda, and at the dining room table, commenting on the human condition, their observations now and again curdling into gossip. (Consider this cutting remark: One disgruntled vacationer, lamenting that her female coreligionists were given to "talking small talk all day long . . . and judg[ing] others by the clothes they wore," allowed how these women liked to "think of themselves as the cream of Jewish society. Perhaps they were," said she, "but the cream has turned rancid.")[2]

Chairs, as Kenneth L. Ames pointed out years ago, are not simply decorative; they are also object lessons in posture, in the etiquette of proper form—and more. In late nineteenth century America, he writes, "sitting was not merely taking a load off your feet. It was a way to reveal character, gender, social class and power." For the Victorian Americans whom Ames studied, chairs were agents of gentility and restraint.[3] Catskill chairs were something else again. Their occupants slouched in them, their bodies splayed and relaxed; no one gave a fig about sitting up straight, ankles neatly crossed. Chairs were for getting up close and for nestling even closer, for generating talk, for playing cards, for eavesdropping. Proximity and portability were their hallmarks, not propriety. Chairs made for a good time; chairs made for sociability. They were, quite literally, conversation pieces.

Now and again, vacationers would forsake their chairs for the swimming pool. In the "kingdom of outdoor happiness," as Grossinger's exuberantly styled itself, the Olympic size pool was king, the cynosure of all eyes.[4] Even the lesser lights of the Catskills, the more modest bungalow colonies and less luxurious hotels, boasted one. Transforming what had once been a region of farms into a resort, the presence of a pool spoke of modernity and of cleanliness, too. Promotional gestures such as postcards were replete with images, some hand-drawn and colored, others photographed, of pools, pools, and more pools. A postcard of Arcadia Lake Hotel in Hurleyville, New York, a "modern and up-to-date hotel," referred

not once, but twice within as many sentences, to its pool, which, it affirmed, was both "large" and "filtered."[5] To bring home that point, it offered a bird's-eye view of the place in which the pool nearly dwarfed everything else in its immediate vicinity. Or consider a postcard of the Hotel Seven Gables in Greenfield Park, New York. To attract prospective guests, it chose to feature only two of its many accoutrements: the hotel's handsome exterior and its pool.[6] Meanwhile, Hotel Brickman in "So. Fallsburg" went its competitors one better by trumpeting its "magnificent terraced swimming pool area."[7]

The owners of Hotel Brickman had it right. No matter their form—square, rectangular or bean-shaped—Catskills pools were designed for splashing about, for a quick dip, before seeking the comfort of one's berth and buddies once again. As cooling and inviting as the water might have been, the pool and its surround was really another venue for conversation and people-watching: a lobby with water. The pool had little to do with improving the body and everything to do with pleasuring it. In the Old World, the European spa towns like Marienbad to which the Jews repaired in great number placed a premium on health—or, more to the point, on its restoration.[8] Abetted by clocks and scales and other sorts of measuring devices, guests followed a strict daily regimen designed to reduce their blood pressure and calm their nerves; a team of medical men with a long string of degrees after their names monitored their behavior. European spa culture, an exercise in the medicalization of leisure, was fueled by discipline. Not so, the Catskills. Here, a different sensibility prevailed, one given over to well-being, to a celebration of bounty: a salute to appetite in the broadest sense of the word. Sholem Aleichem had a field day satirizing the goings-on at Marienbad and comparable spa facilities.[9] One can only imagine what he would have made of the Catskills, where in lieu of physicians, tummlers (or social directors, a description that, in English, doesn't quite do them justice) saw to the equilibrium of the guests.

Up in the mountains, the swimming pool was the sole concession to health consciousness, the only acknowledgement of the body's limitations. Mucking about in its clear, carefully delineated blue waters instead of in a muddy lake was safe and contained, a risk-free way to enjoy the joys of nature. Hefty daily doses of chlorine kept the bugs at bay, and if that didn't

do the trick, the water was "filtered," or so guests were constantly reassured. Meanwhile, a hunky life guard was always on hand to supervise the proceedings and to ensure that nothing untoward other than harmless flirting might befall any of the guests. Then again, when it came to control, nothing beat the indoor pool. Outdoors, it might be raining cats and dogs (or snowing away in winter), but indoors, guests were both cossetted and protected as they practiced their breast stroke. Indoor pools, like the sleek glass and wood structure at Grossinger's, with its floor to ceiling windows, thumbed their nose at Mother Nature.

These days, Mother Nature has the last laugh. Carpets of vegetation have supplanted bodies of water while geometry has given way to shapelessness, so much so that often a former pool merges seamlessly with its environment, making it difficult to figure out where one begins and the other leaves off. It's not for nothing that abandoned pools loom large in Scheinfeld's barrage of imagery, a testament to their former prominence. But now they're so overgrown, so misshapen by the ravages of time and neglect, you are often not sure of what you're looking at. What had once beckoned, invitingly, now mystifies and even estranges. What are those bizarre concrete containers, their sides stained by rust and who-knows-what-else? Or those unattached, curvaceous blue bars poking out of the ground like tulip bulbs. What are we to make of them? Even as it decomposes, the pool remains an indelible part of the landscape, catching us by surprise.

On the strength of Scheinfeld's imagery, you have to admit that there is nothing quite as forlorn as a former swimming pool. But stairs that go nowhere, another recurrent visual motif, are a close second. They speak of interruption, of arrested motion. Most of us associate stairs with propulsion, with moving toward a goal, but that is clearly not the case in the Catskills of today where they either straggle or come apart. Their treads covered with moss, these stairs trail off, as if in mid-sentence. A set of narrow metal stairs, supported by two skinny poles, leads to a diving board, or so I surmise since there's nothing at the top but yawning sky. Elsewhere, a sloping set of stone steps is submerged in a meadow of wild flowers: a pretty sight for those of us with a painterly eye, a sad sight for the rest of us. Besides the stairs, additional architectural remnants litter the landscape: elements of a multi-colored stone chimney,

The
NEVELE
Country Club

Ellenville, New York

"Vacationing the year 'round"

whose fireplace once assuaged the chill of a late August night, stone pillars that long ago stood like sentries at the entrance to a resort, welcoming one and all.

How vividly these crumbling and inert architectural elements contrast with the former energy of the Catskills where, within the contours of a relatively small footprint, everyone, guests and staff alike, was continuously in motion. In the course of their stay, guests wended their way down one long corridor and up another, migrated to the dining room and then on to the Ali Baba Room or the Moulin Rouge Nite Club to dance the night away. Guests arrived and guests departed in a swirl of activity as bellmen hustled them in and out. And then, abruptly, or so it must have seemed at the time, there were none: no guests and no employees to tend to them. American Jews en masse had moved away from the Catskills, quitting its precincts for good. It would not be a cliché to say that they left in search of greener pastures.

Why American Jewry collectively checked out is subject to endless discussion. Some blame the airlines, others point to changing notions of leisure. Still others bring in the kitchen sink—the economy, the rise of the so-called blended family, the prevalence of divorce. Explanations are thick on the ground. Why, I've even heard people insist that feminism was the culprit behind the region's decline. Whatever the reason, the abandonment of the Catskills was volitional. No external forces insisted on it; no outside powers expelled the Jews from this patch of land. The Catskills didn't give up the ghost; American Jews gave up on the Catskills—and then and only then did it give up and collapse onto itself. When American Jews mourn its passing, which they do loudly and often, they have only themselves to blame. How fitting, then, these architectural fragments. Like tombstones or totems, they mark the spot where the Jews learned to modernize and Americanize, to relax and have fun within the company of their own. The Catskills was where American Jewry came of age.

It is tempting to situate Marisa Scheinfeld's images of the tumbledown and the weedy within the context of ruin photography and to promote them as a latter-day and decidedly postmodern iteration of that long established genre. After all, her body of work, much like that of Andrew Moore's celebrated study of the Motor City, *Detroit Disassembled*, or *Stages of Decay*, Julia Solis's moving inquiry into abandoned movie palaces and vaudeville houses,

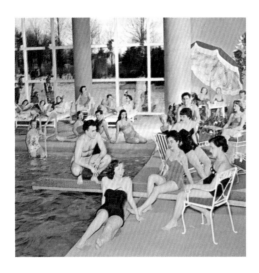

documents the afterlife of both a region and a cultural institution.[10] Scheinfeld deserves to be placed within their distinguished company. Visualizing happenstance and serendipity as well as the often curious collusion between human hands and Mother Nature, her assemblage of images, like theirs, helps us to think of decay as an active process, graced by its own special beauty.

All the same, I have a sneaking suspicion that Scheinfeld would prefer to have her work understood, and embraced, more as a valentine than as a valedictory. As troubling and upsetting as her portrayal of the contemporary Catskills may be to those who were familiar with the thriving bungalow colonies and resorts of yesteryear, it doesn't so much break with the past as extend its hold on us. The taking of pictures, you see, was central to the experience: photography was to the Catskills as cream cheese is to a bagel. For one thing, it was the seductive medium by which potential guests were encouraged to head for the hills of upstate New York. Colorful (and carefully scripted) photographs of their coreligionists—of people just like them—at play both reassured and stimulated the American Jewish imagination.

For another thing, the mildew-streaked hotel hallways that figure in Scheinfeld's contemporary images were once lined with a procession of celebrity portraits taken by professionally trained staff photographers. Every year another row of headshots would be added to the panoply of stars who had visited over past seasons: American Jewry's very own hall of fame. Lesser mortals also clicked away. Guests wielded cameras, first Instamatics and later Leicas, like tennis rackets, capturing and preserving the antics of their children and of one another. Filling family albums and, more recently, swelling the holdings of the Catskills Institute and other repositories of the American Jewish experience to which they have lately been consigned, these photographs project a wholesome, lighthearted image of a culture at one with its surroundings—happy and content.

It is now Marisa Scheinfeld's turn. Even in death, the Catskills deserves to have its picture taken. Who better to do the honors than a gifted visual artist who, as luck would have it, grew up in that very neck of the woods. In more ways than one, she speaks the language like a native, enriching our understanding of how the past frames the present.

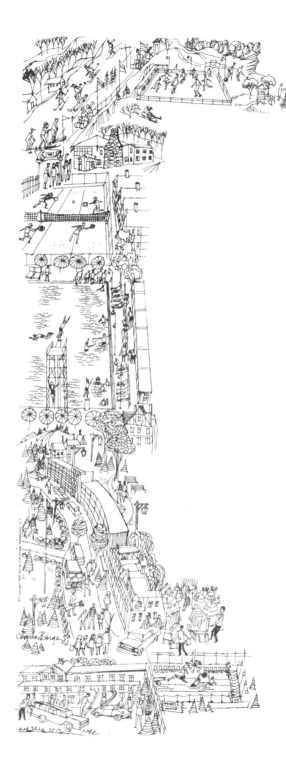

NOTES

1. "In the East Side Cafes," *New York Tribune*, September 30, 1900, in *Portal to America: The Lower East Side, 1870-1925*, ed. Allon Schoener (New York: Holt, Rinehart and Winston, 1967), 139. "A Good Cup of Coffee. It Can Be Had In A Few East Side Cafes," *New York Times*, November 20, 1892, p. 17.

2. See Jenna Weissman Joselit, "Leisure and Recreation," in *Jewish Women in America: Historical Encyclopedia*, ed. Paula Hyman and Deborah Dash Moore (New York: Routledge, 1997), 818–27, esp. 823.

3. Kenneth L. Ames, "Posture and Power," *Death in the Dining Room and Other Tales of Victorian Culture* (New Brunswick: Rutgers University Press, 1992), 185–232, esp. 189.

4. Jenna Weissman Joselit, "Al Harei Catskill: The Vacations of Yesteryear," *Forward*, August 6, 2004.

5. Arcadia Lake Hotel postcard, n.d., Catskills Institute Collection, http://www.brown.edu/Research/Catskills_Institute/. Postcards no longer viewable at this URL.

6. Hotel Seven Gables postcard, 1940, Catskills Institute Collection.

7. Hotel Brickman postcard, 1950, Catskills Institute Collection.

8. On European Jewish spa culture, see Mirjam Zadoff, *Next Year in Marienbad: The Lost Worlds of Jewish Spa Culture* (Philadelphia: University of Pennsylvania Press, 2012).

9. Sholem Aleichem, "Marienbad," in *Zumer Lebn* (New York, 1917). For a lively English version, see Sholem Aleichem, *Marienbad*, translated by Aliza Shevrin (Perigree Trade, 1984).

10. Andrew Moore and Philip Levine, *Detroit Disassembled* (Akron: Damiani/Akron Art Museum, 2010); Julia Solis, *Stages of Decay* (New York: Prestel, 2013).

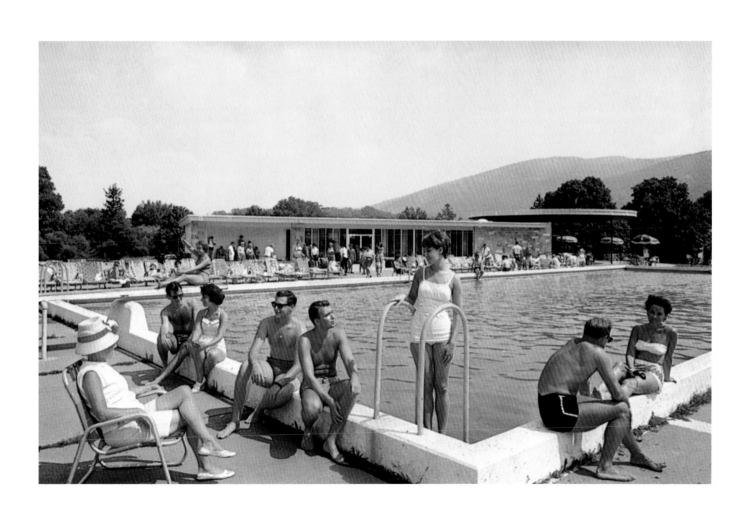

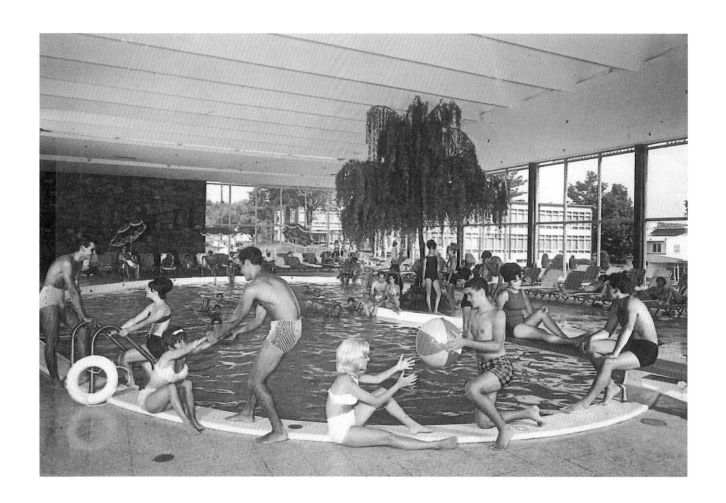

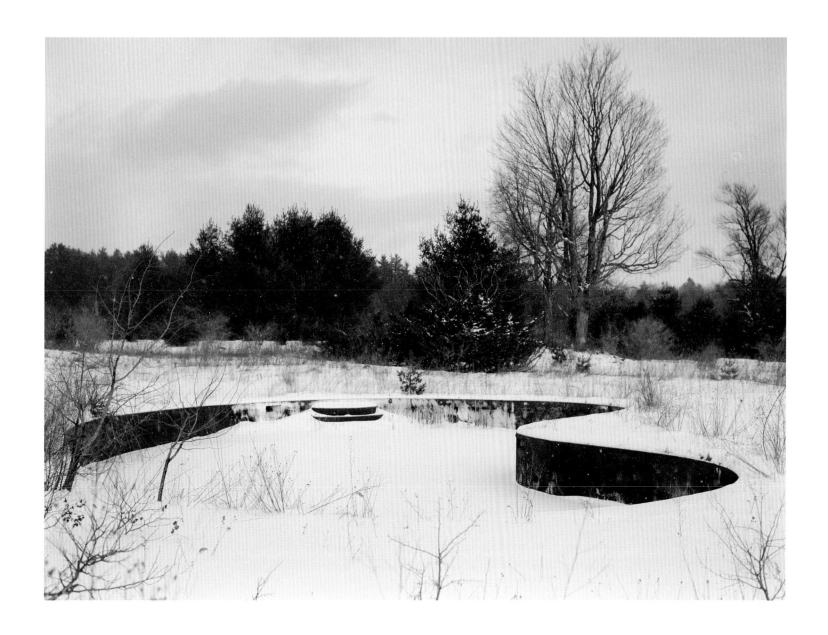

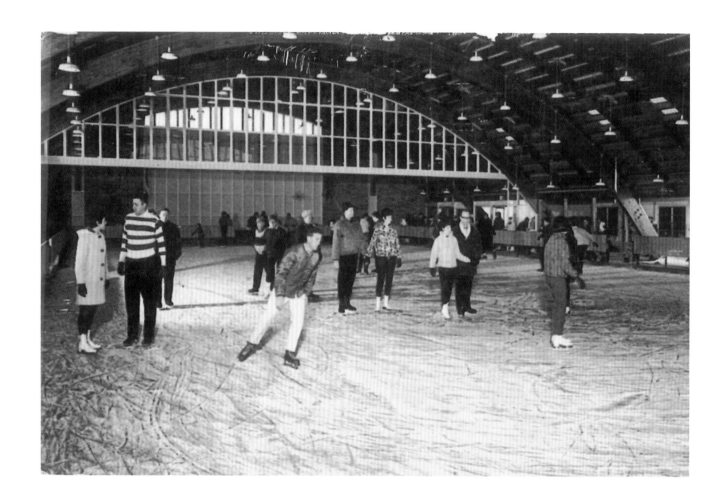

32

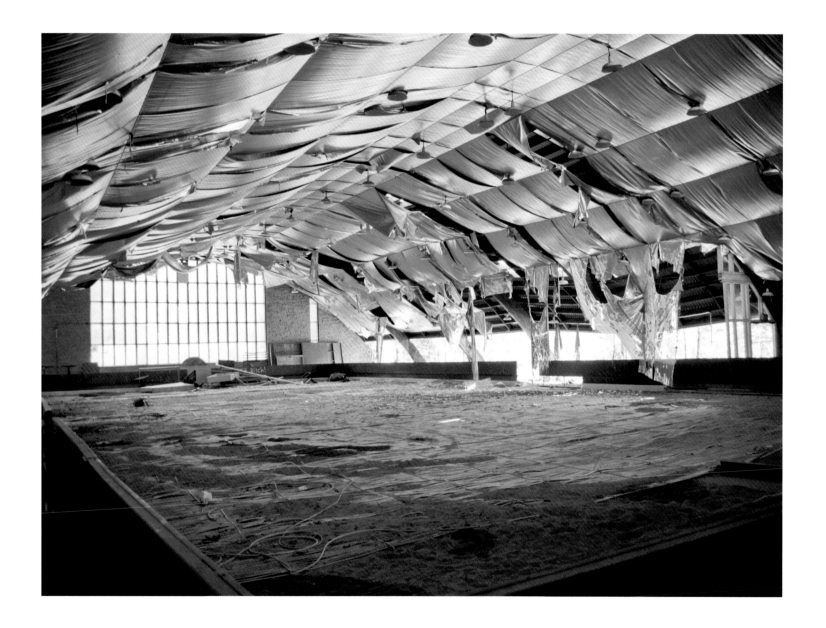

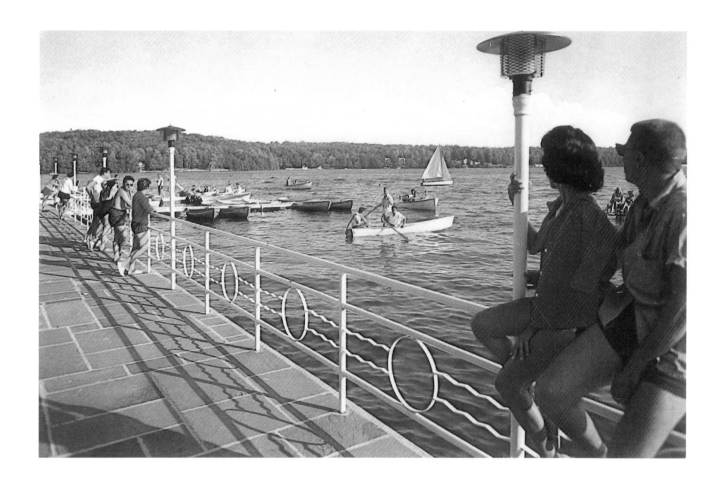

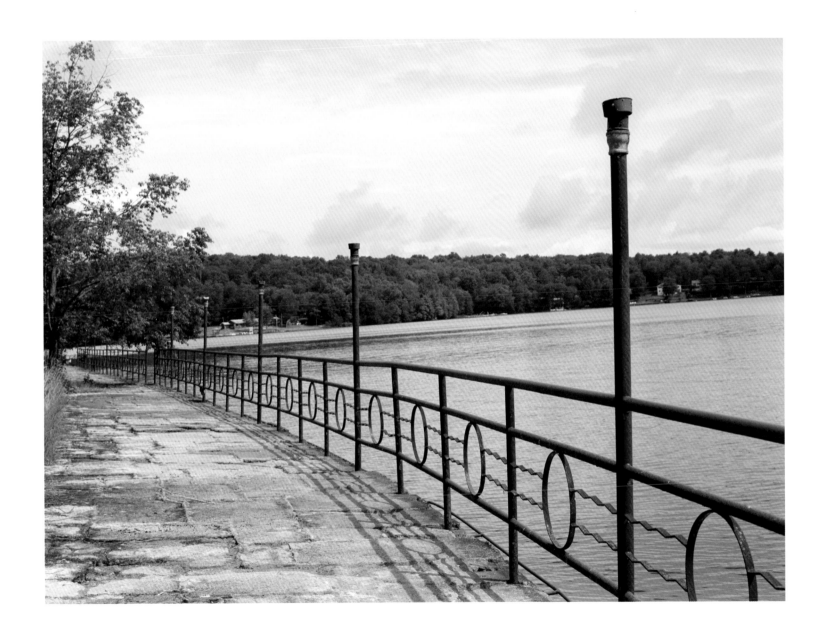

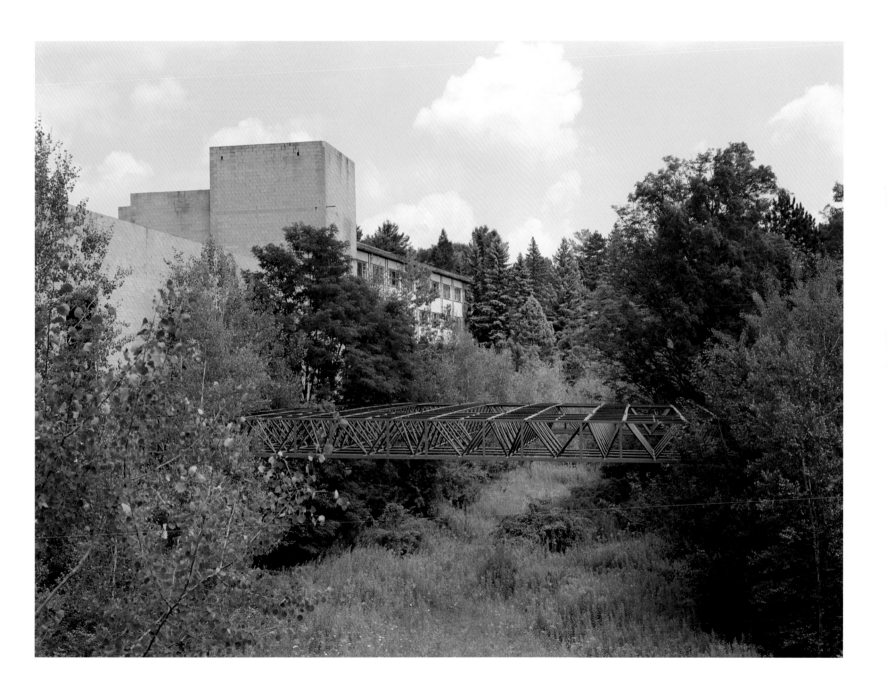

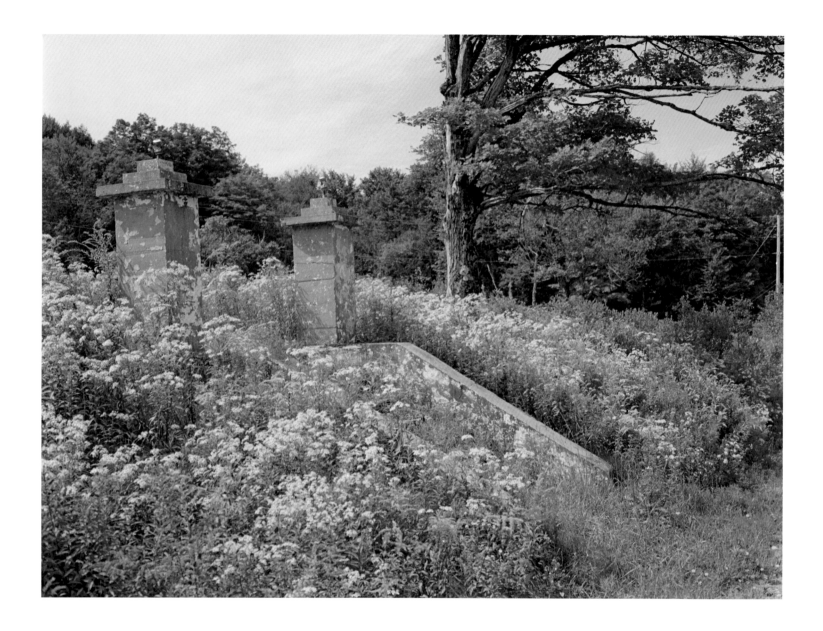

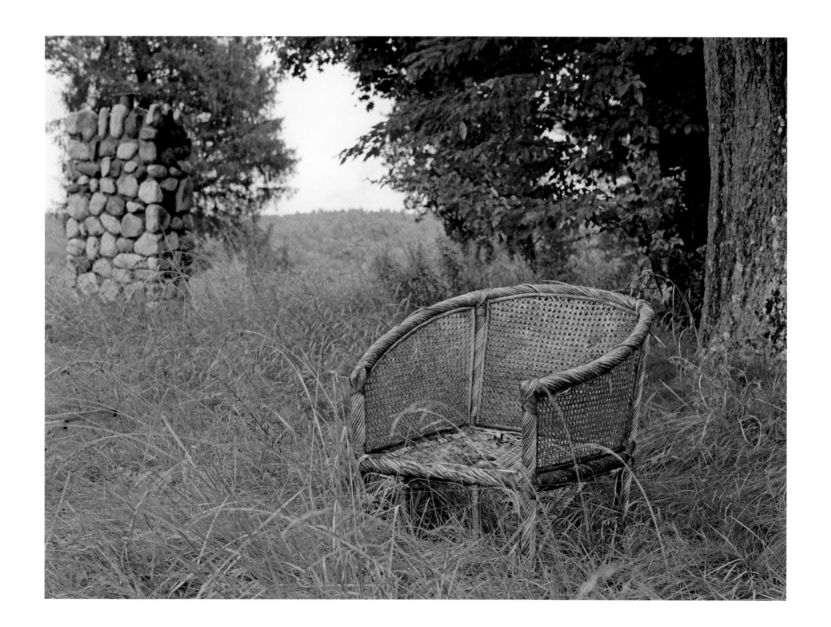

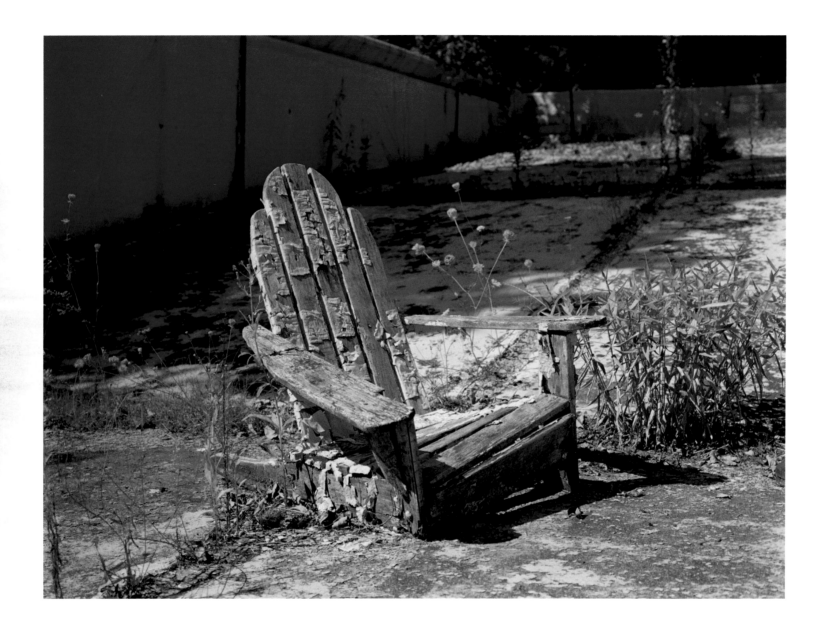

40

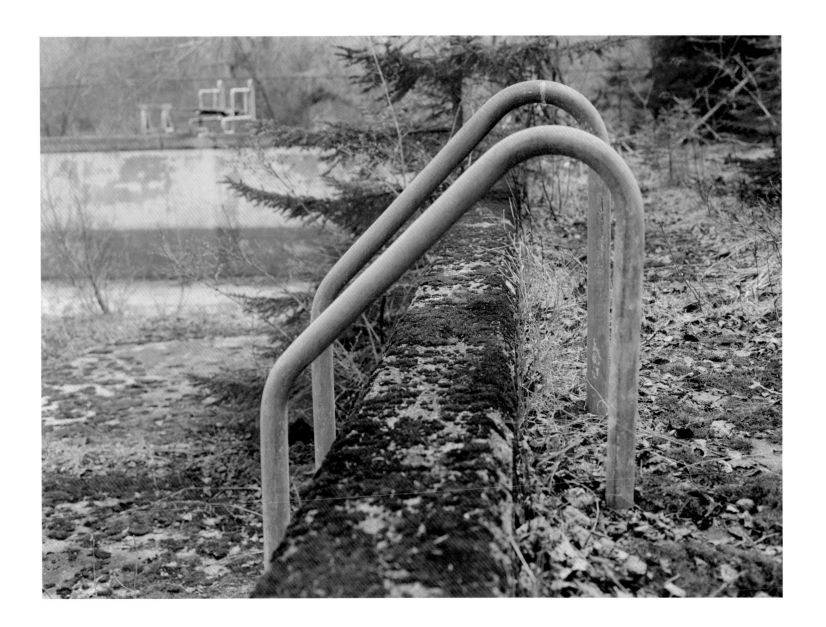

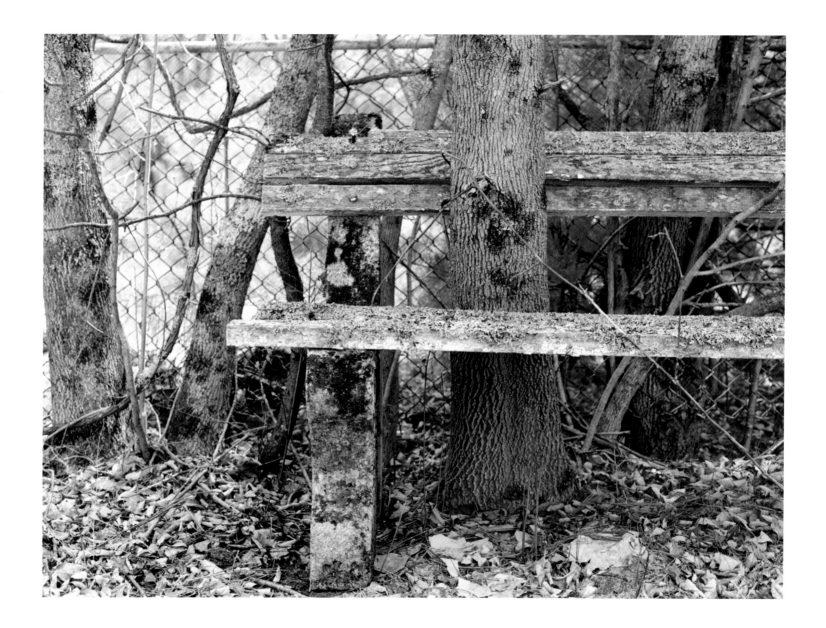

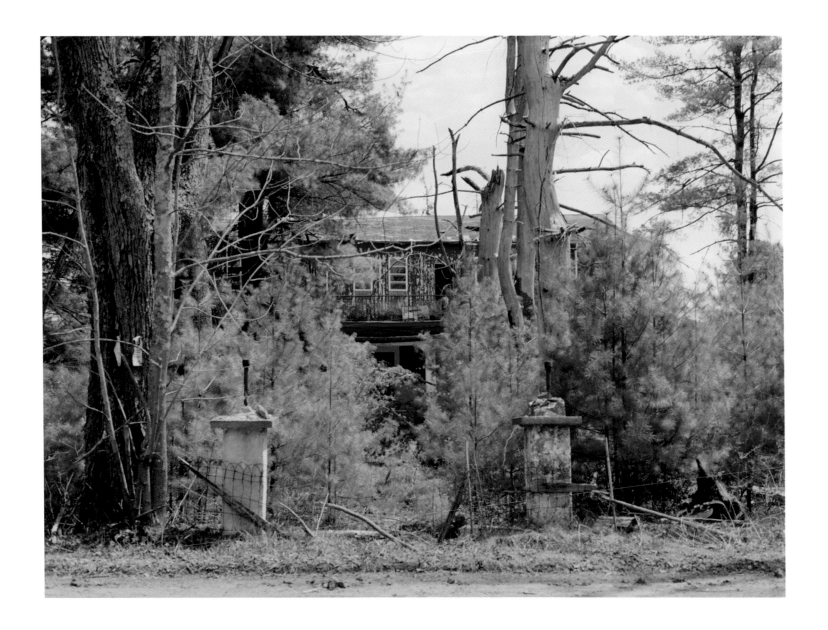

43

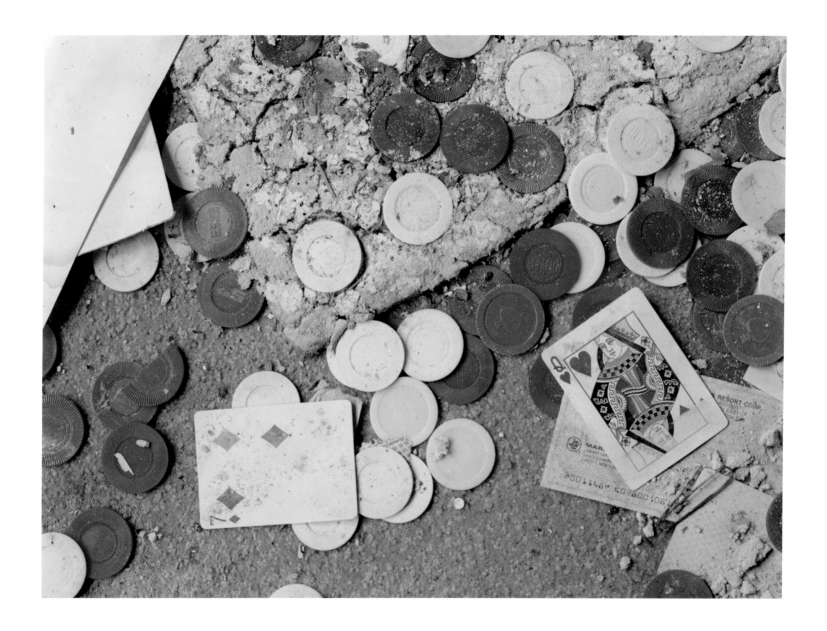

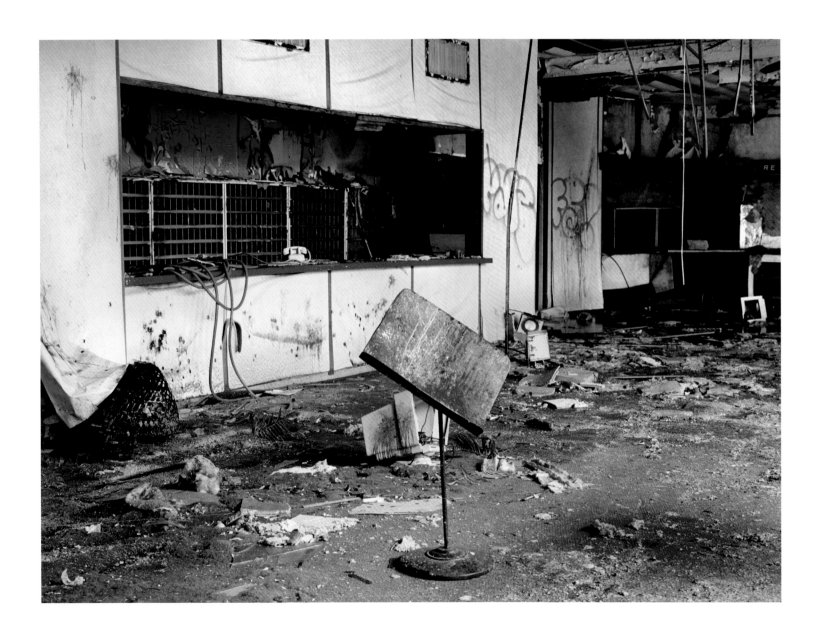

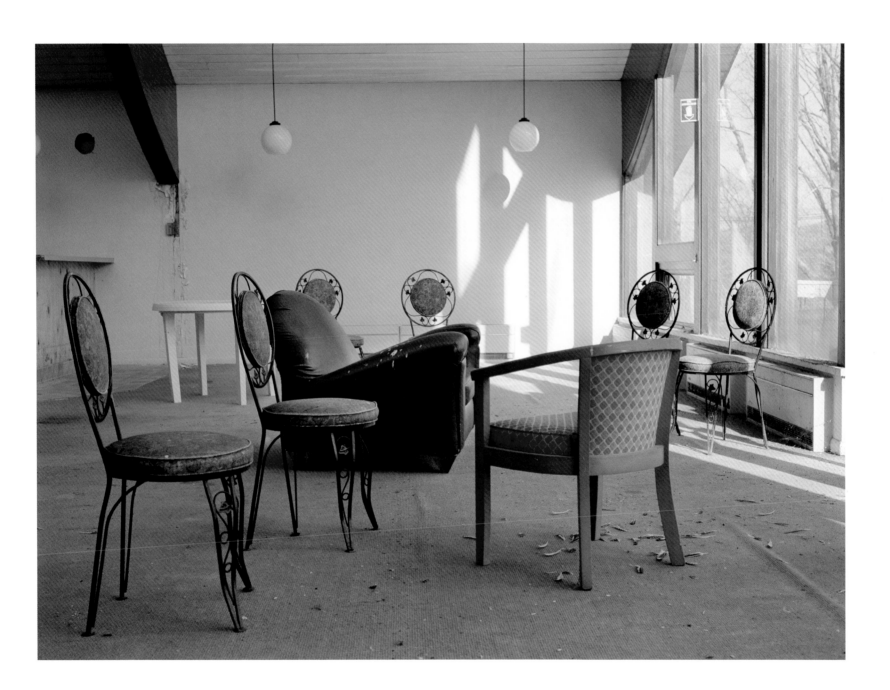

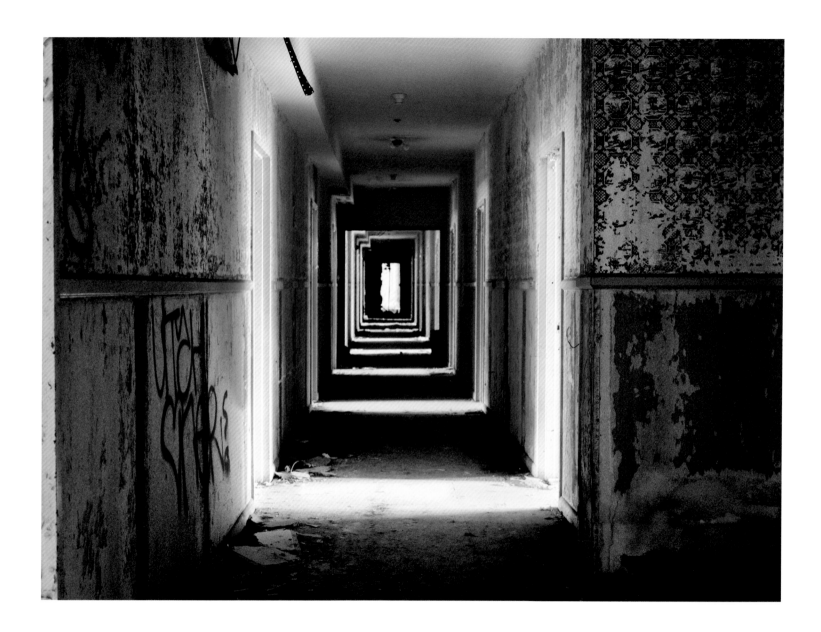

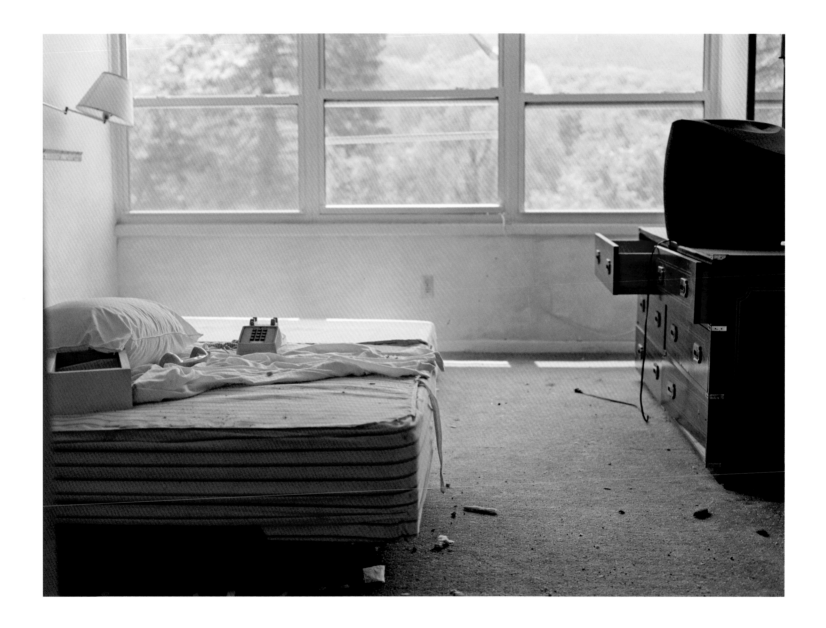

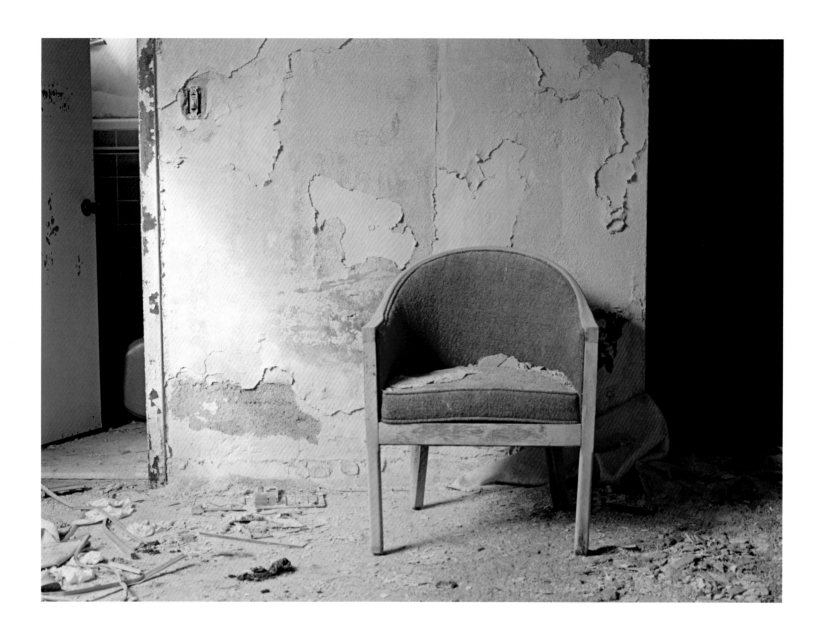

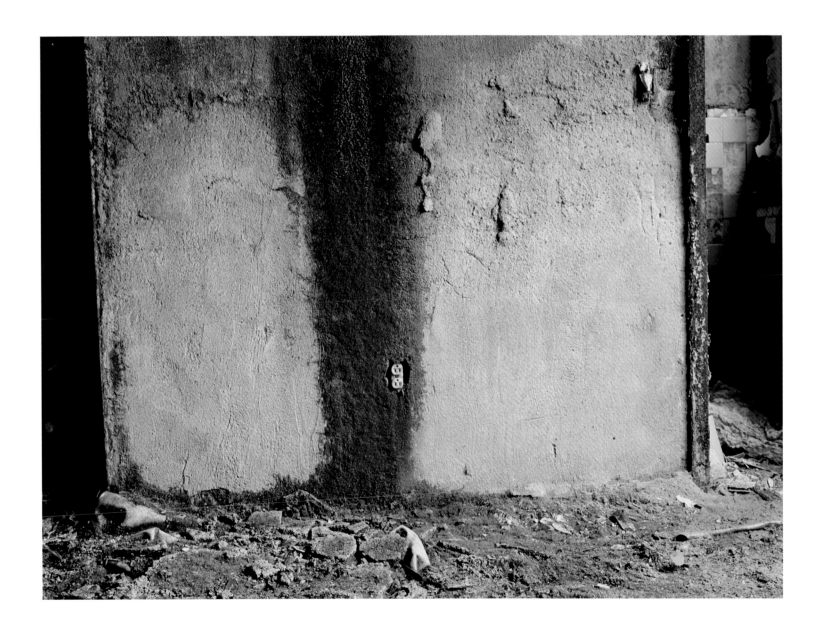

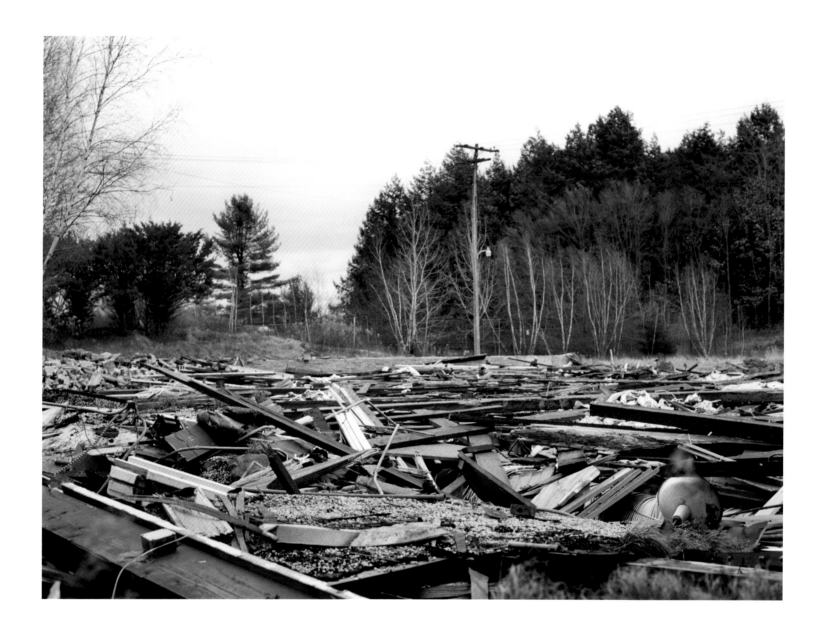

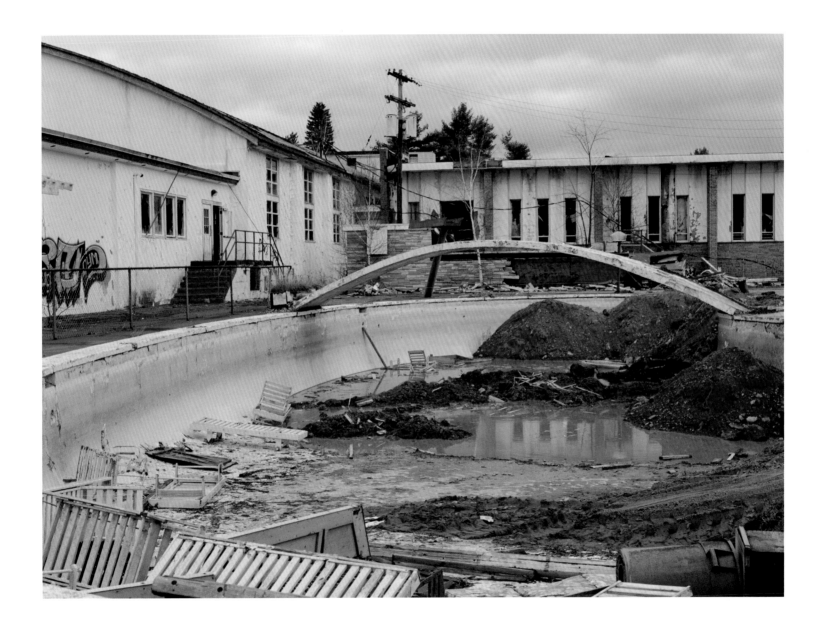

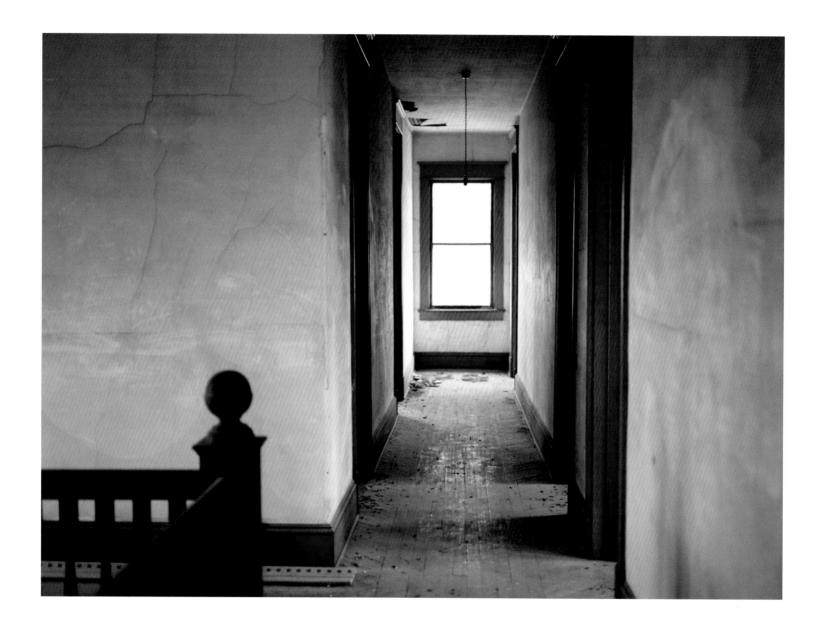

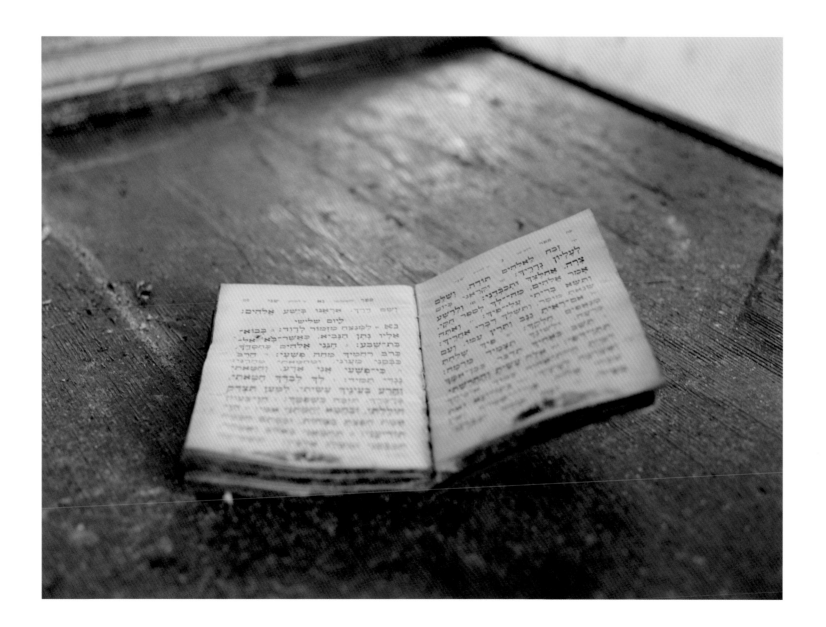

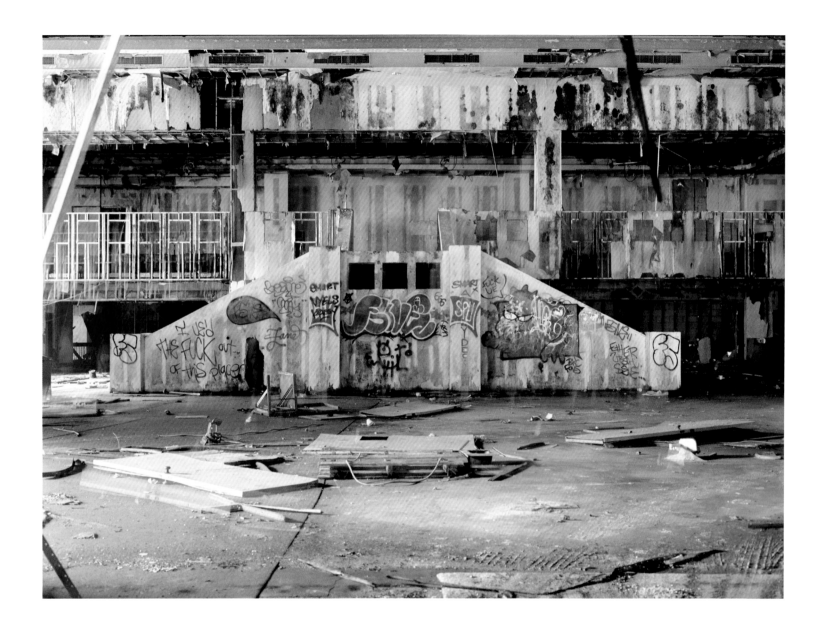

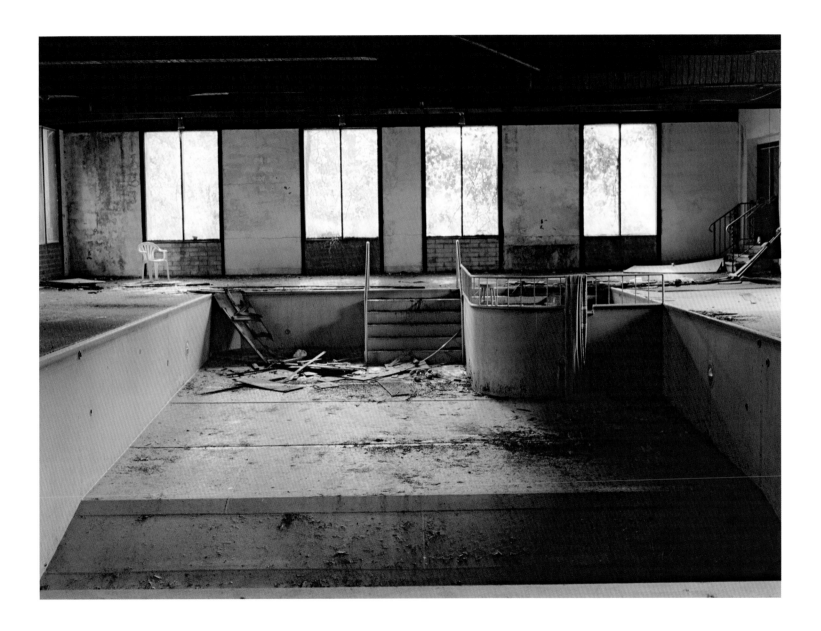

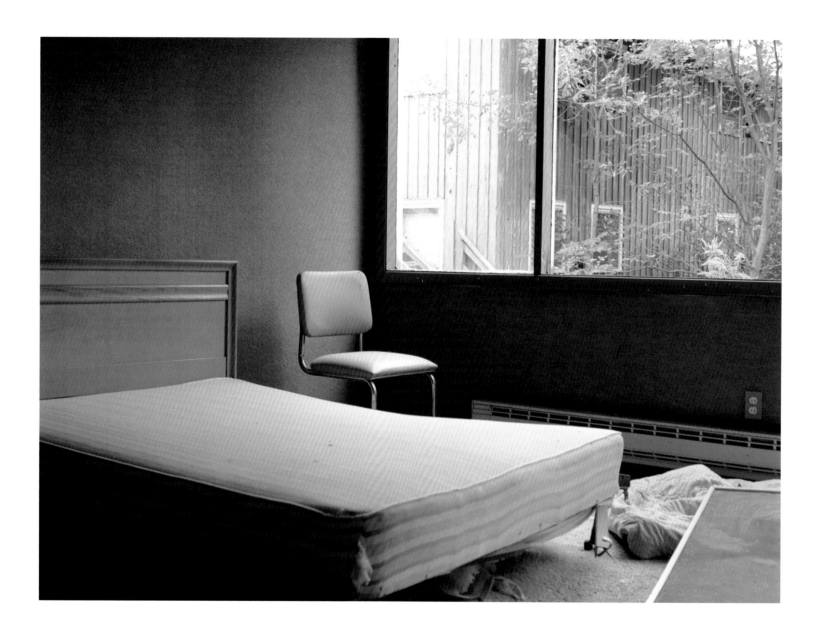

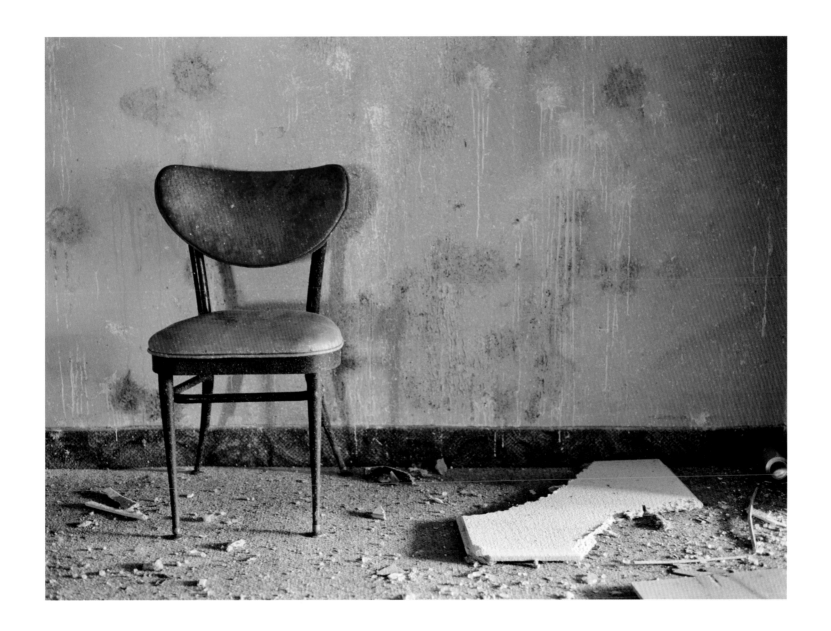

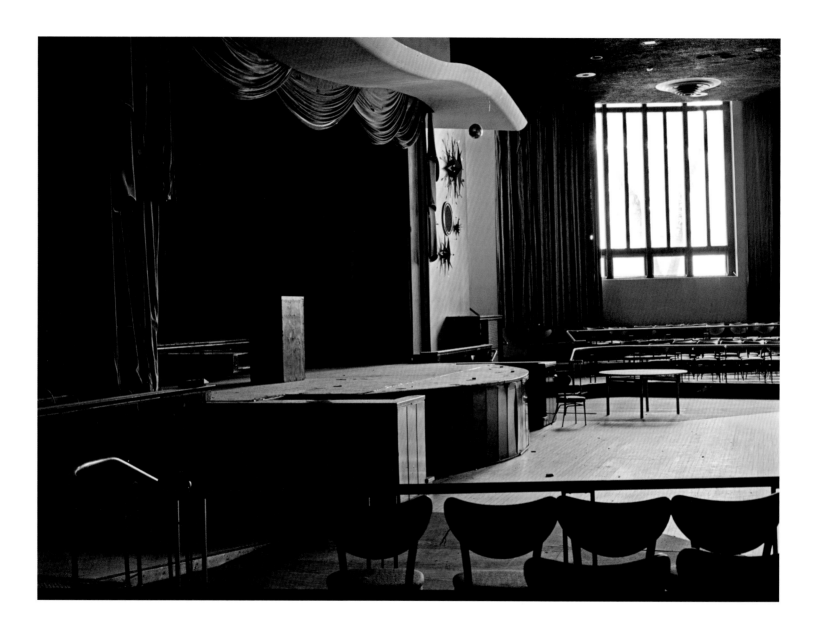

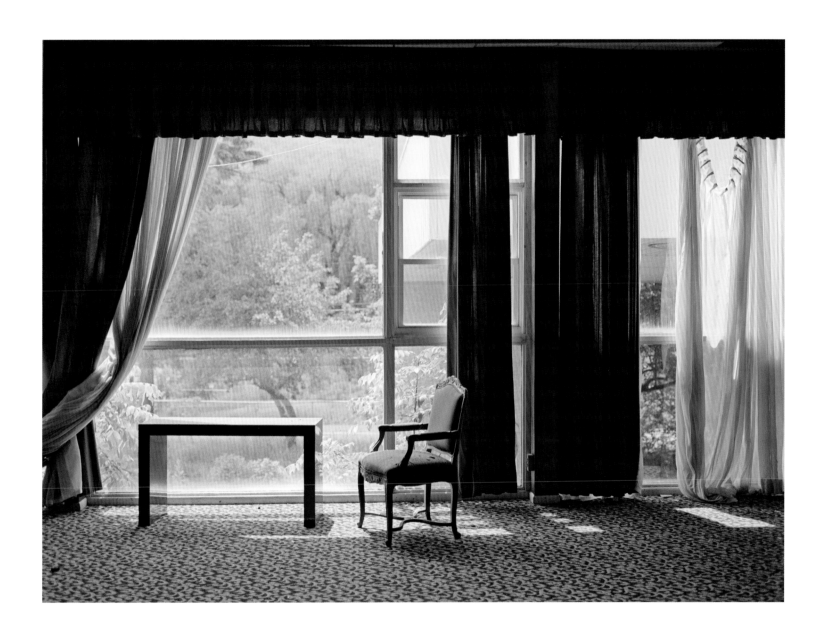

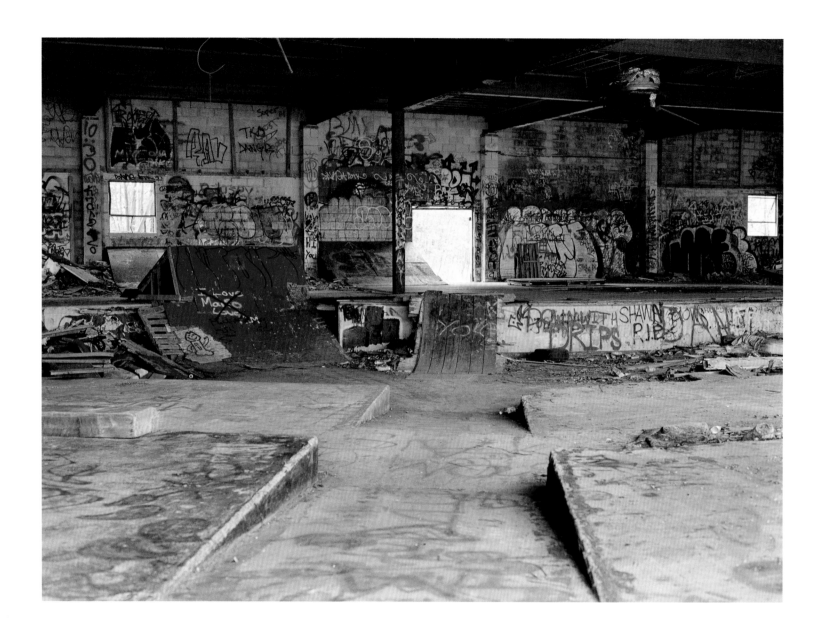

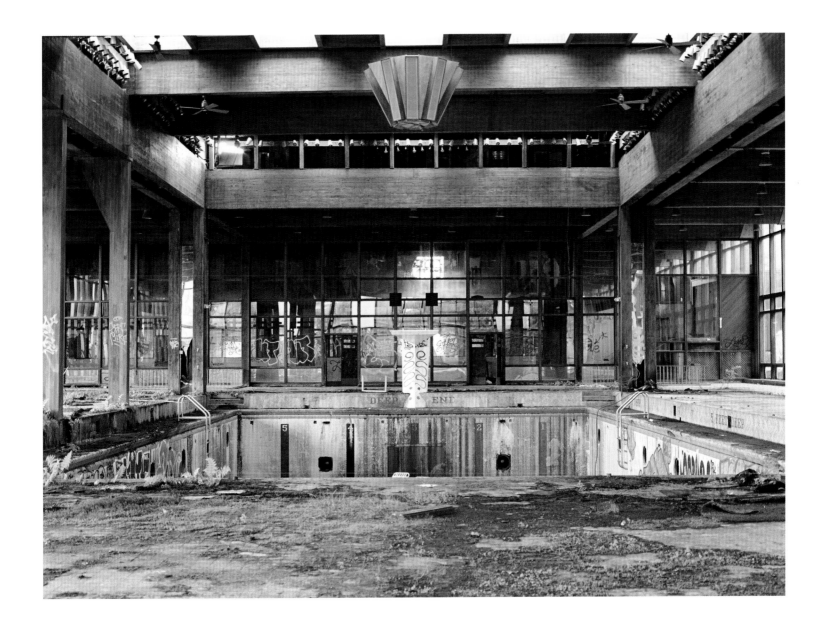

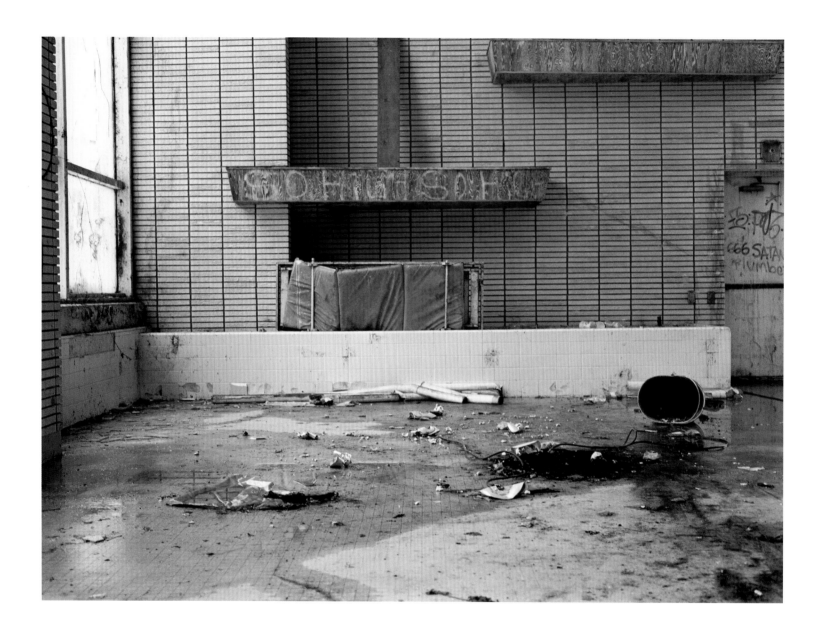

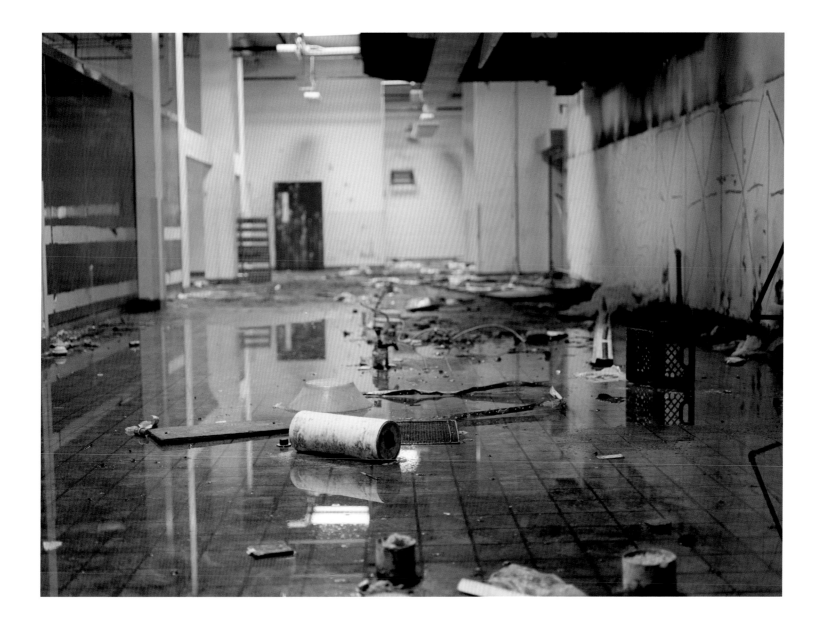

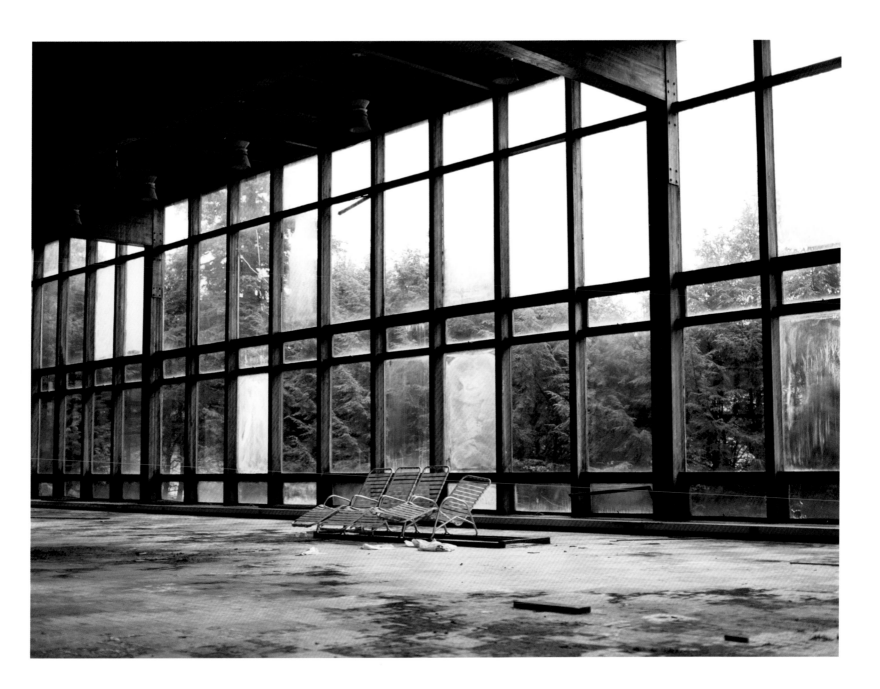

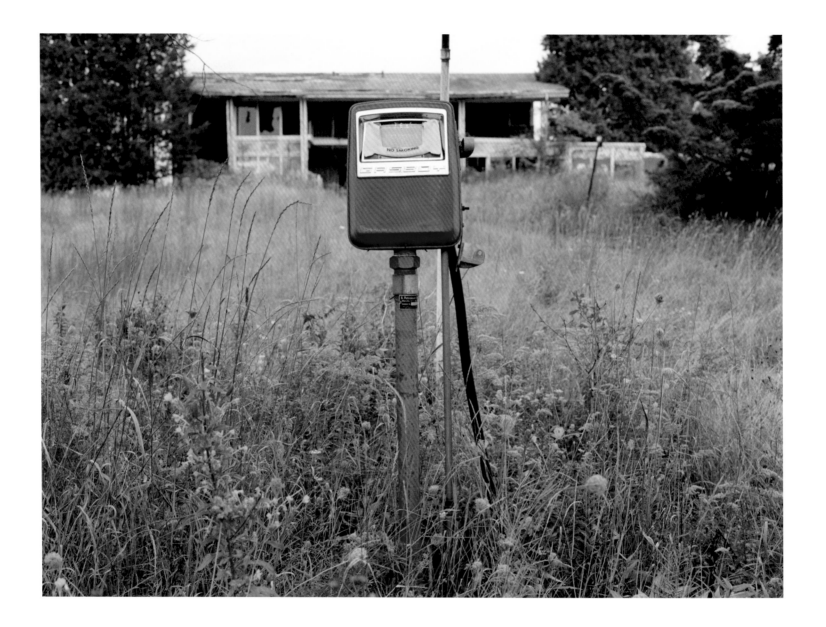

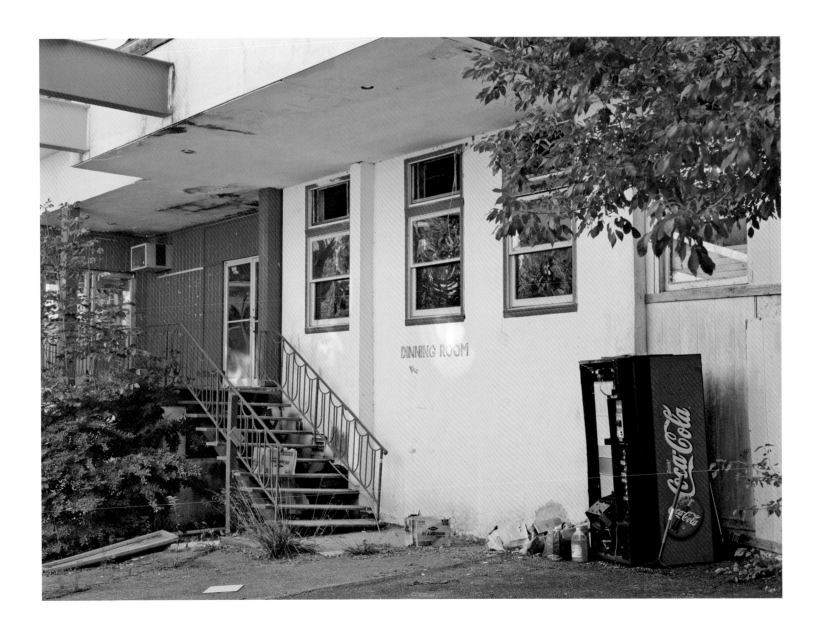

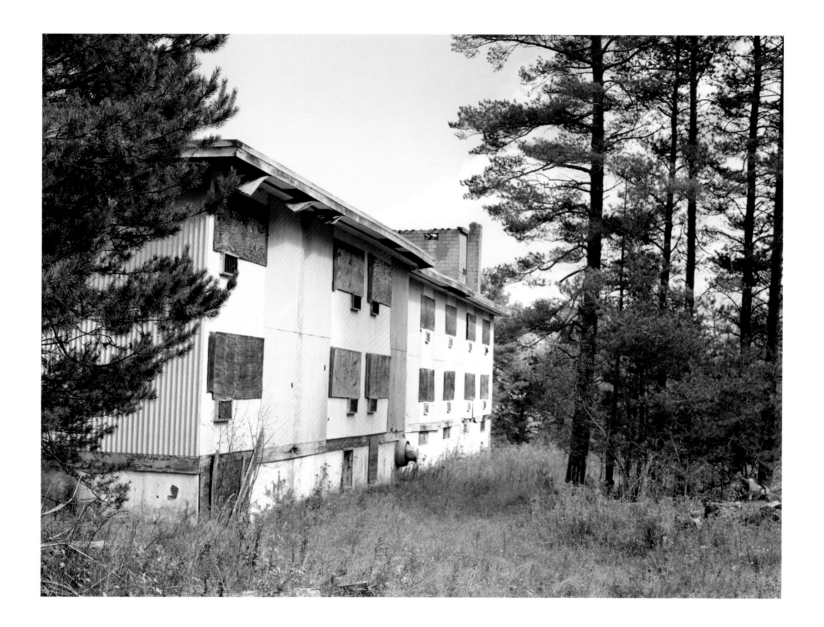

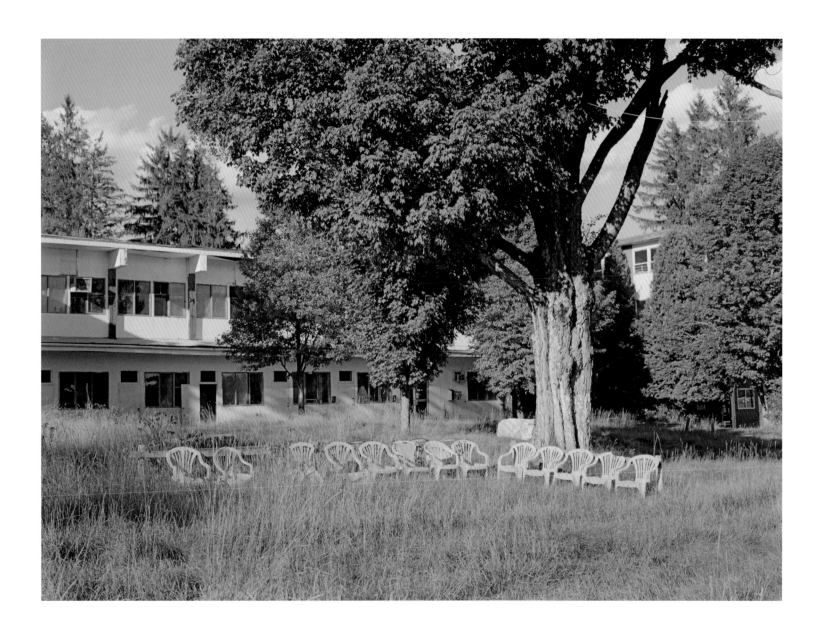

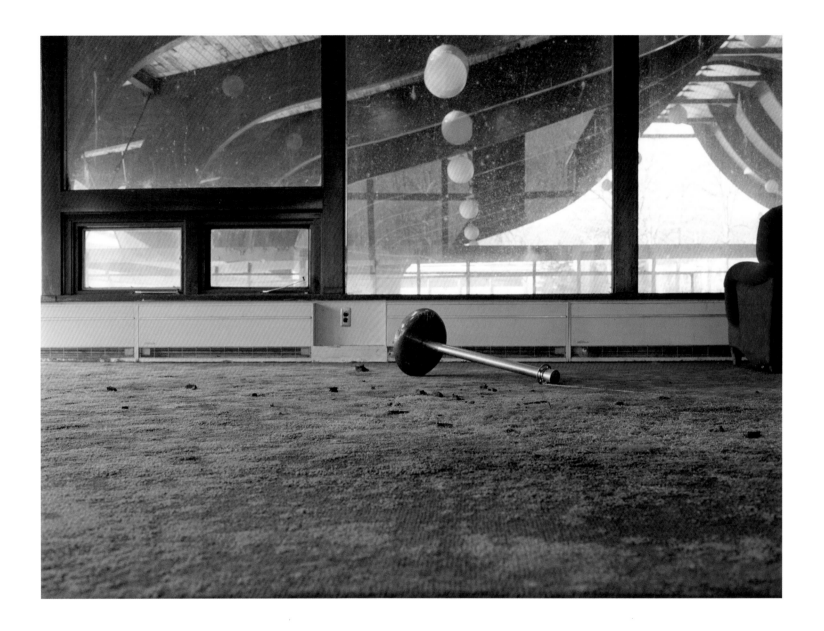

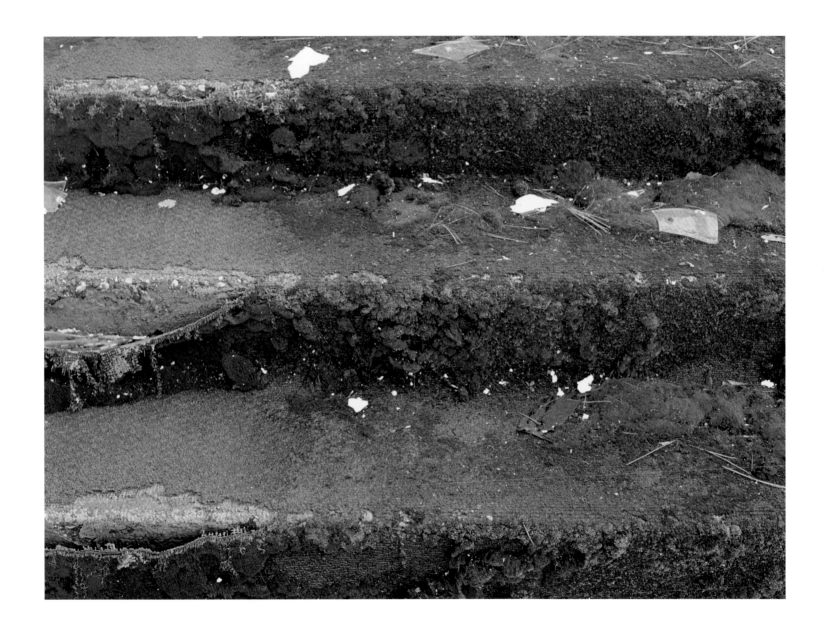

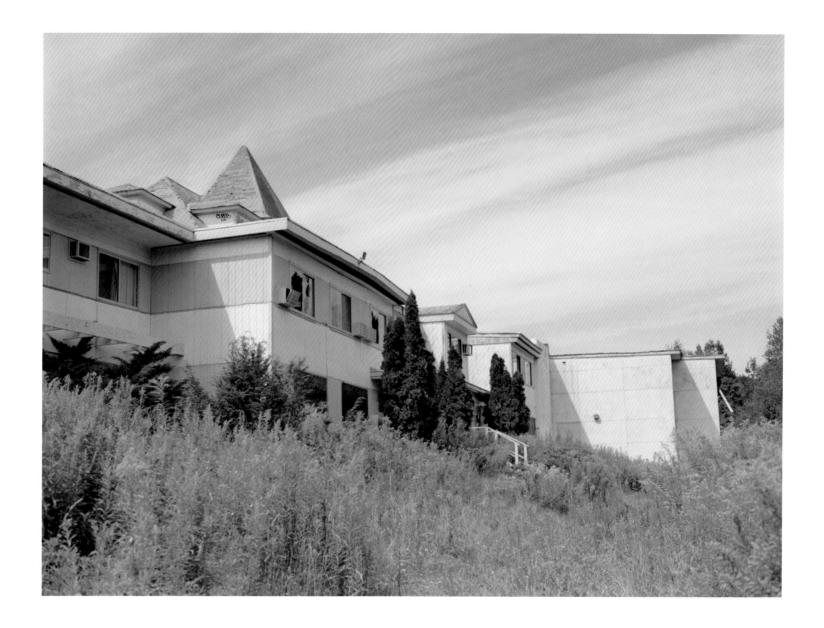

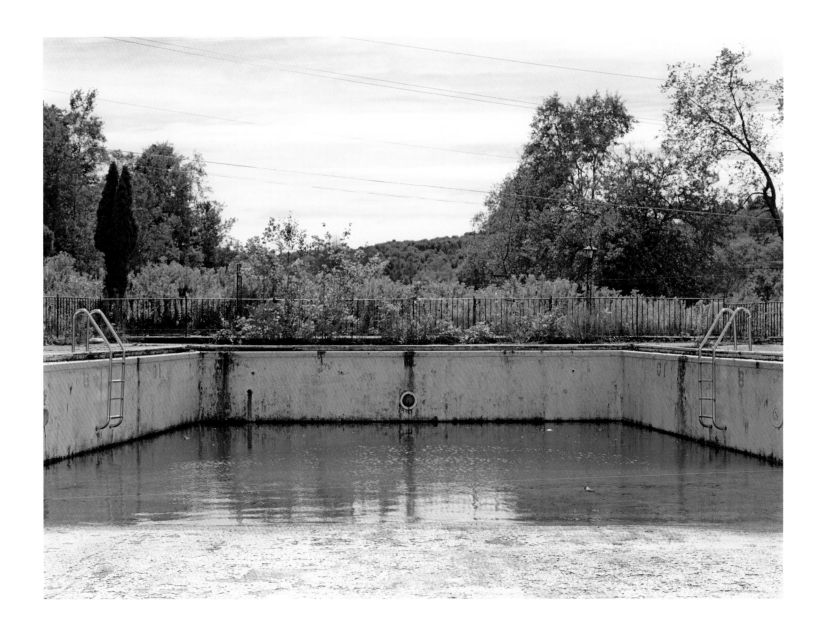

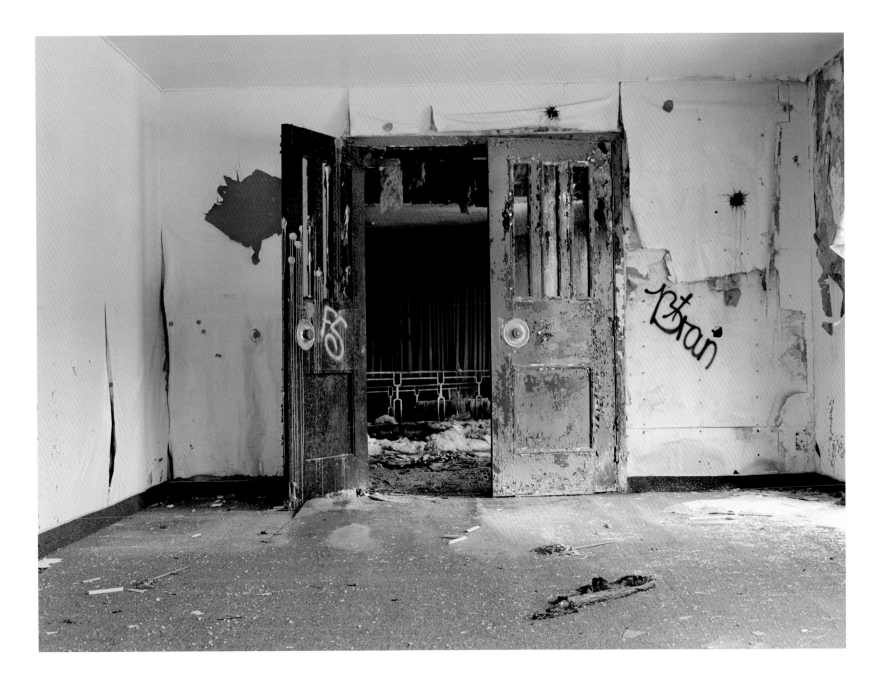

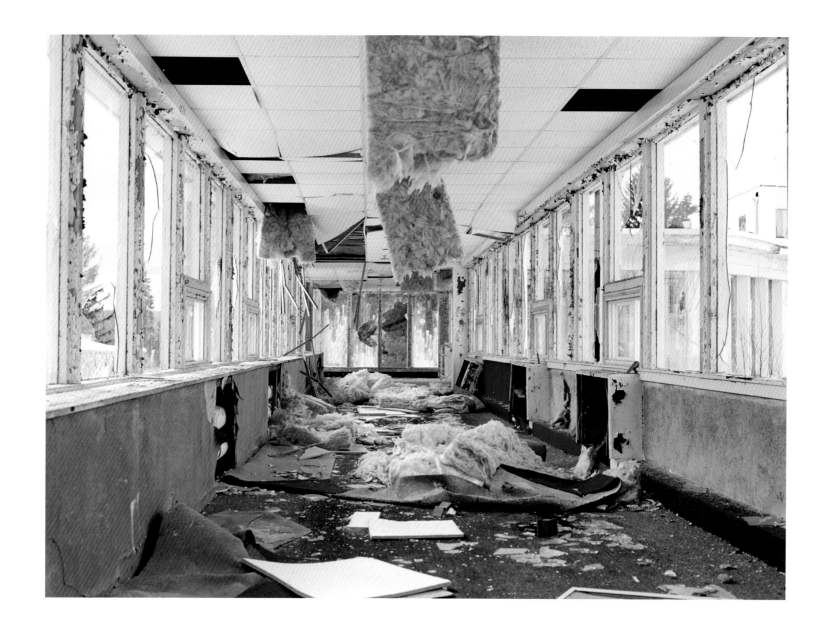

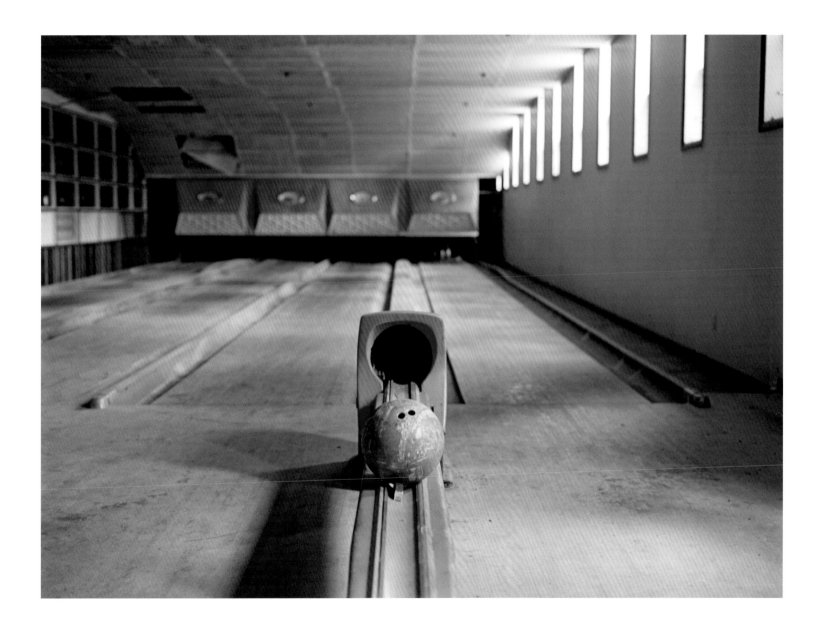

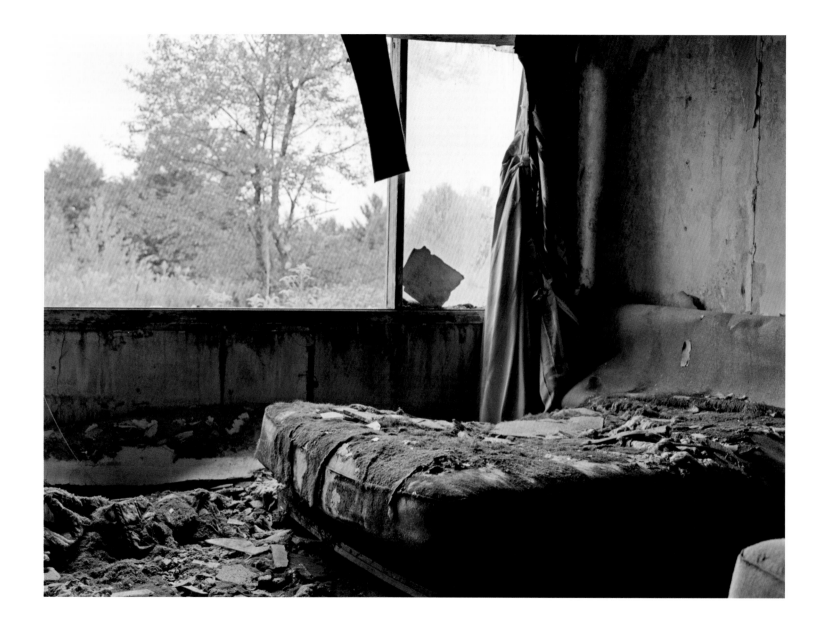

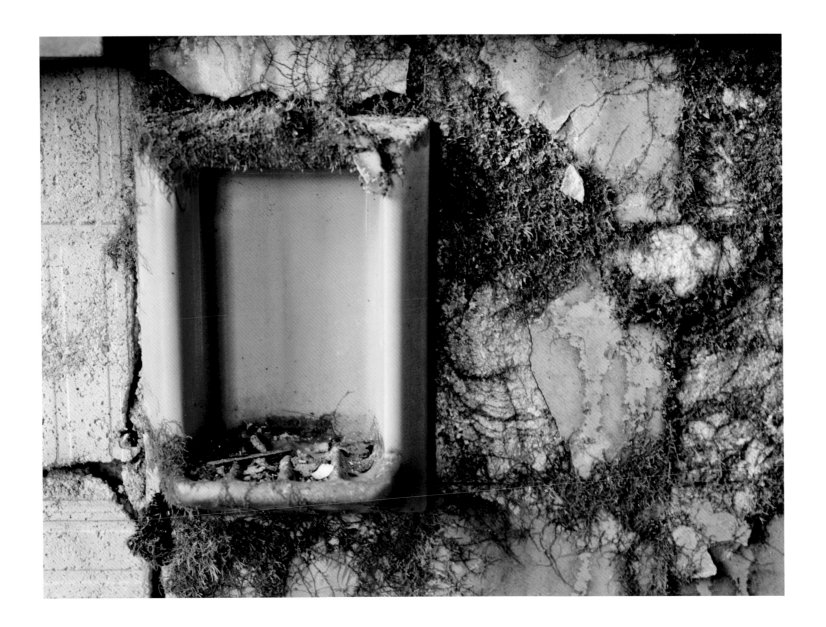

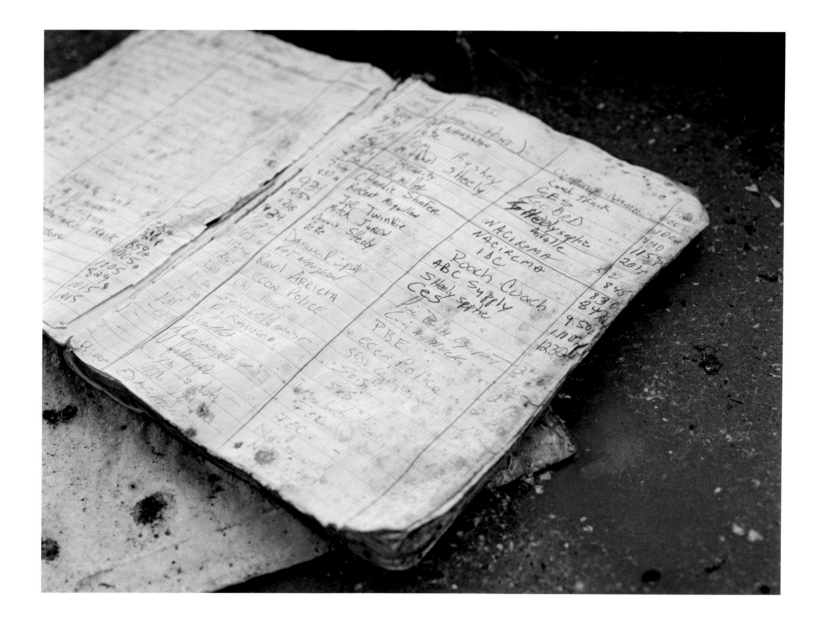

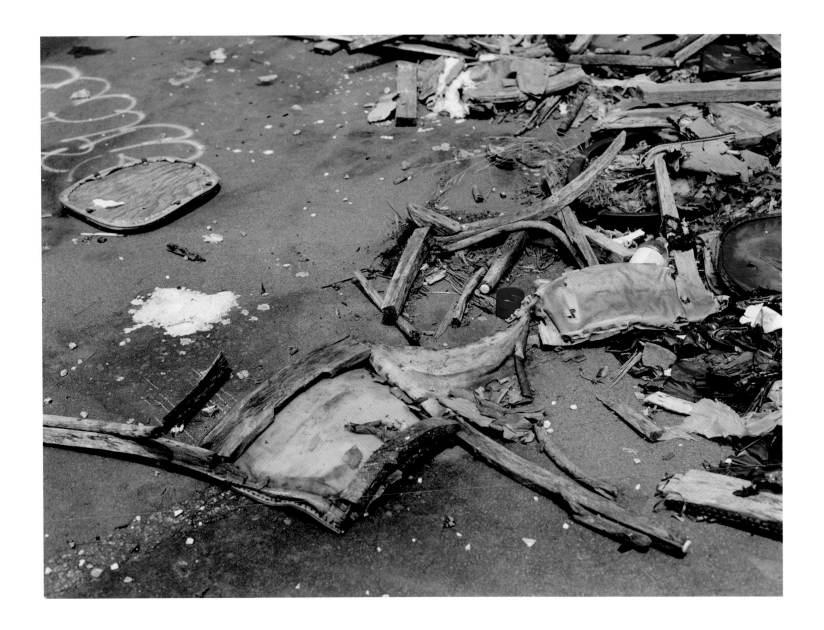

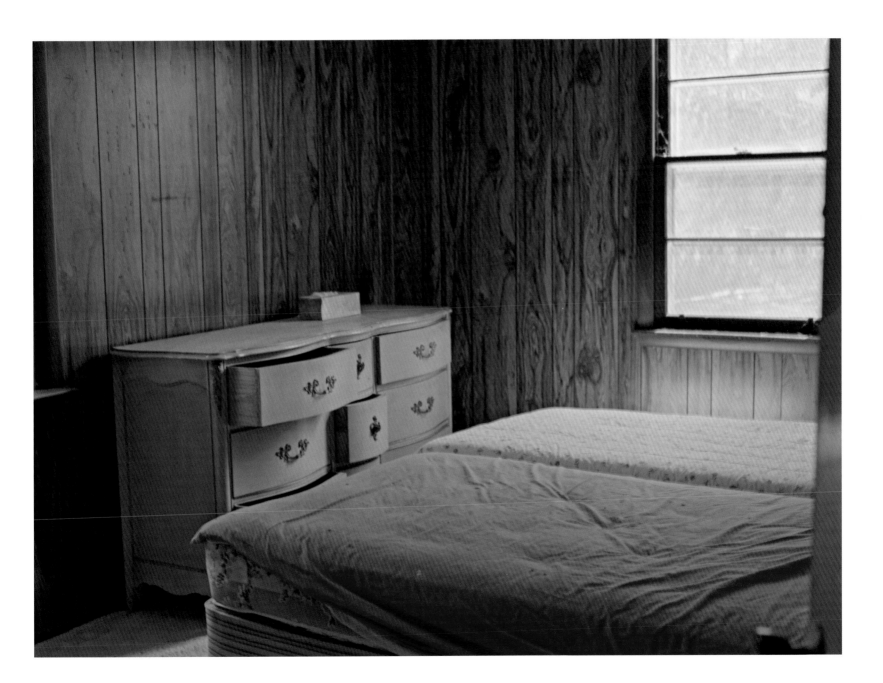

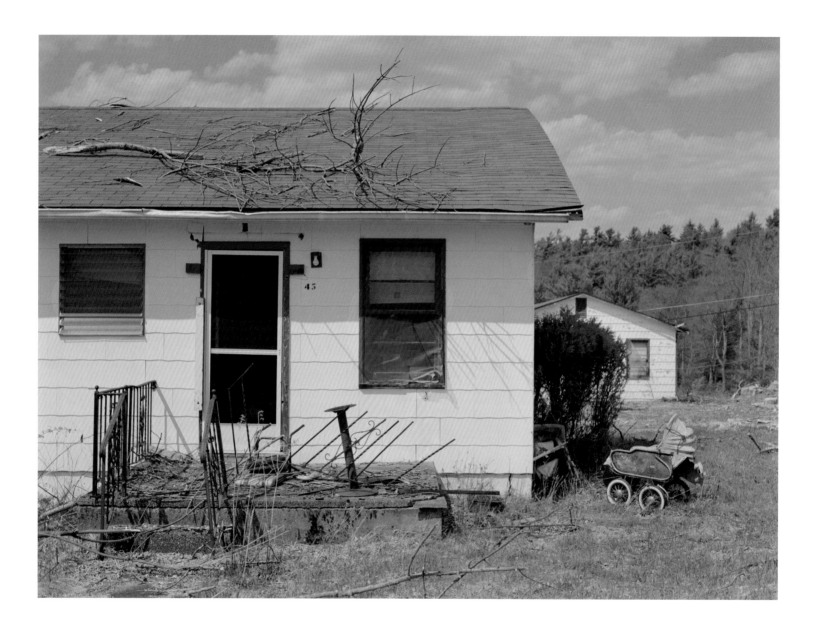

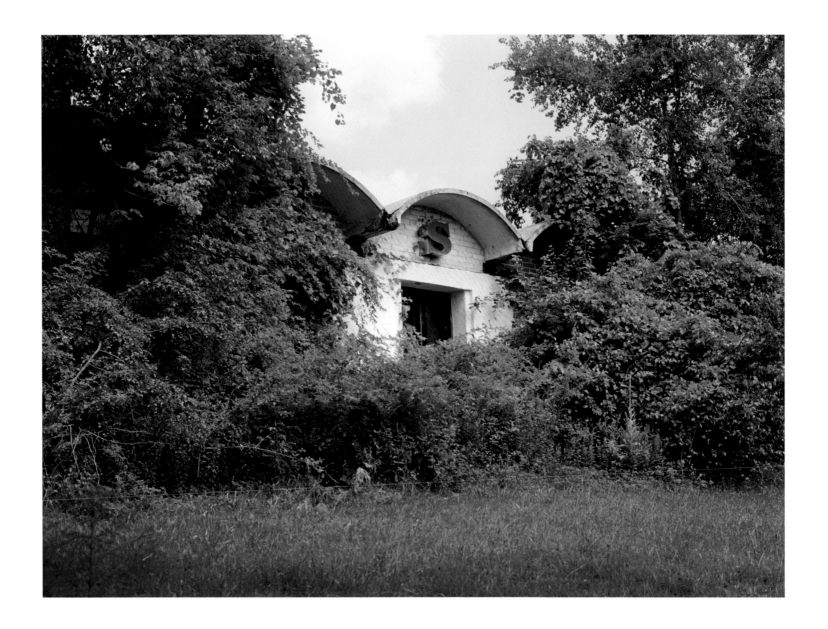

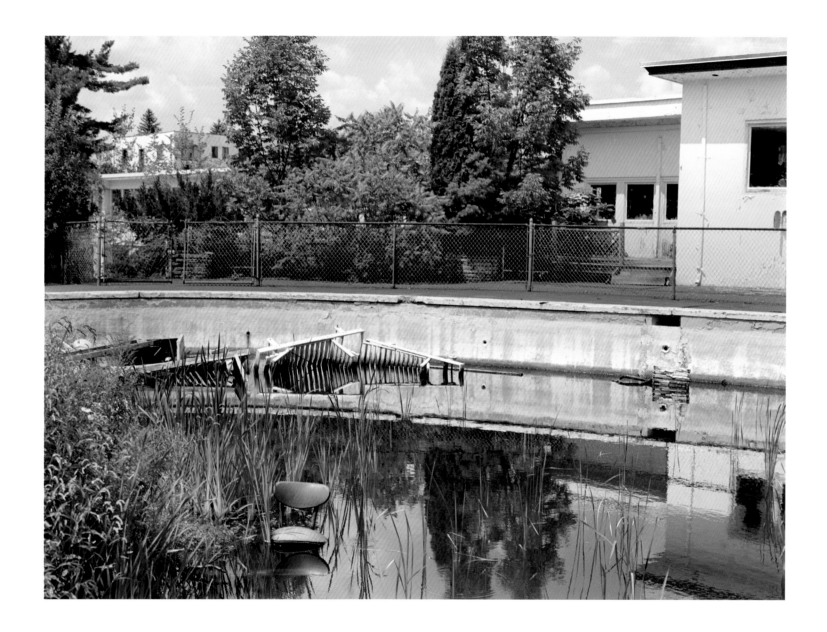

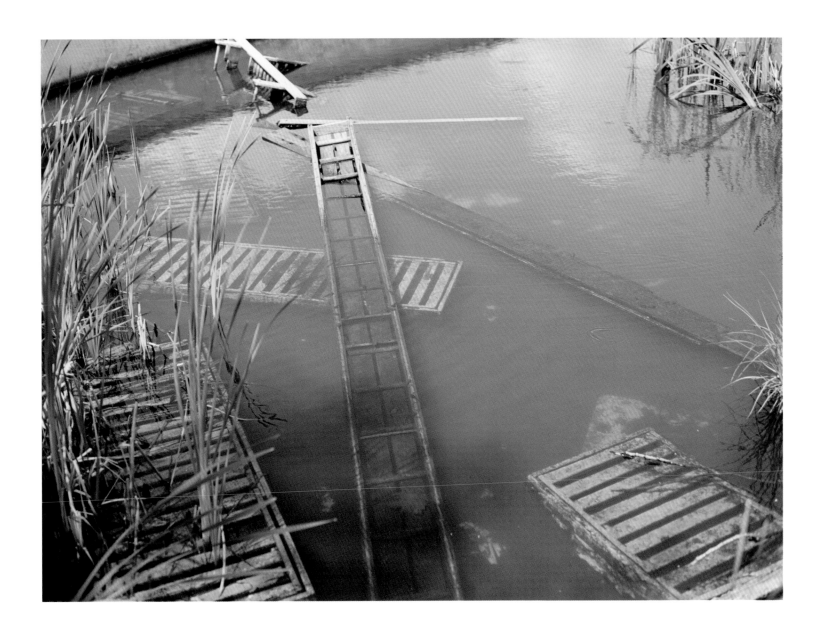

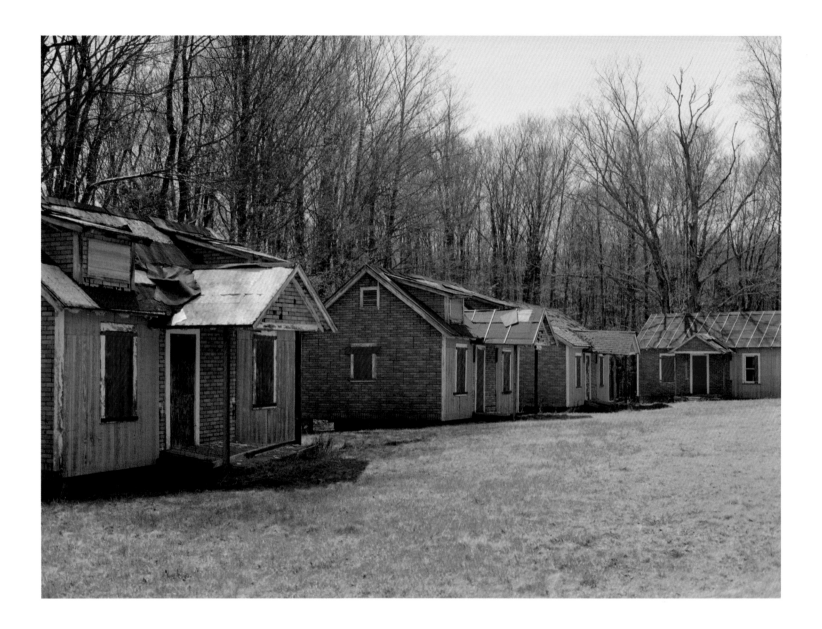

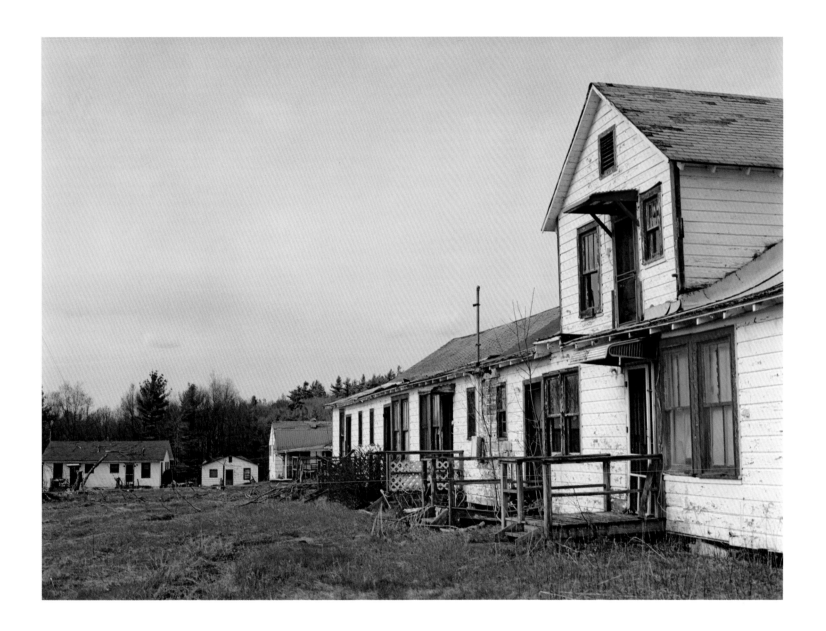

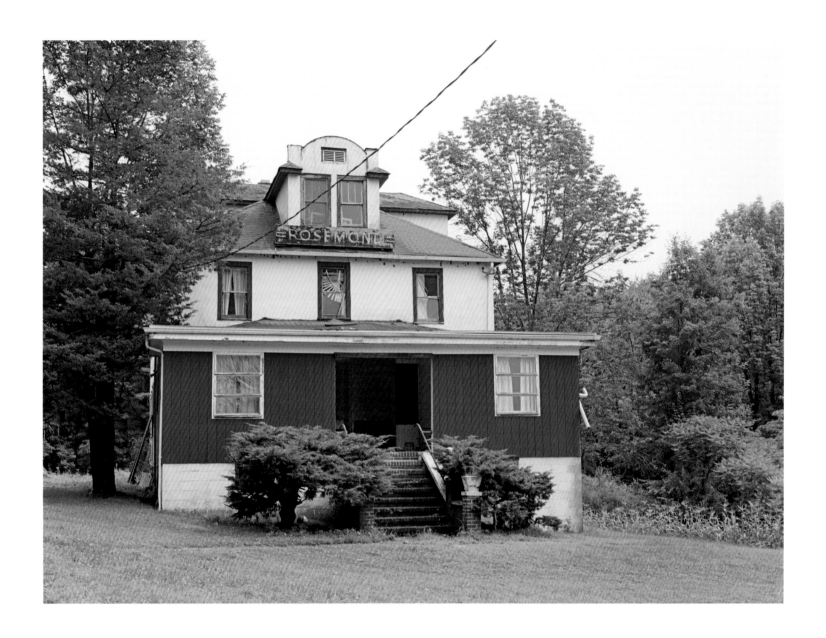

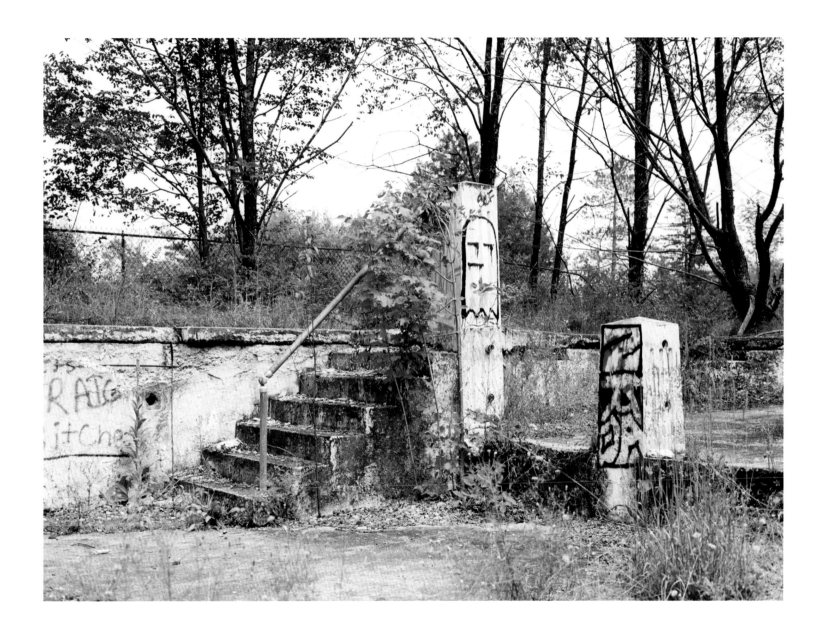

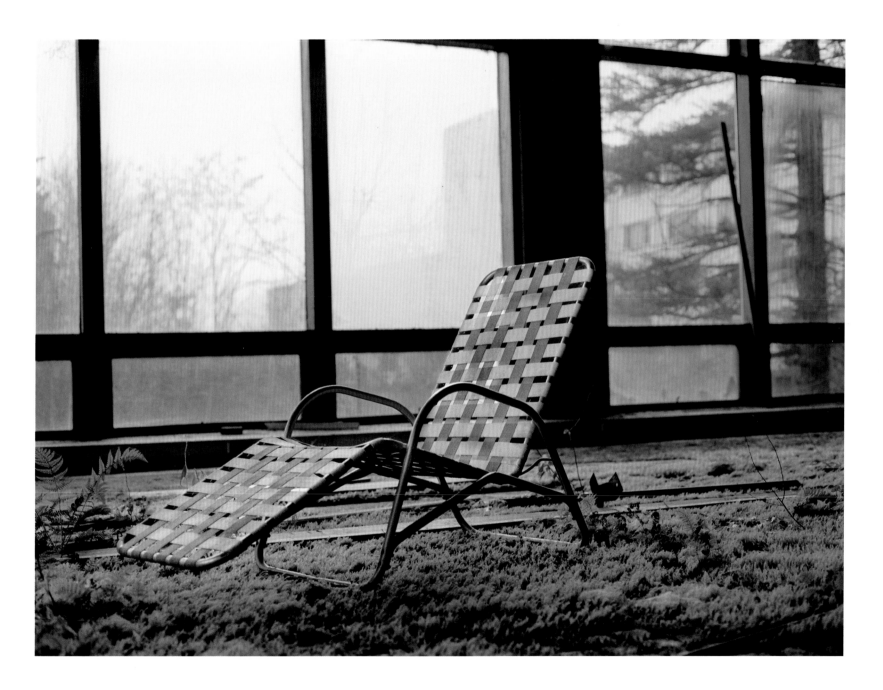

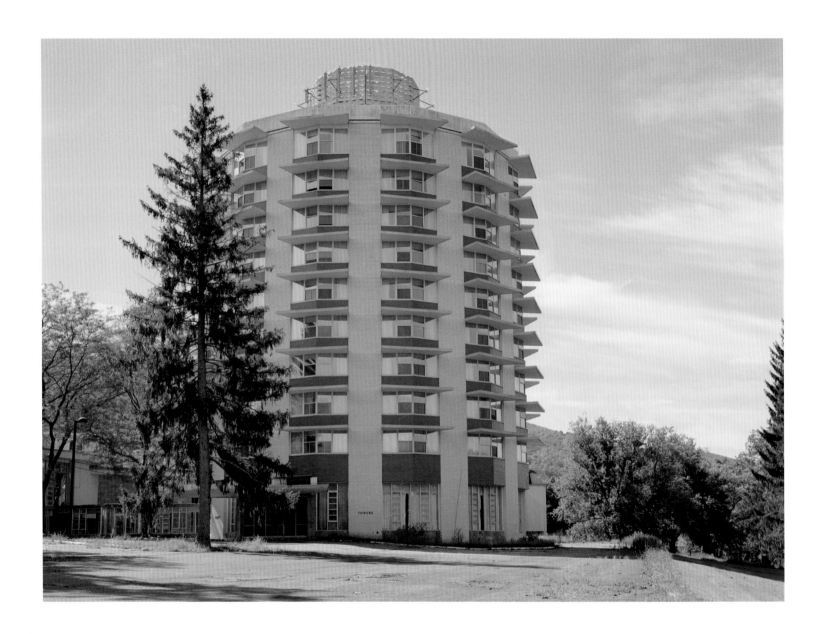

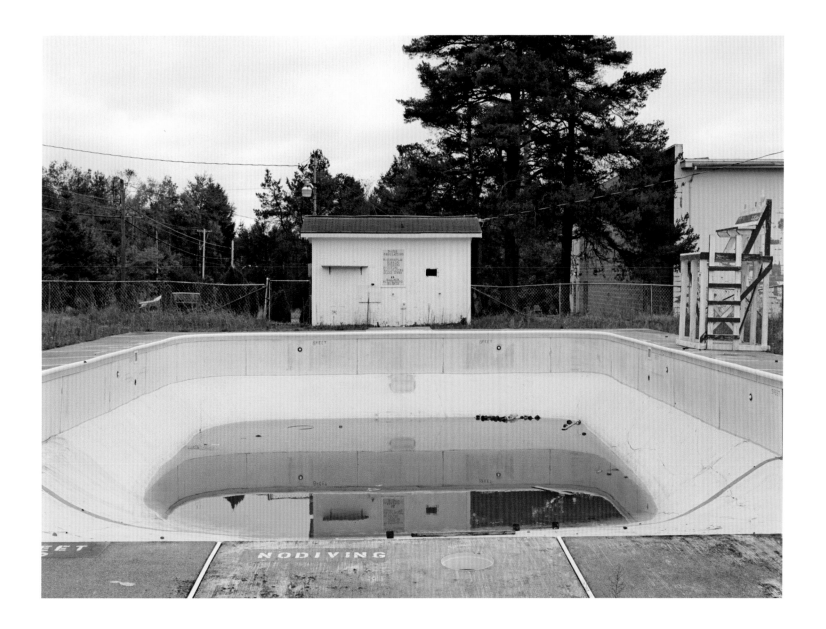

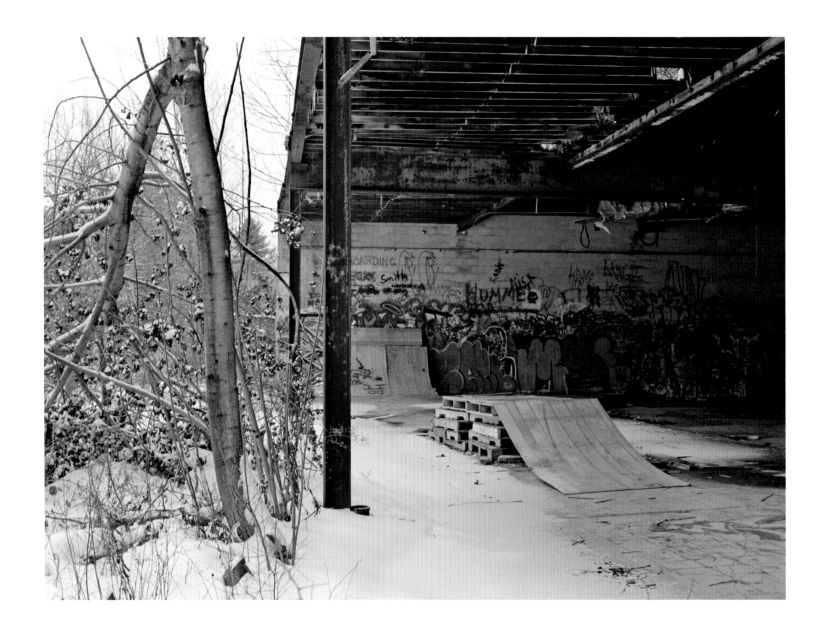

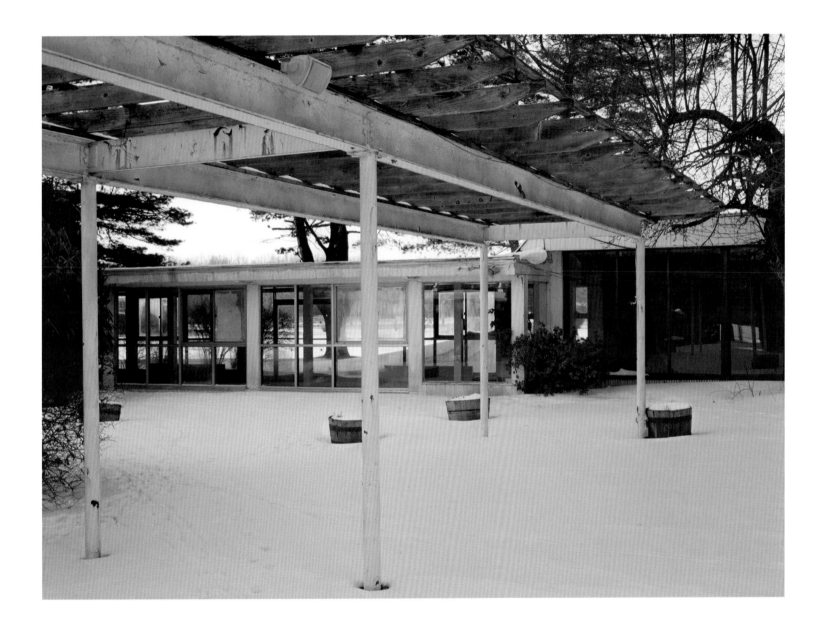

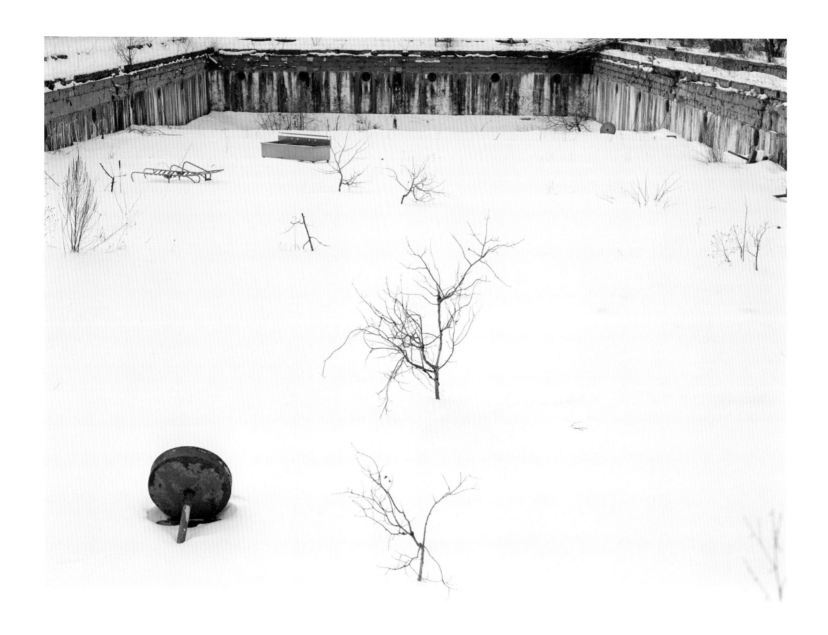

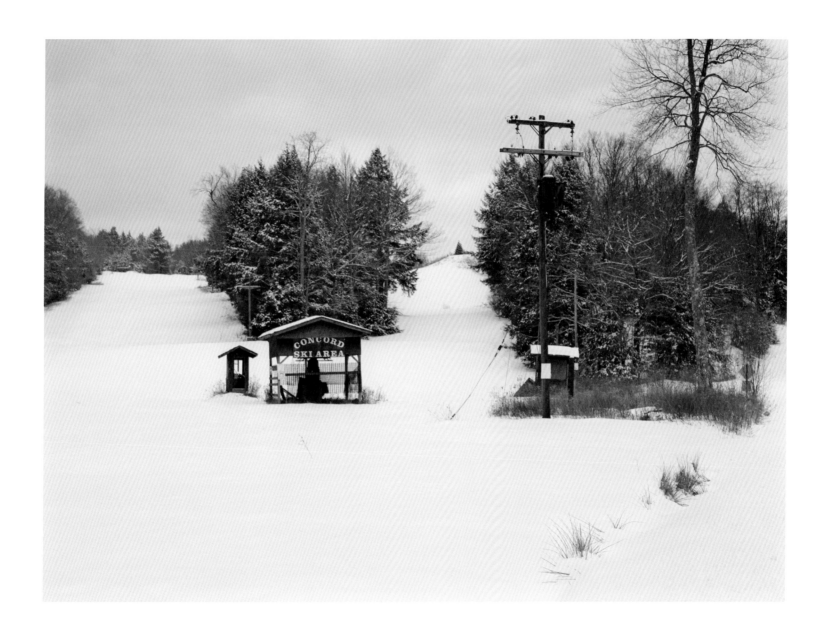

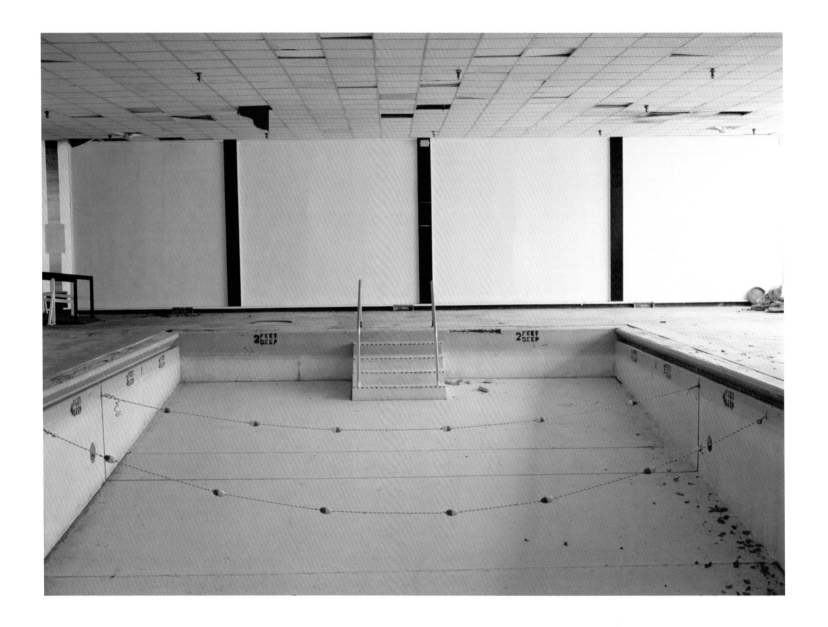

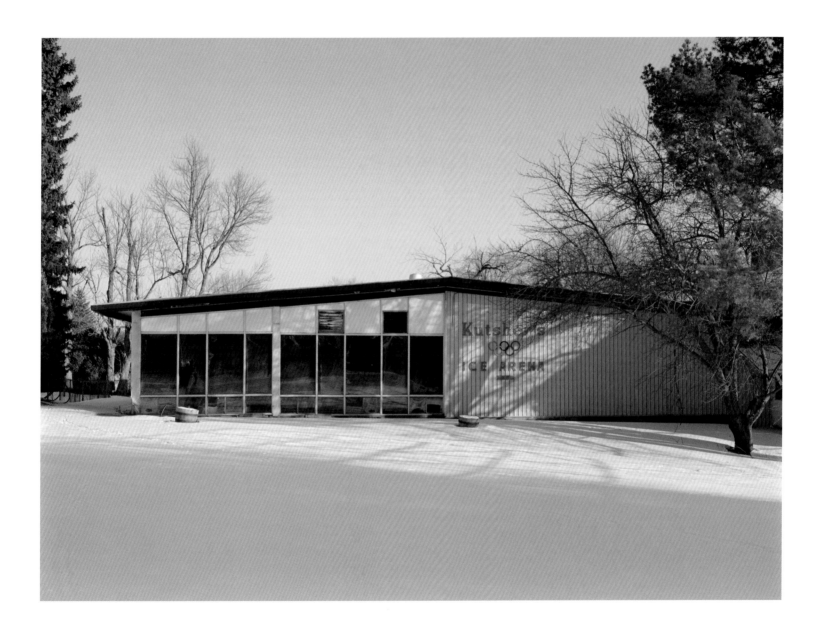

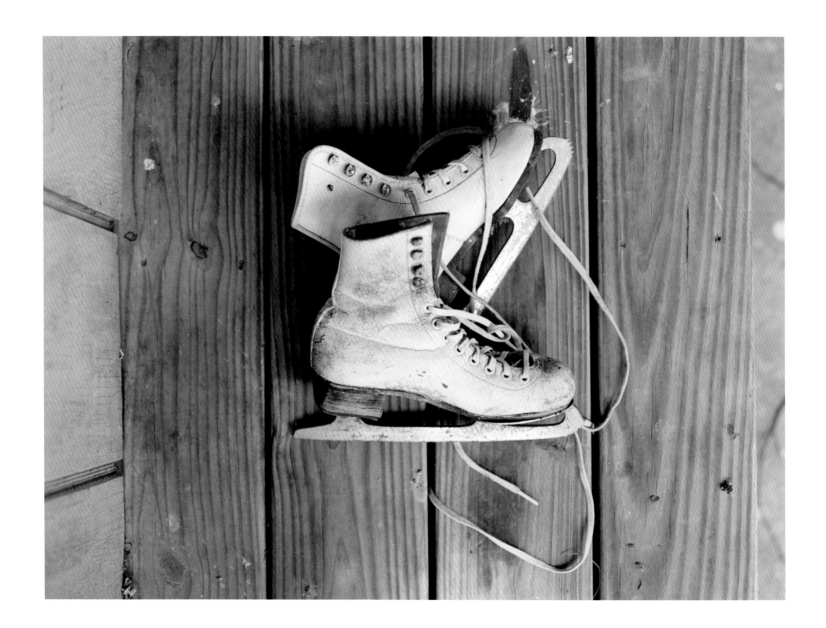

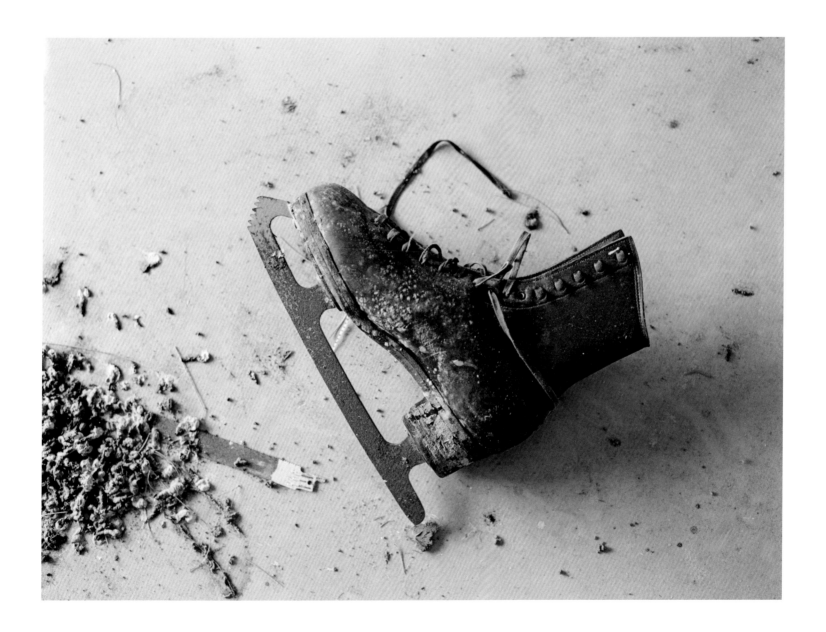

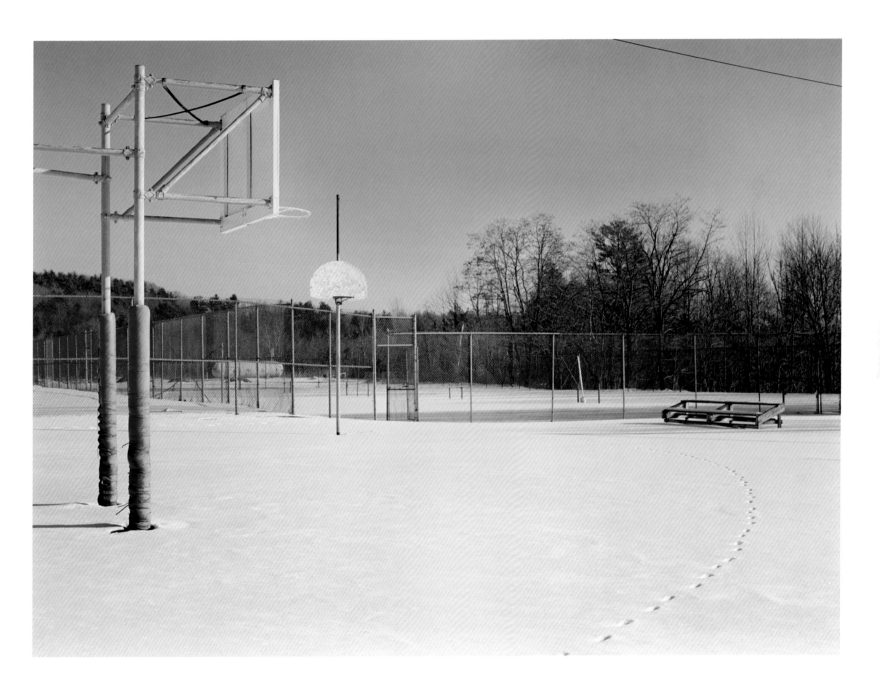

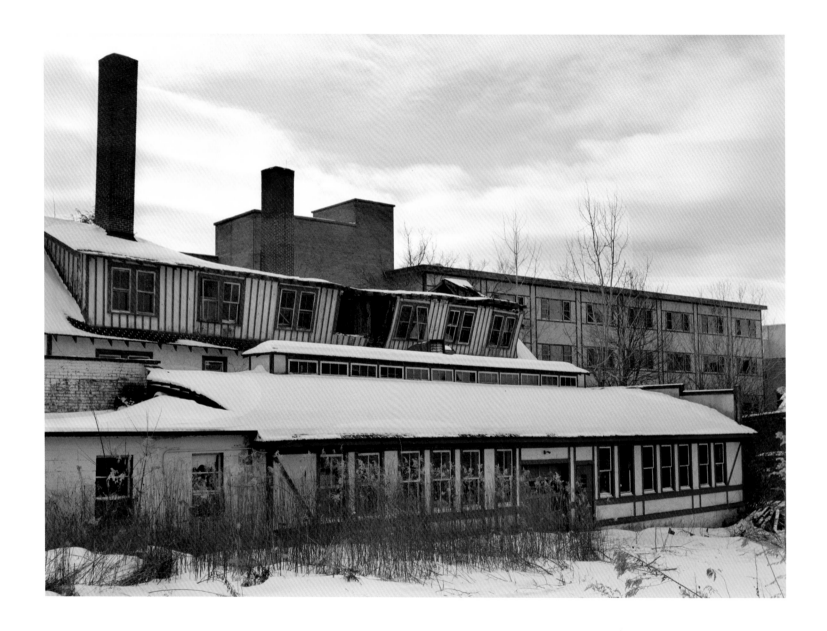

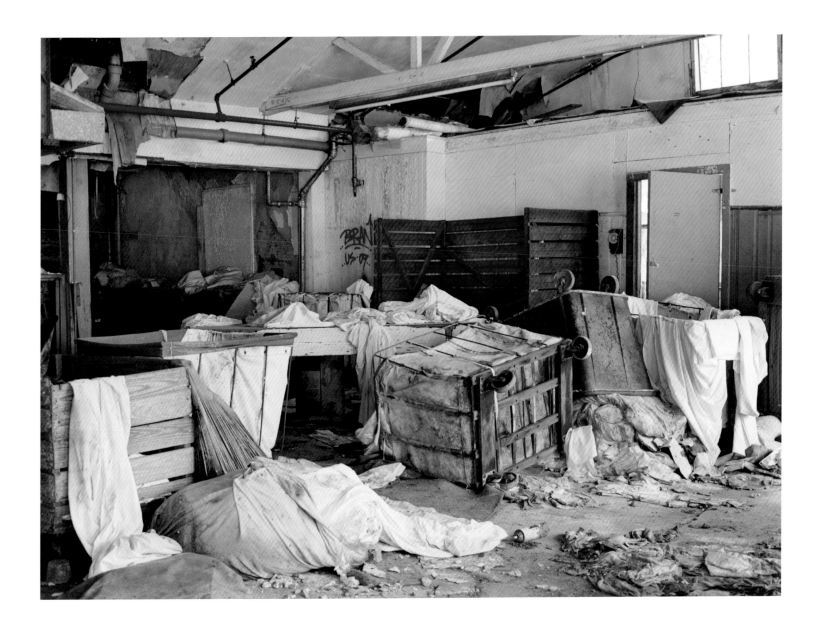

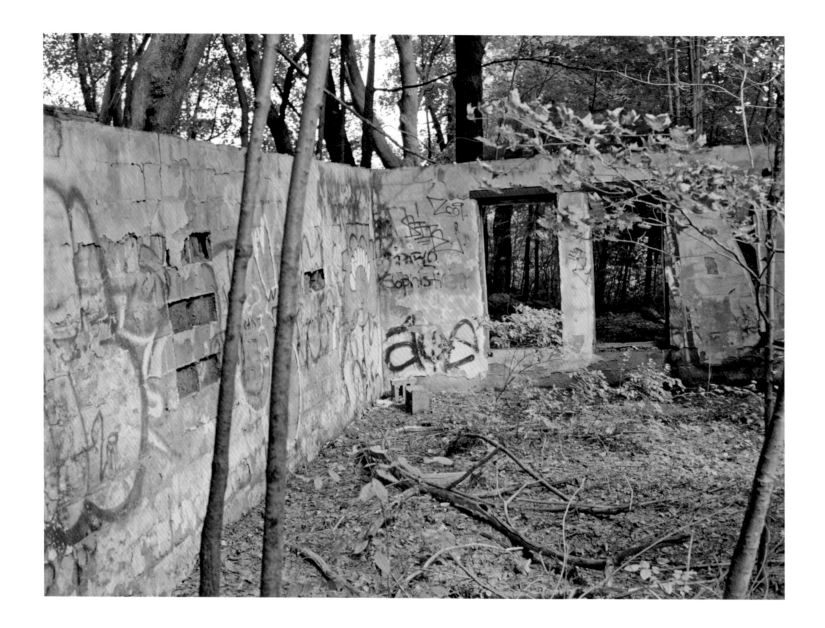

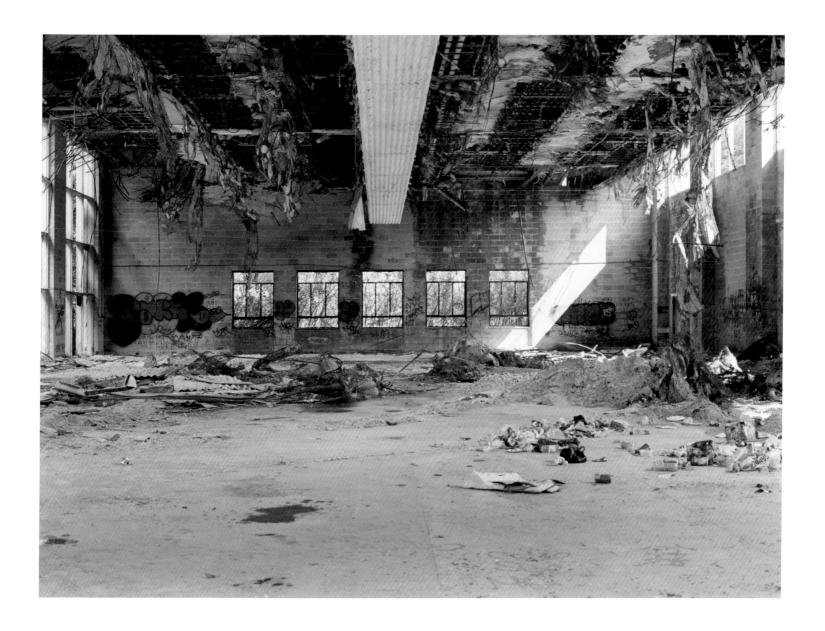

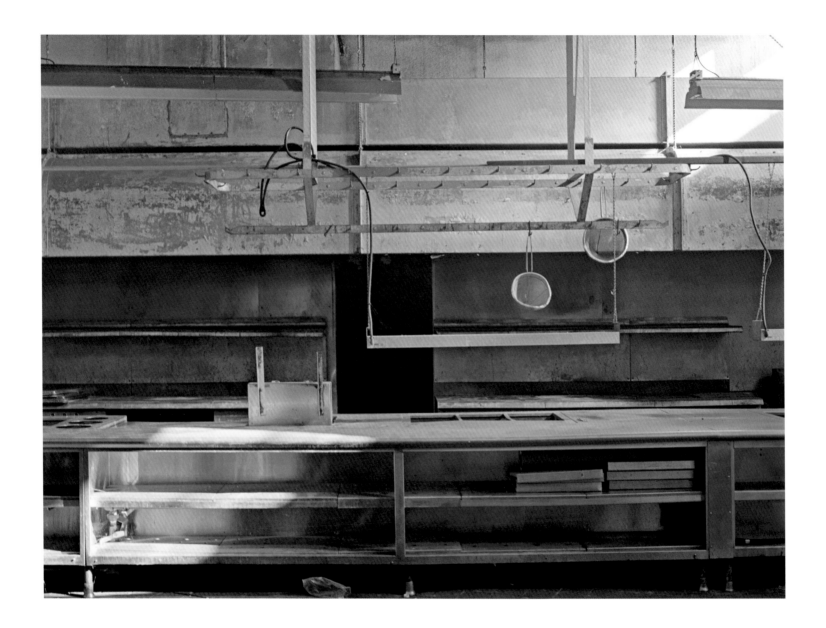

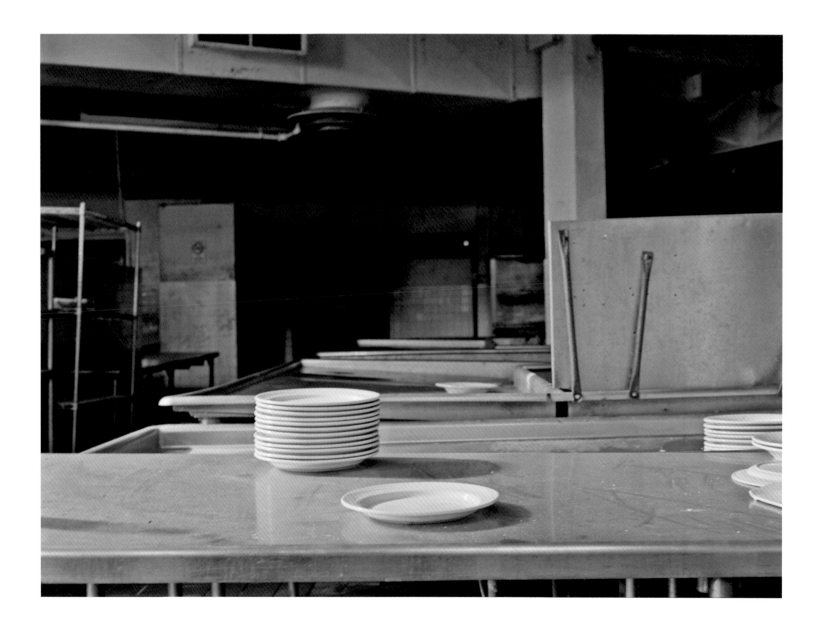

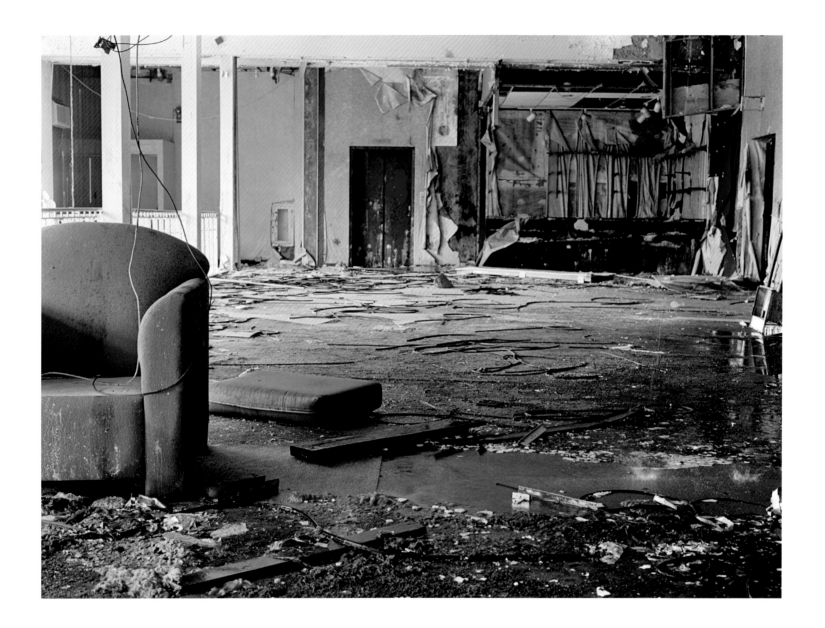

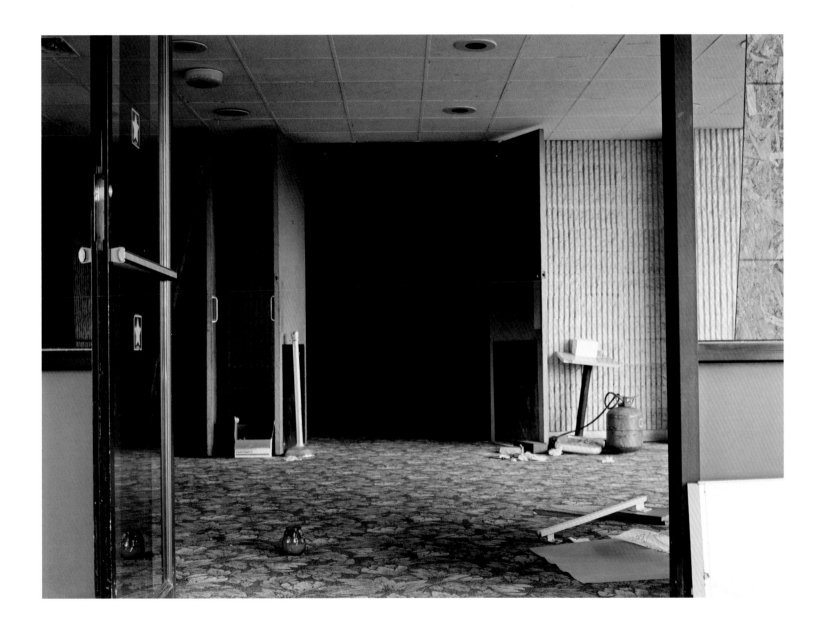

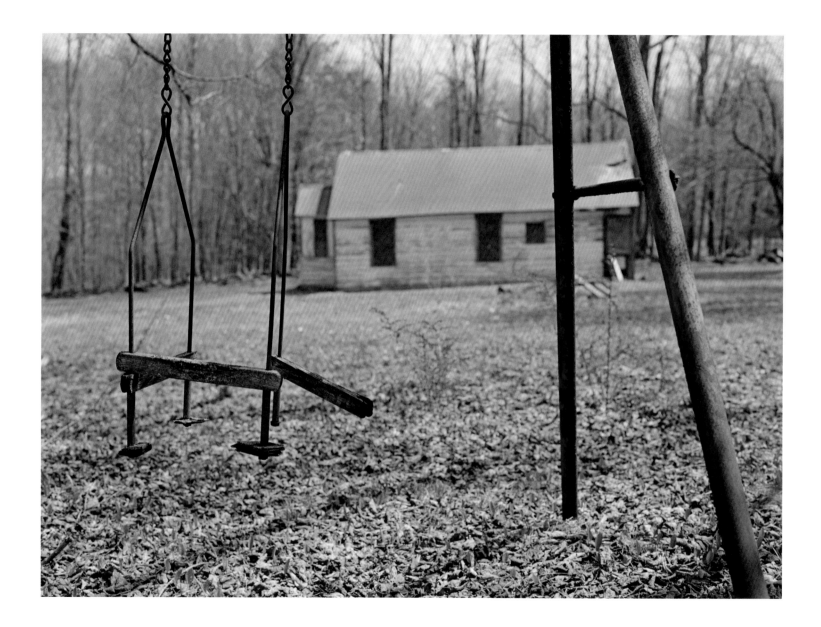

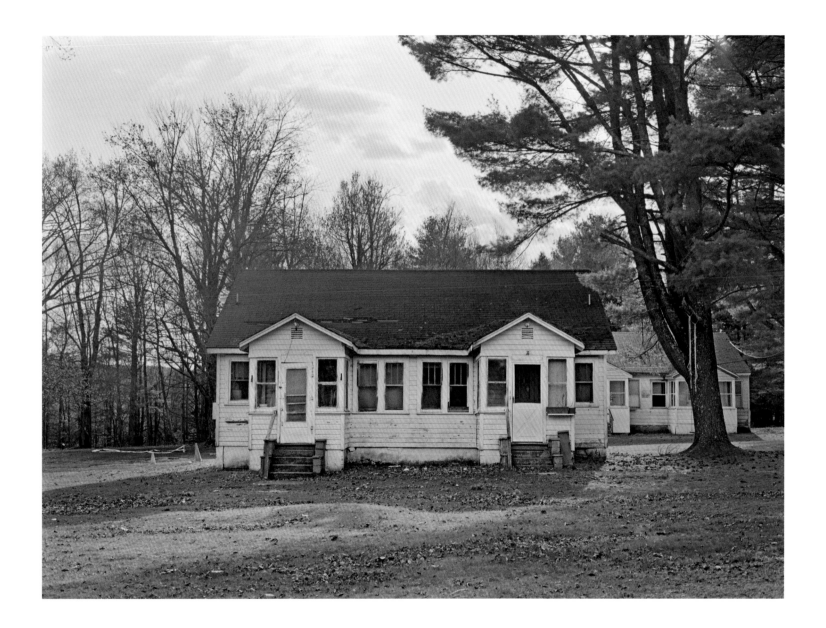

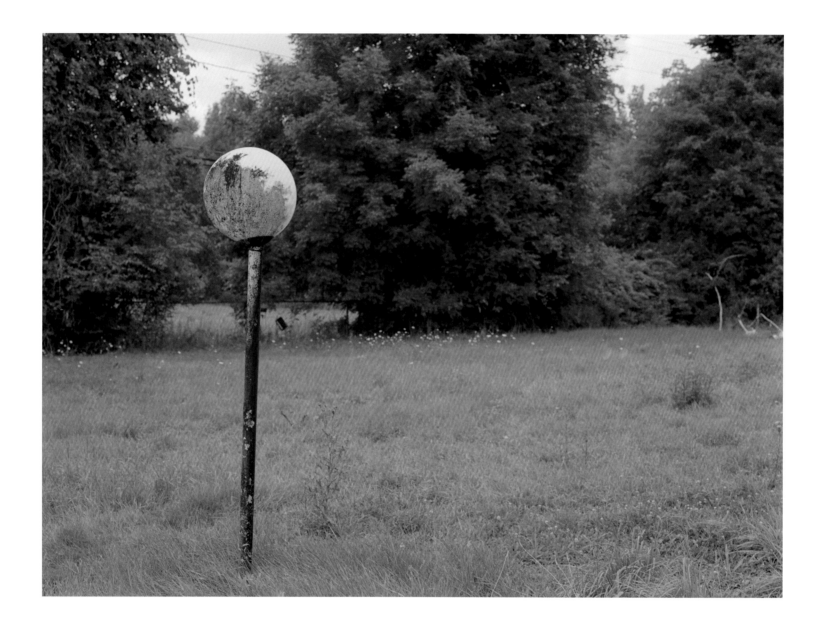

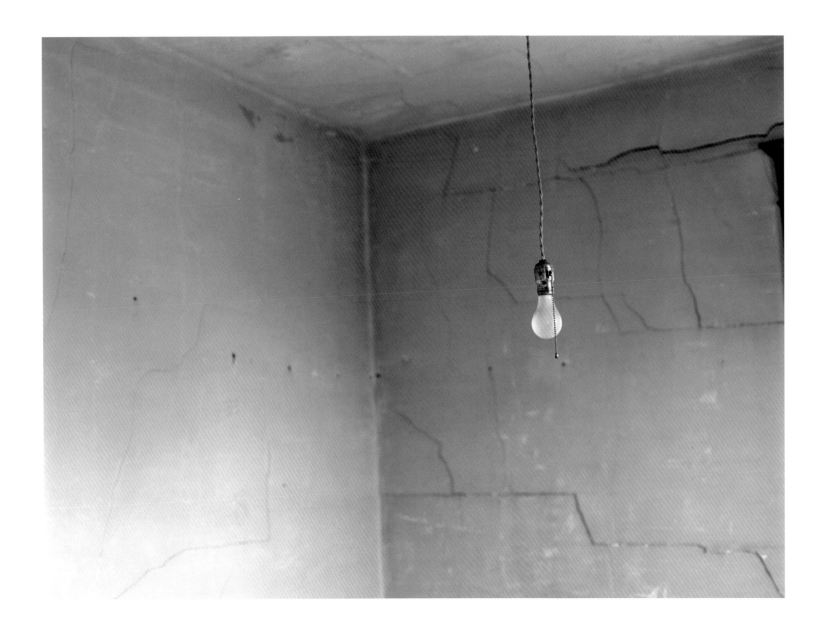

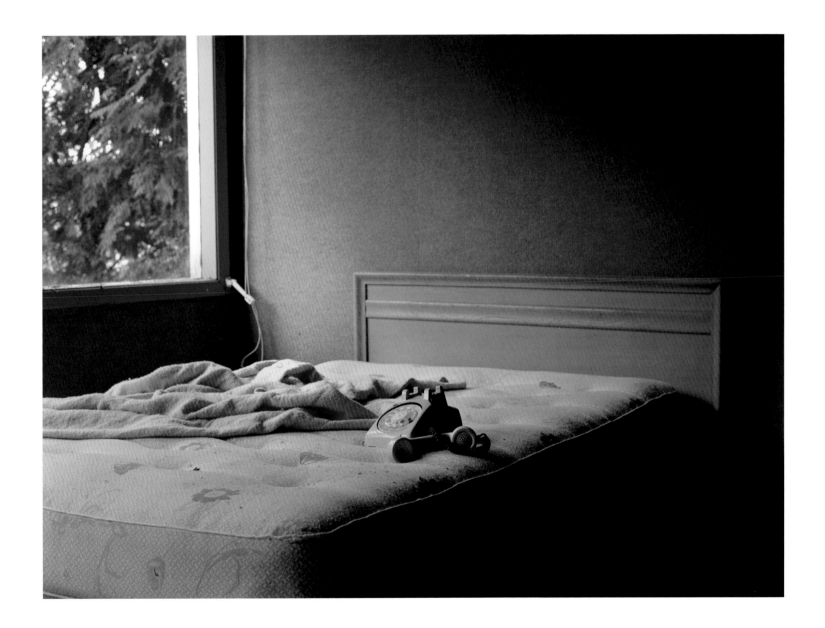

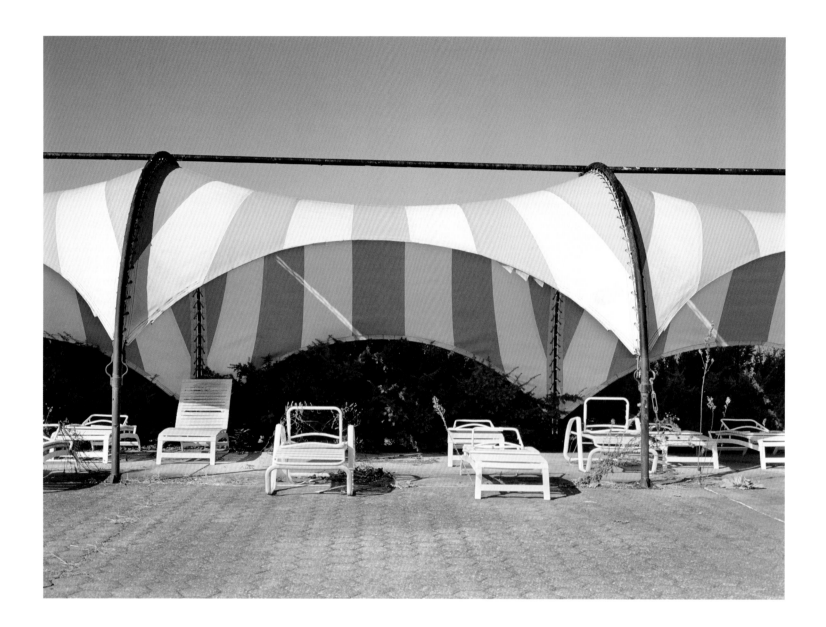

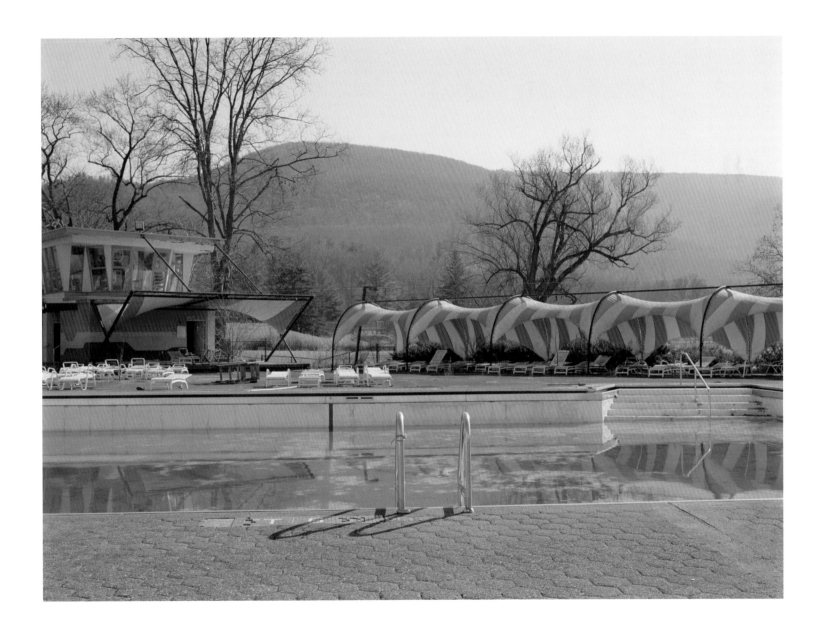

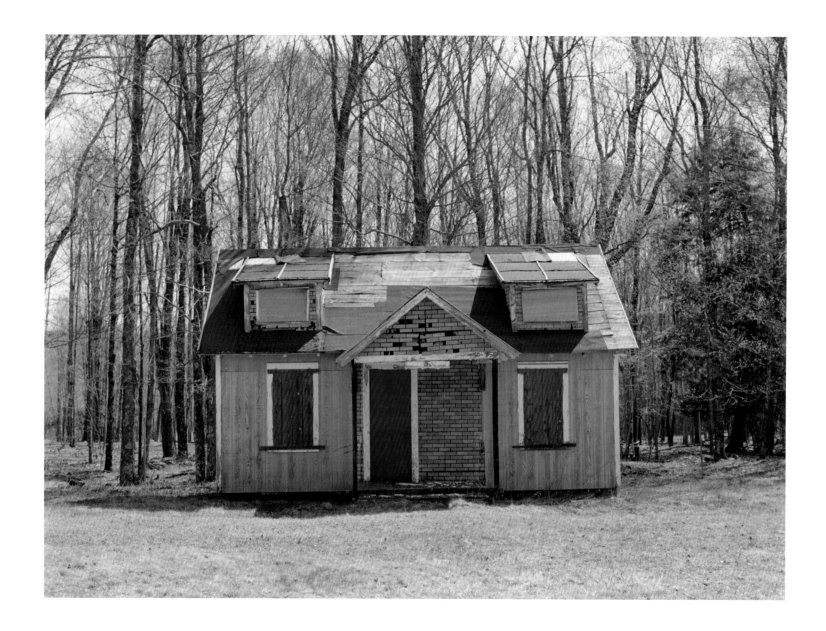

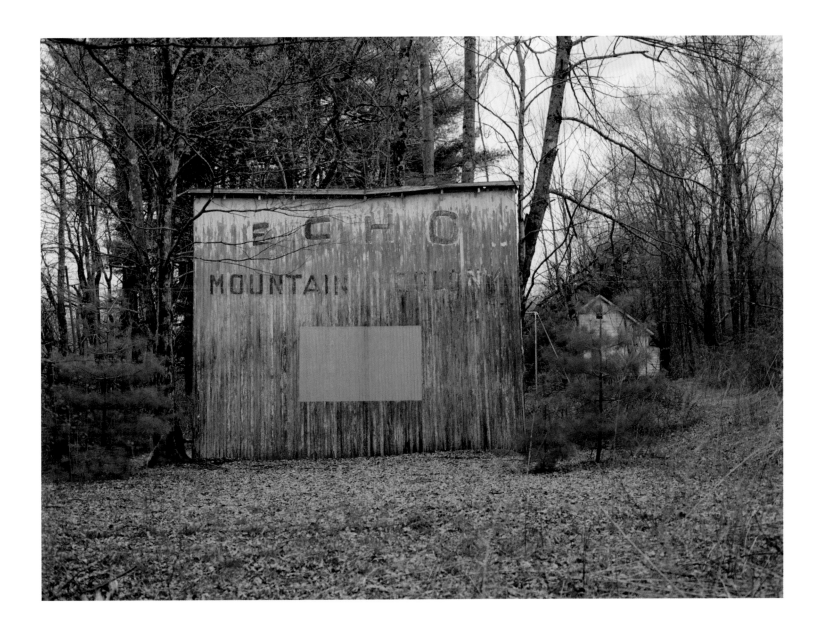

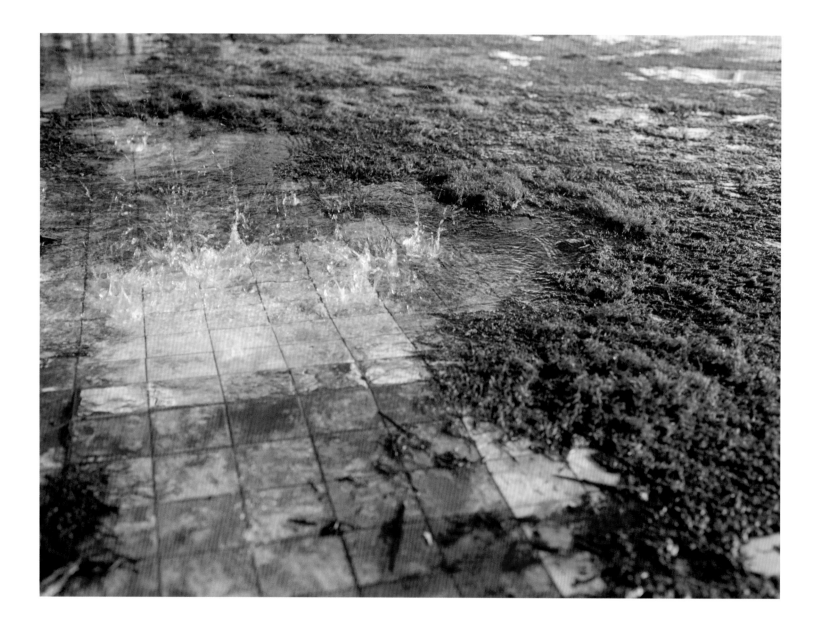

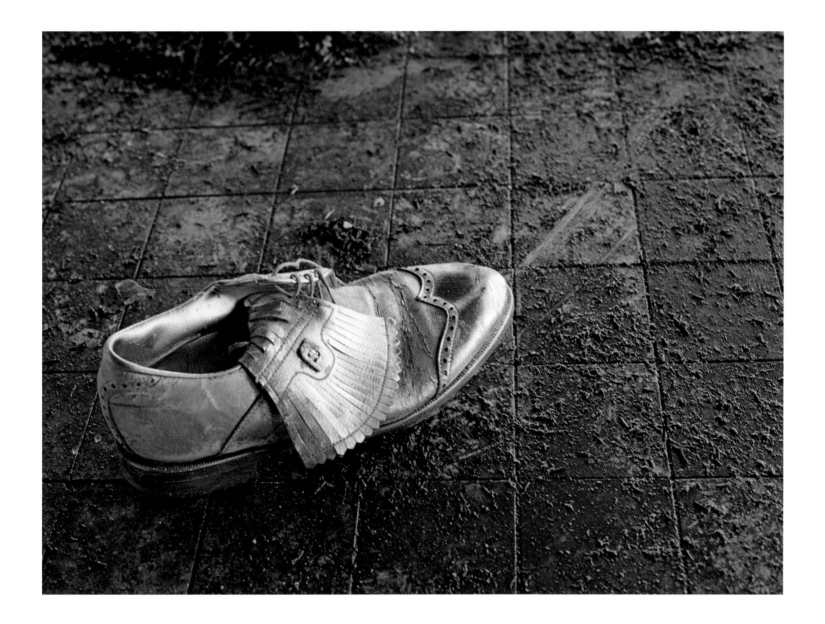

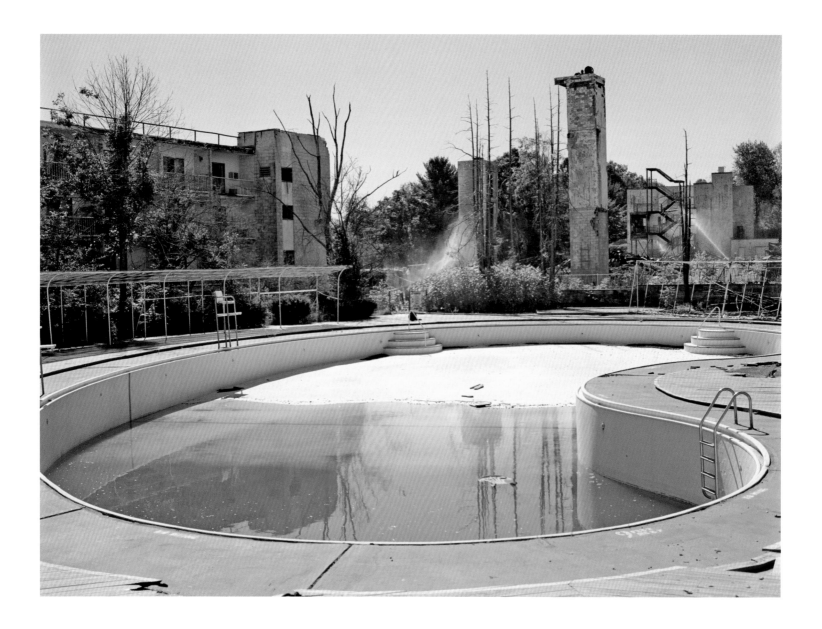

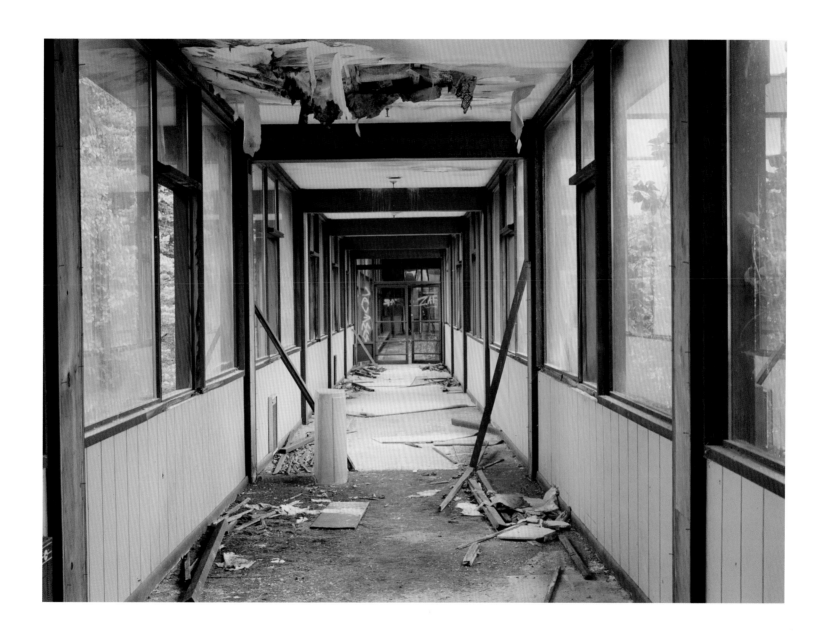

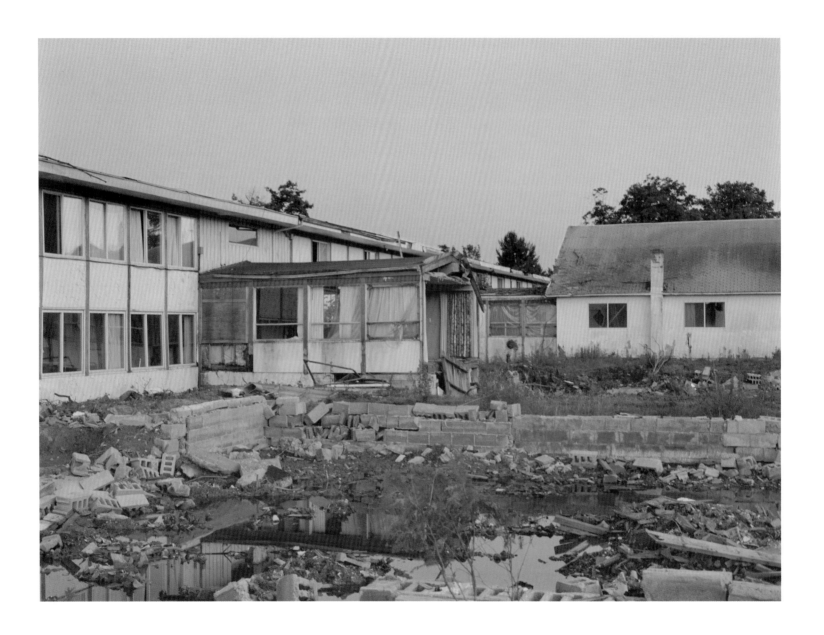

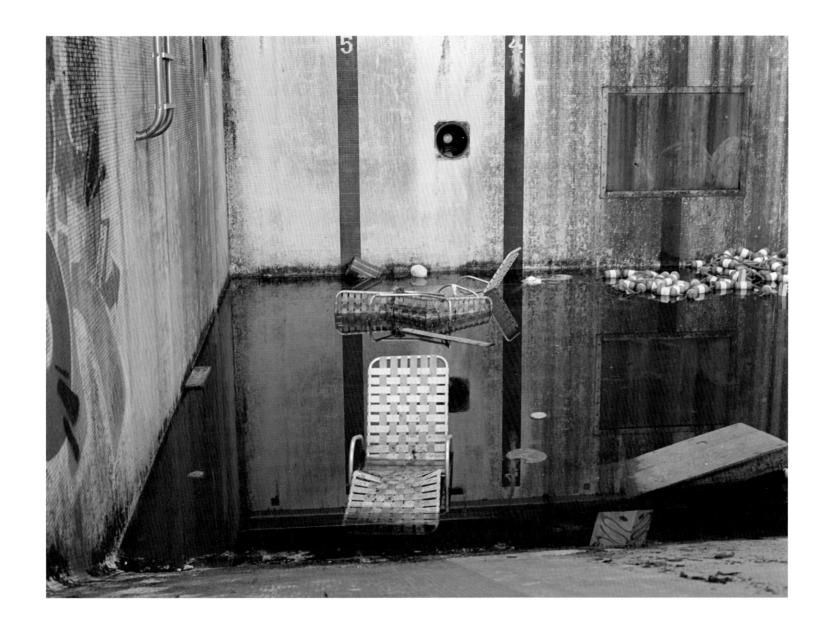

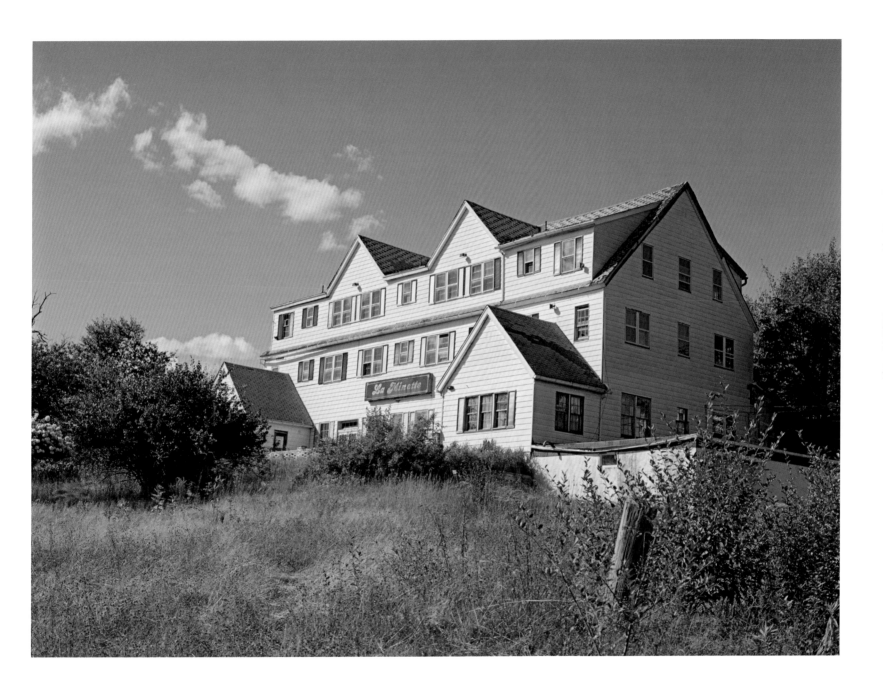

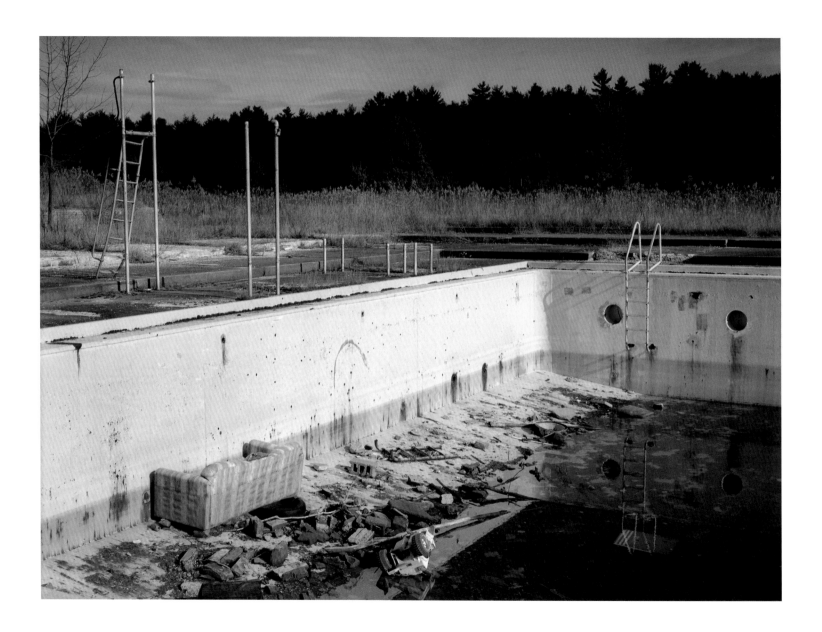

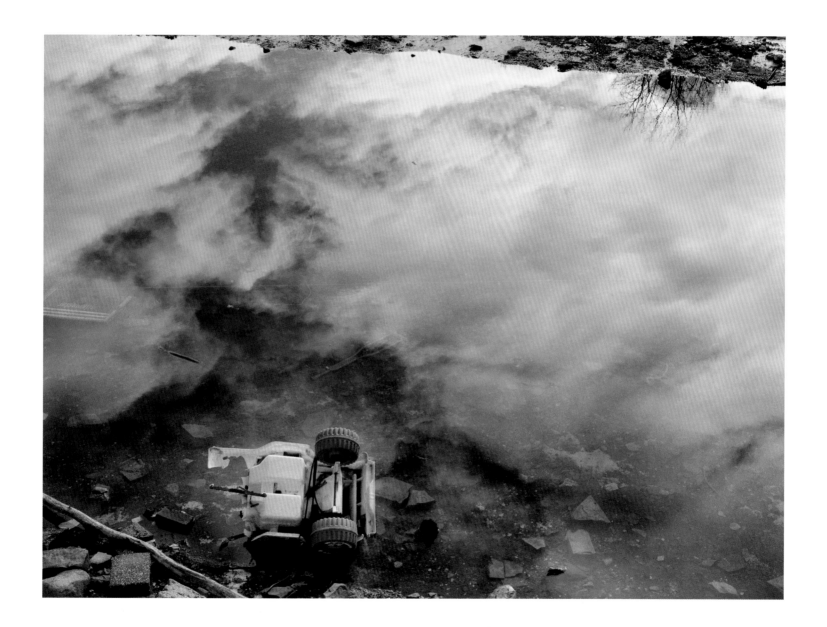

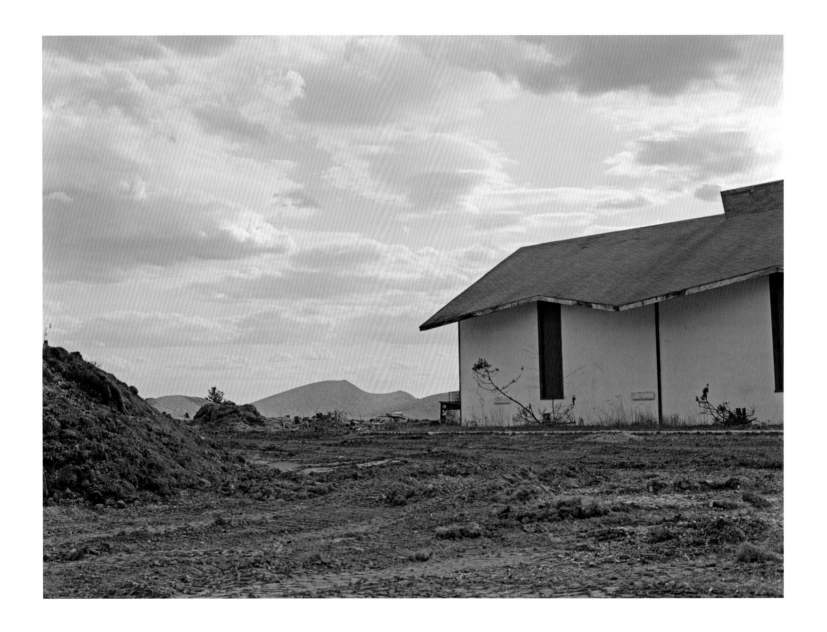

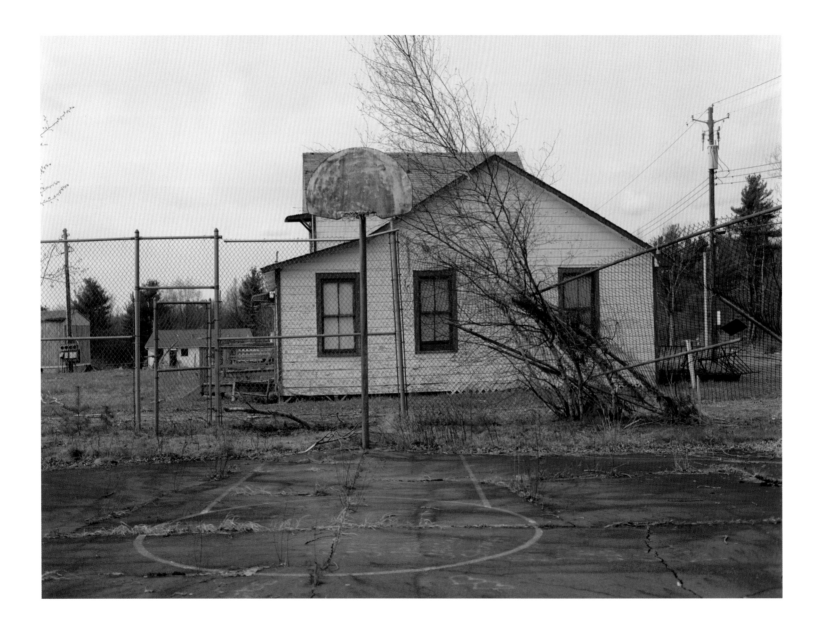

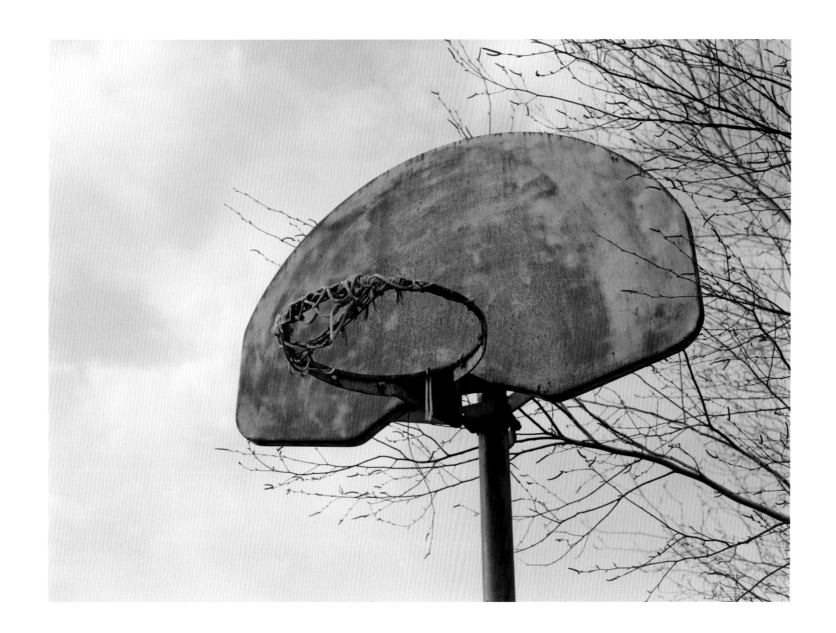

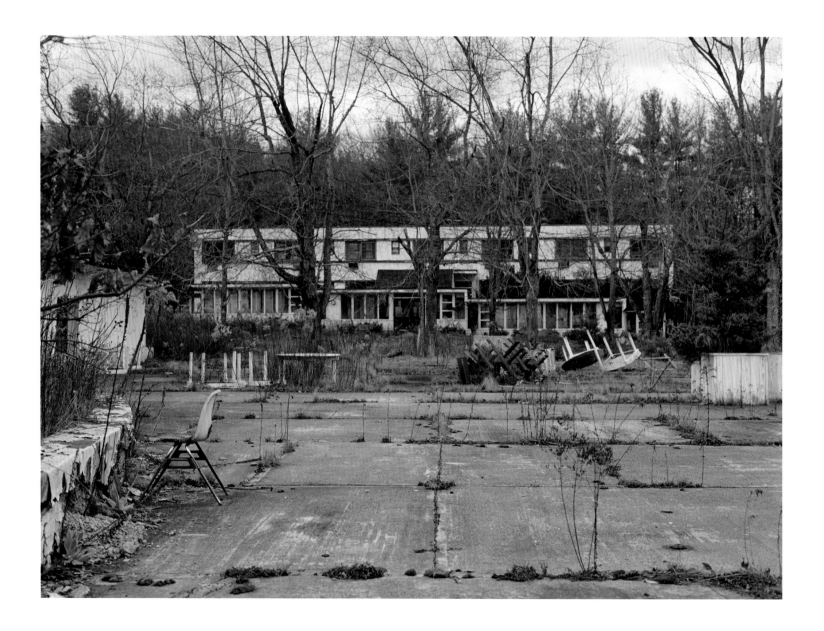

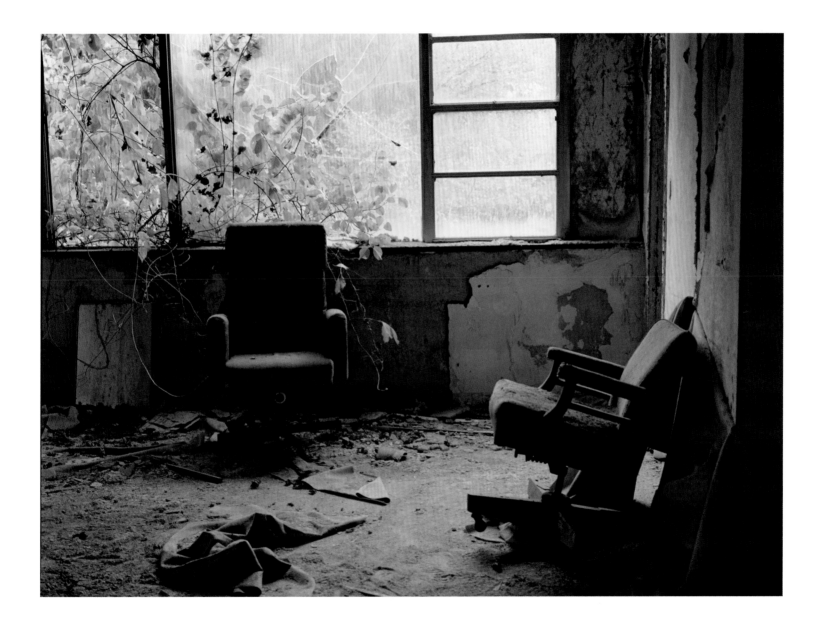

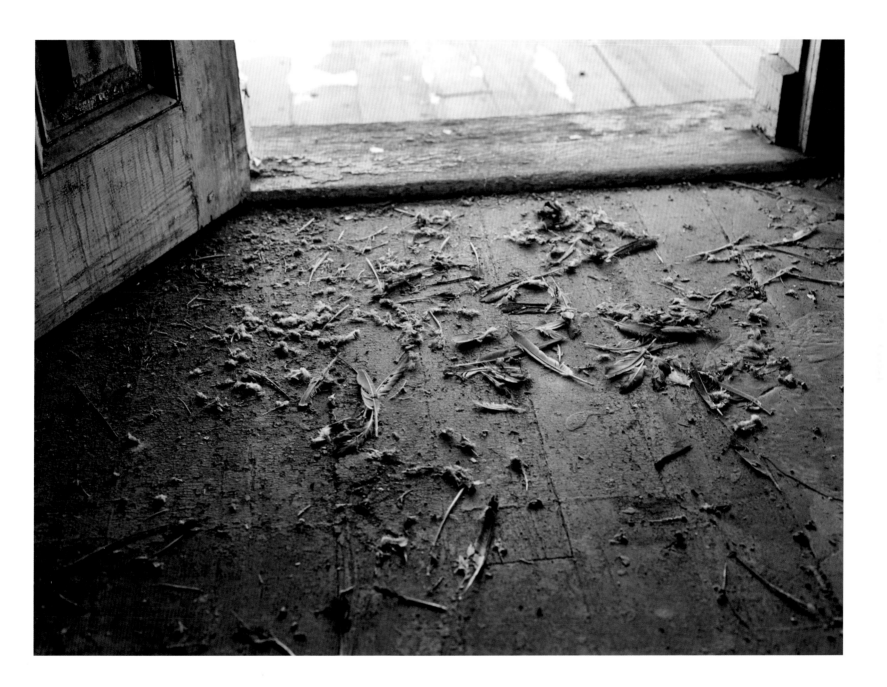

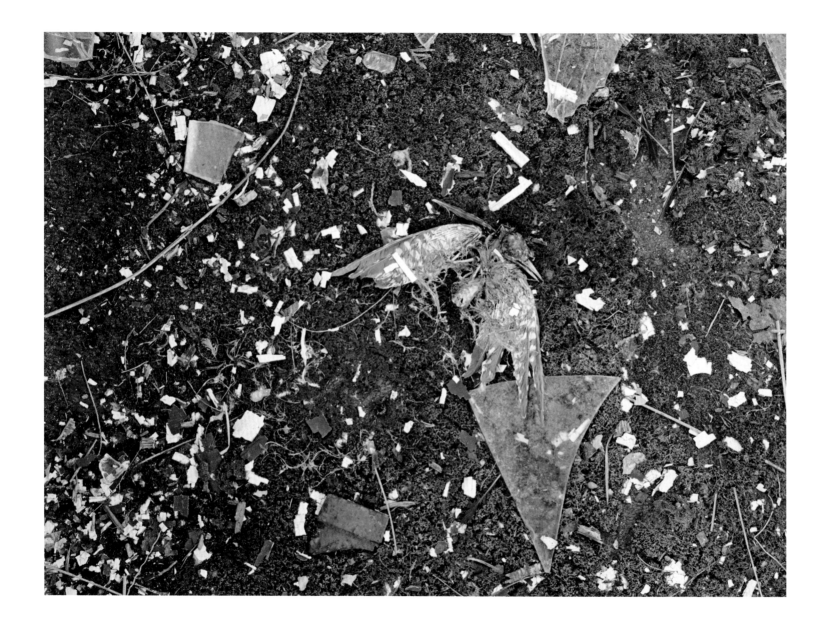

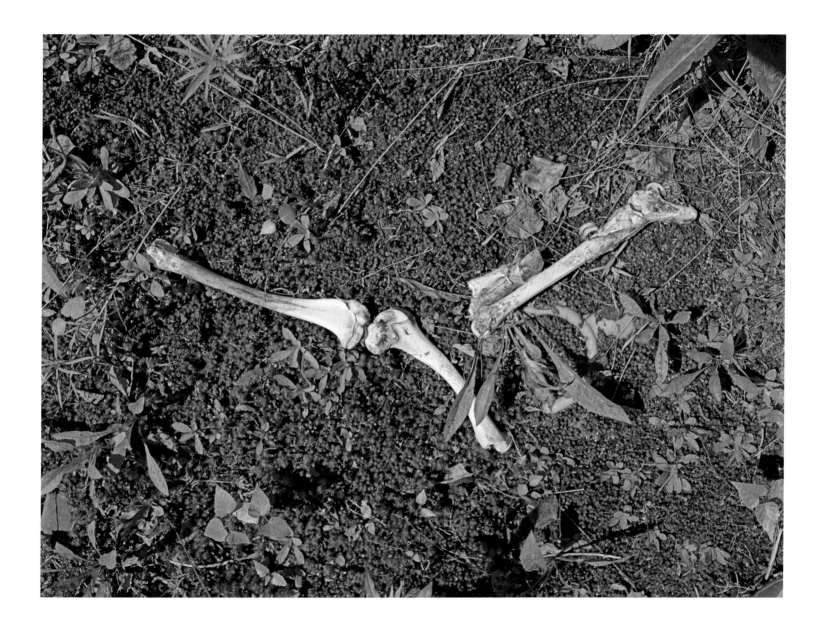

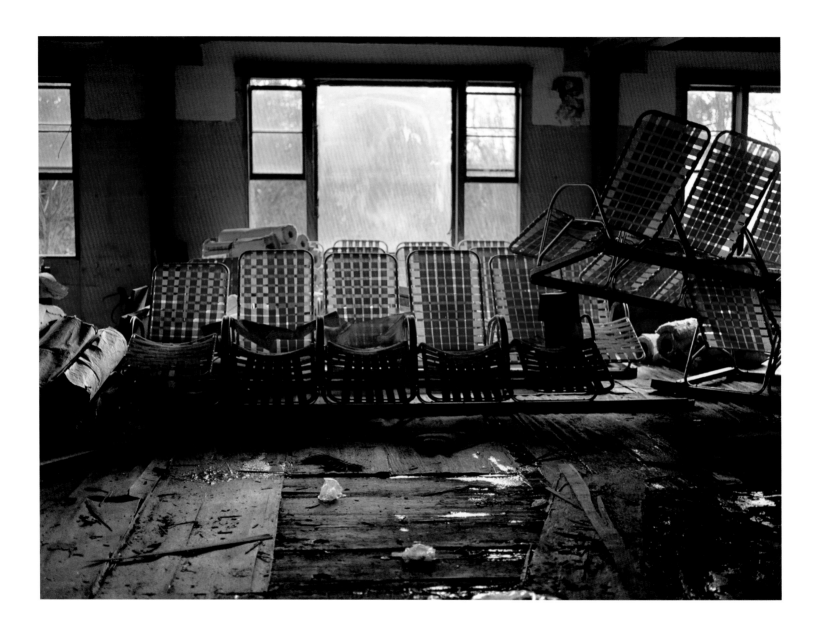

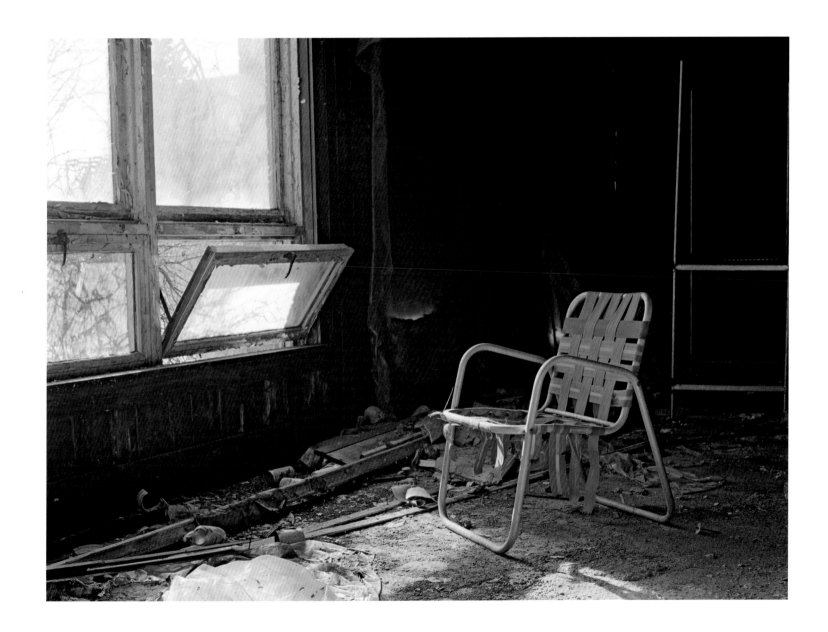

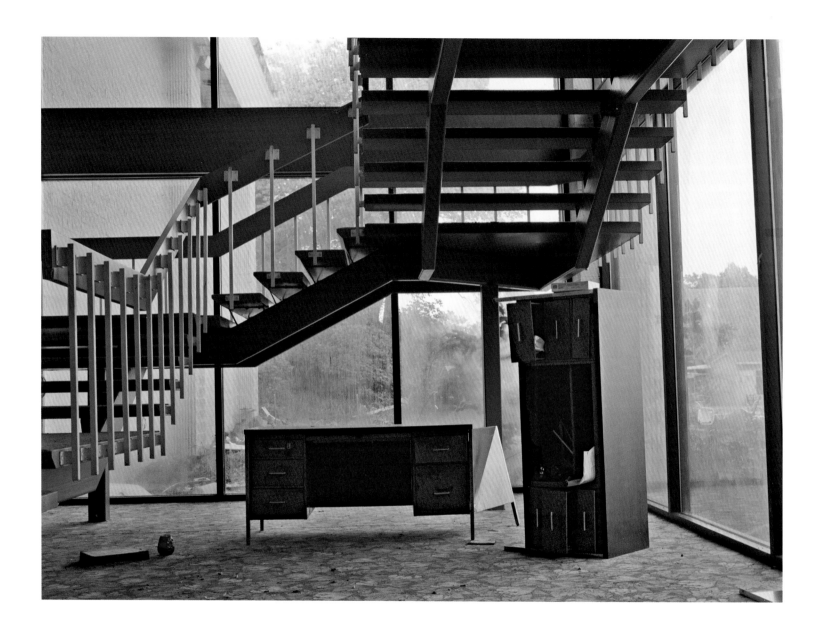

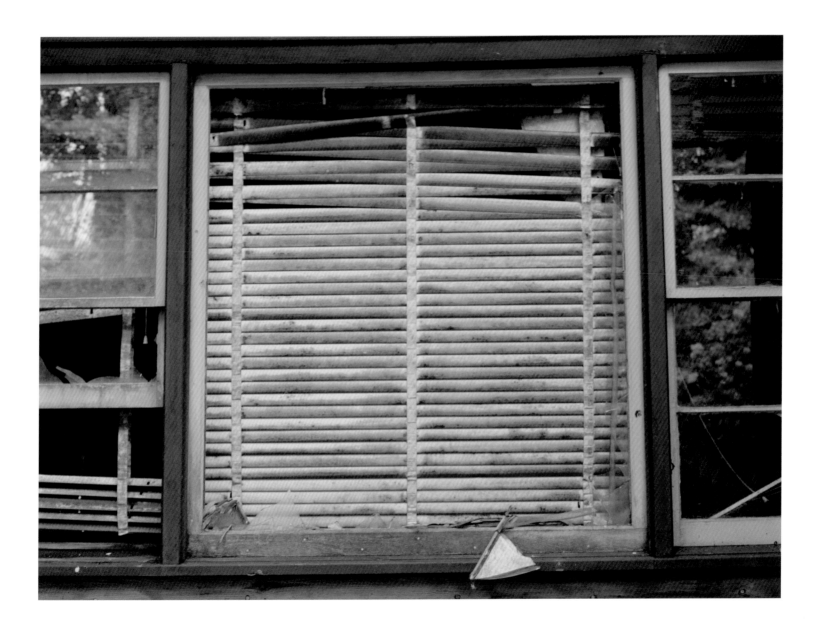

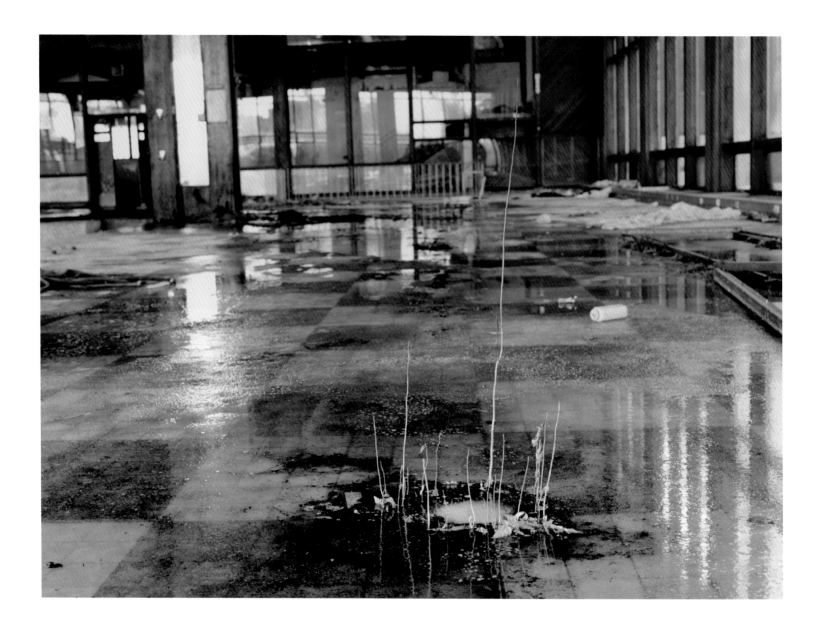

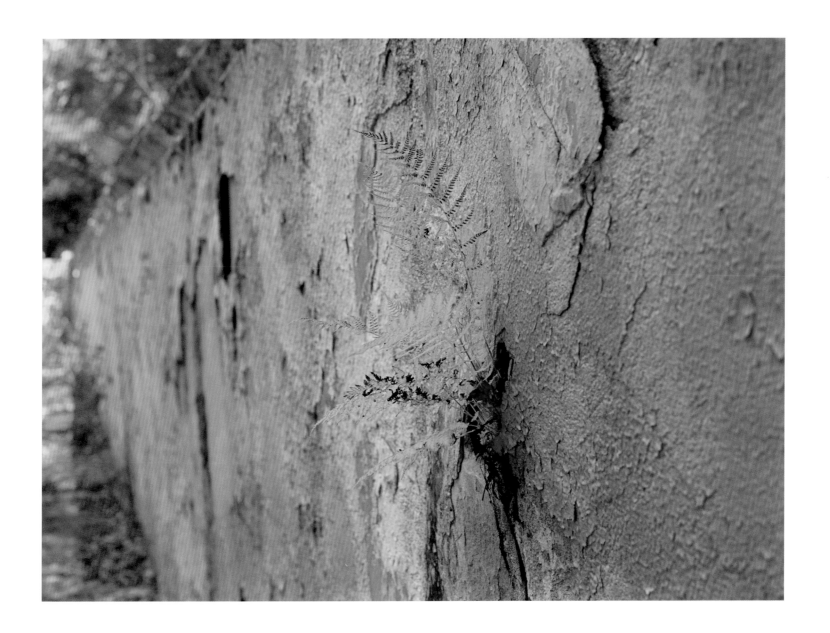

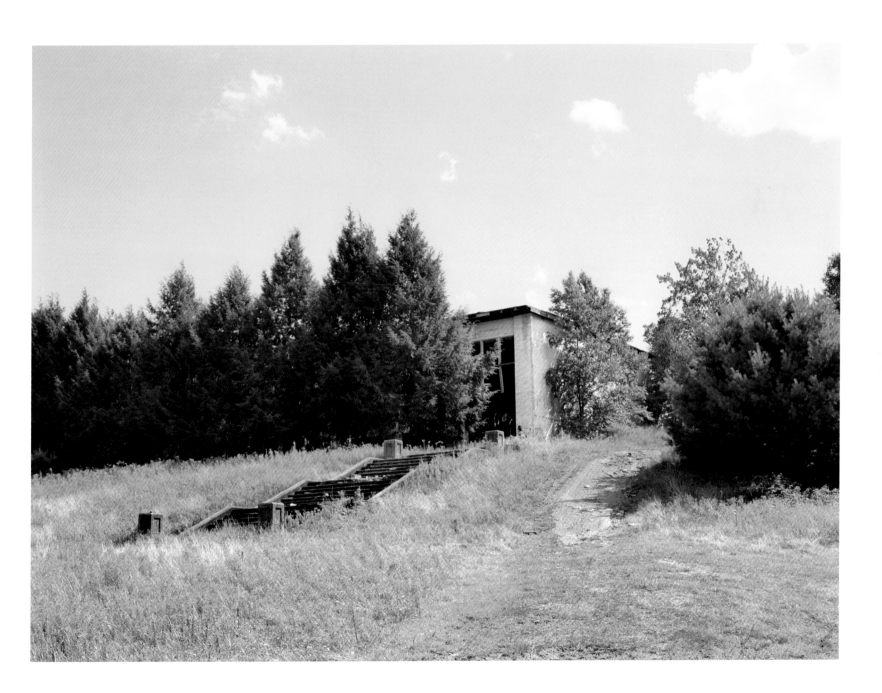

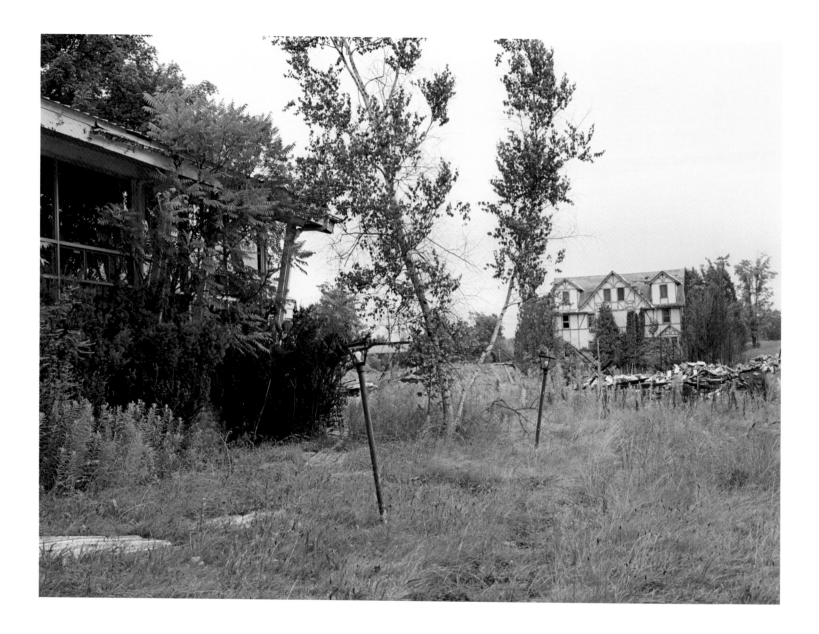

154

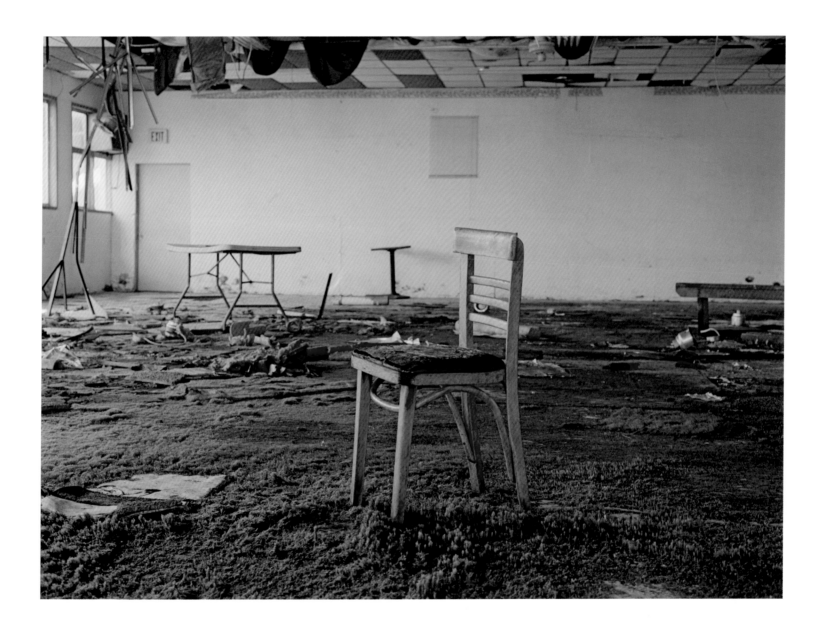

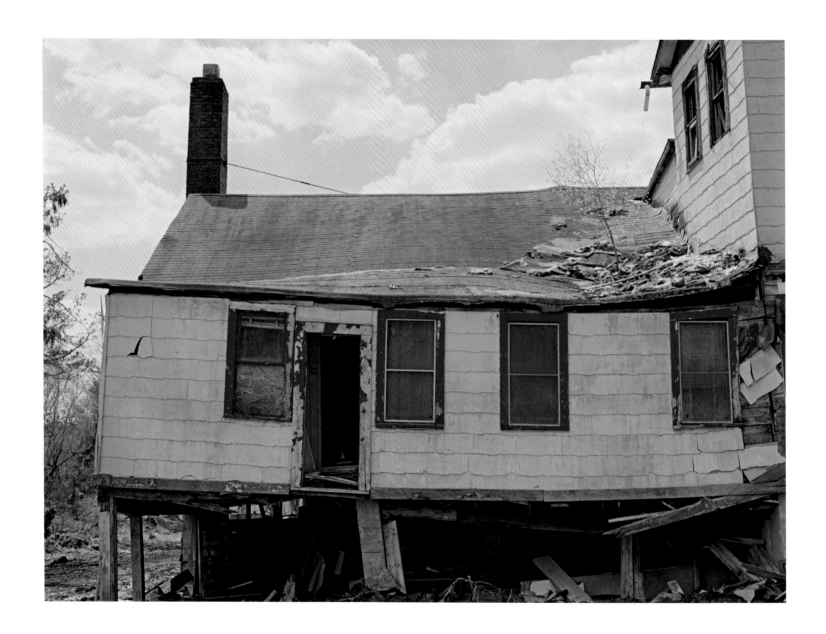

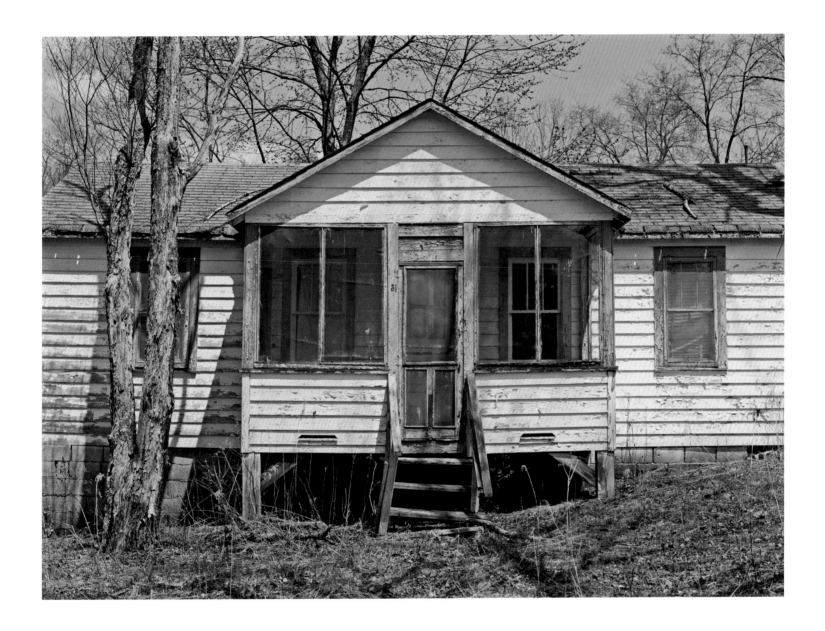

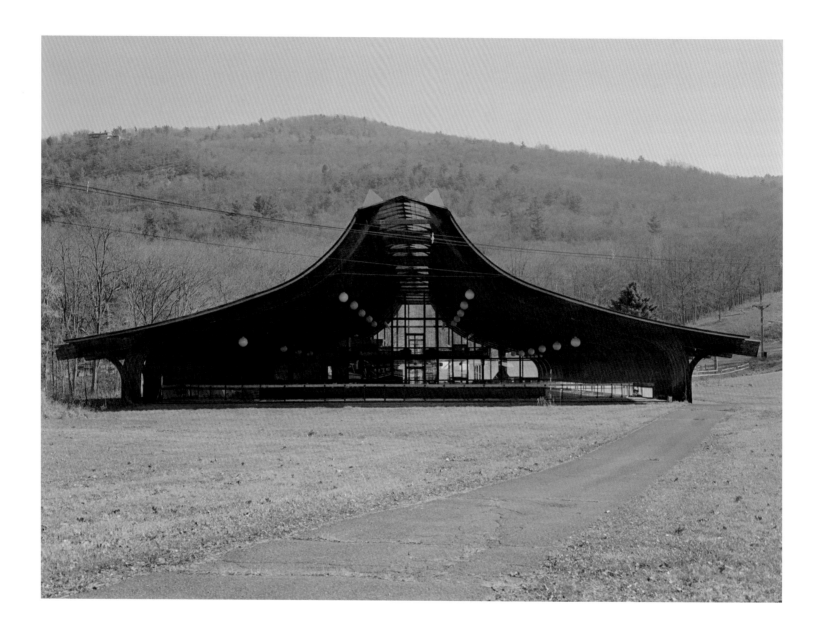

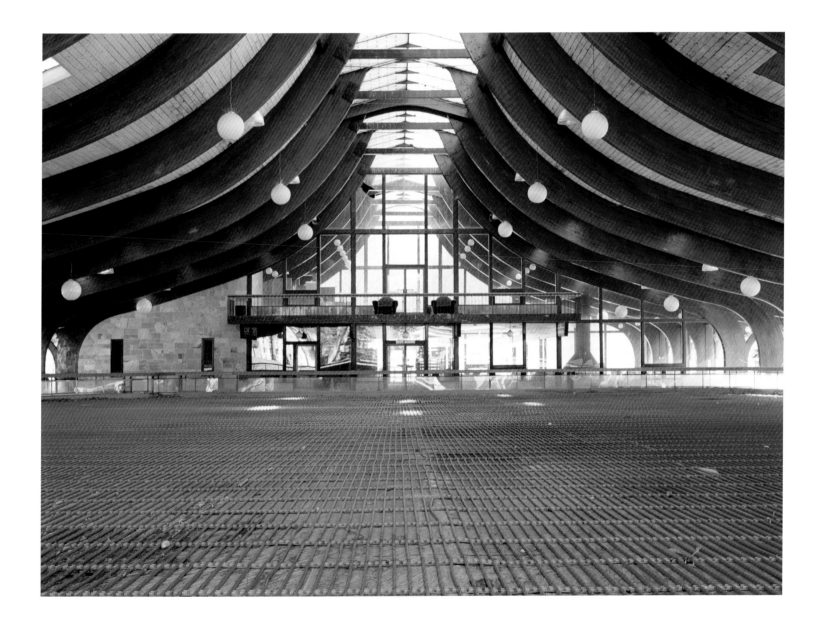

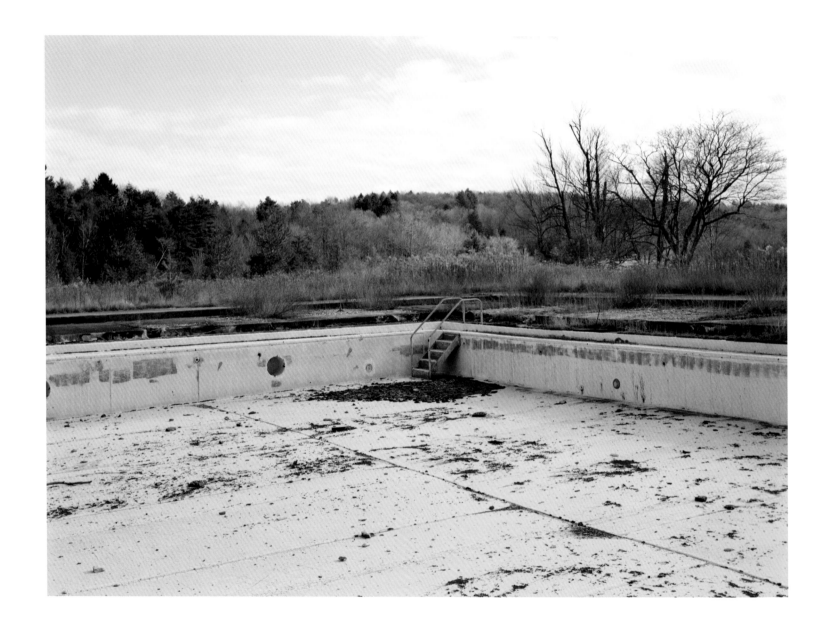

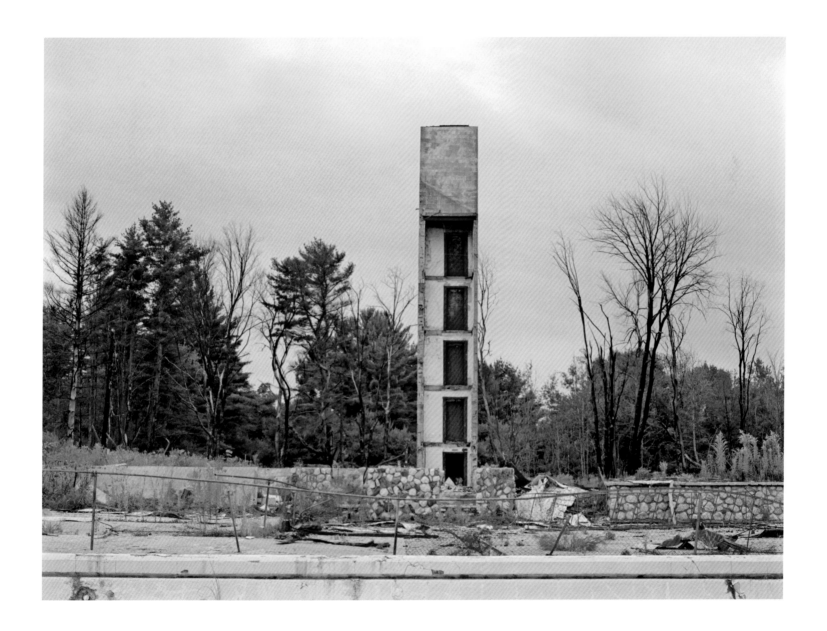

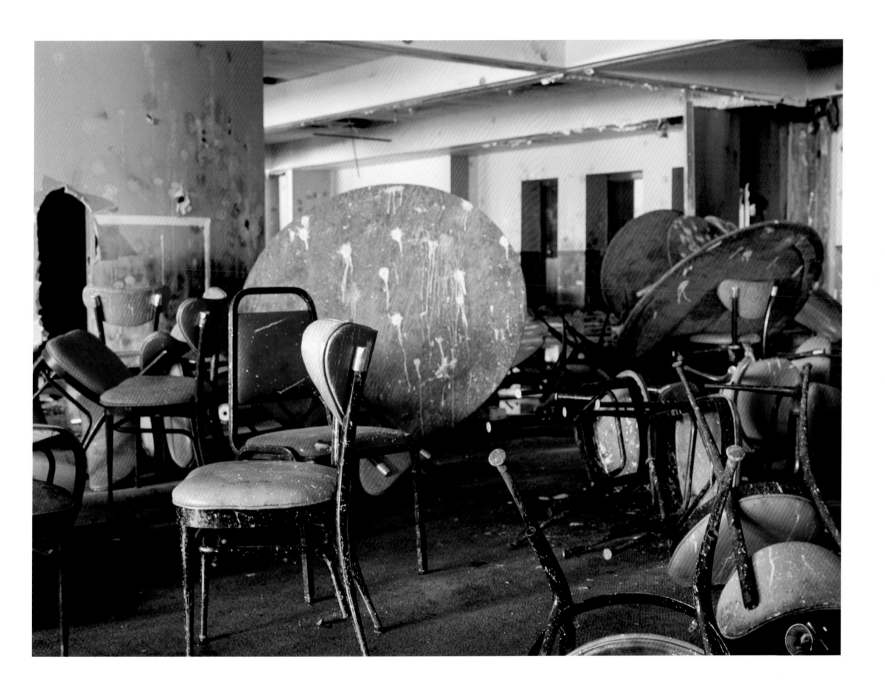

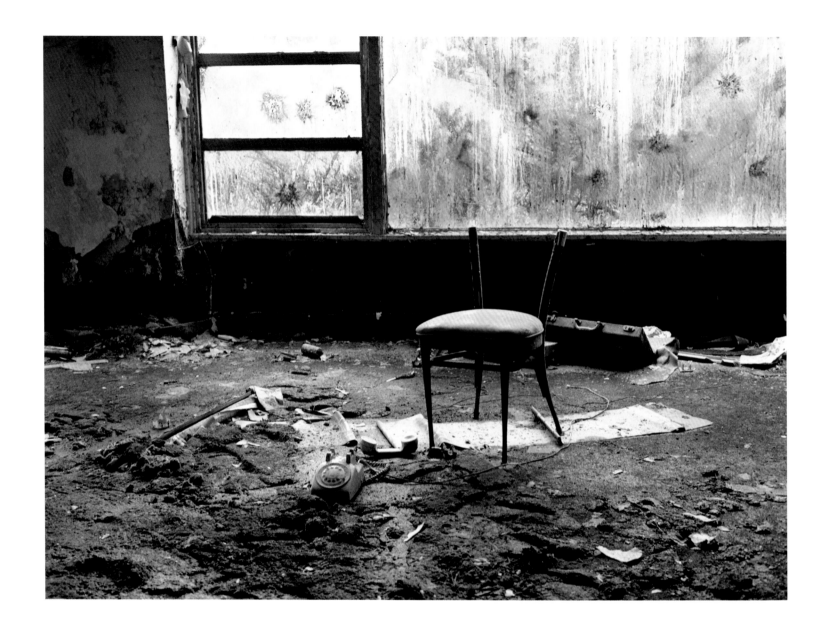

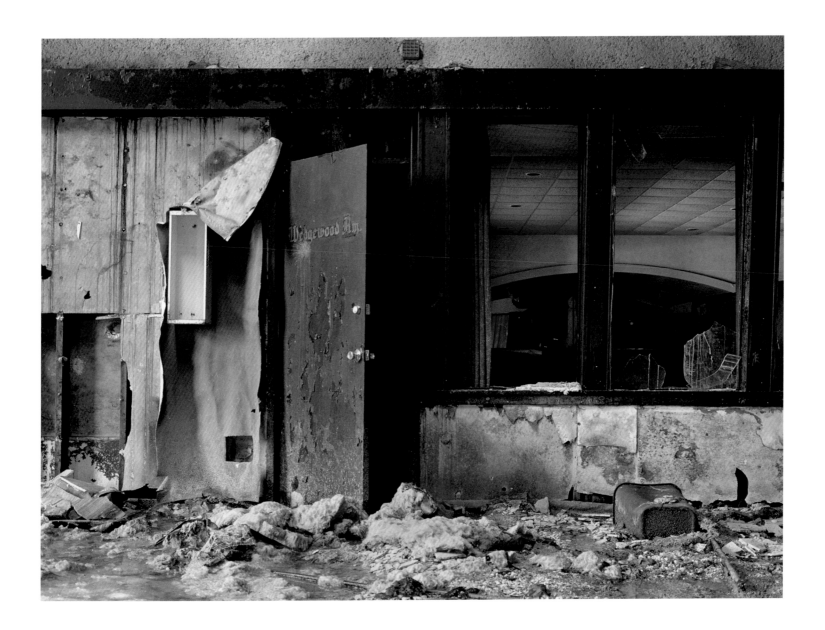

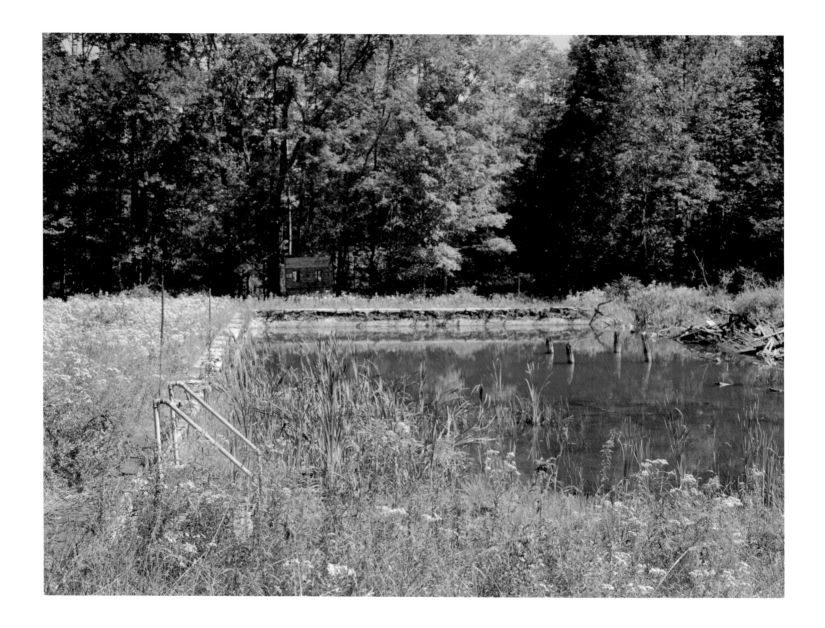

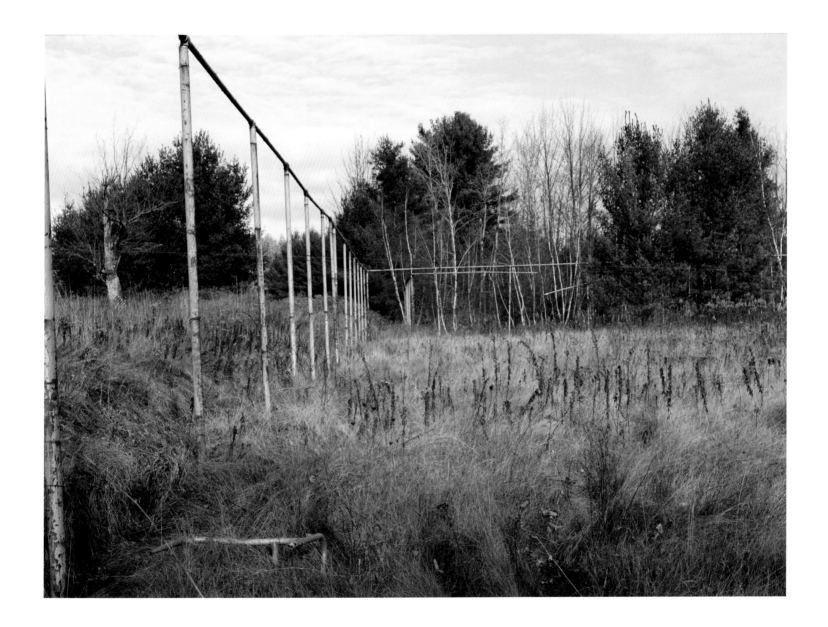

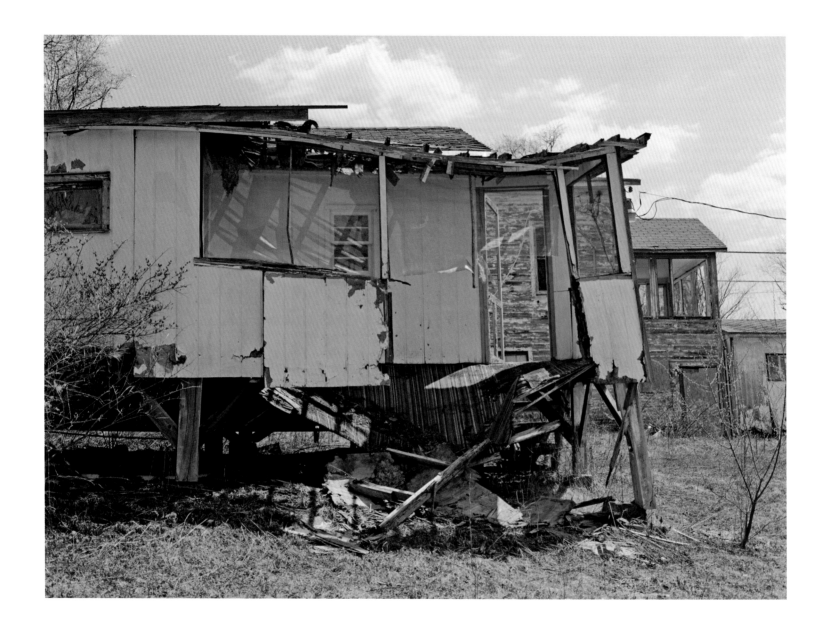

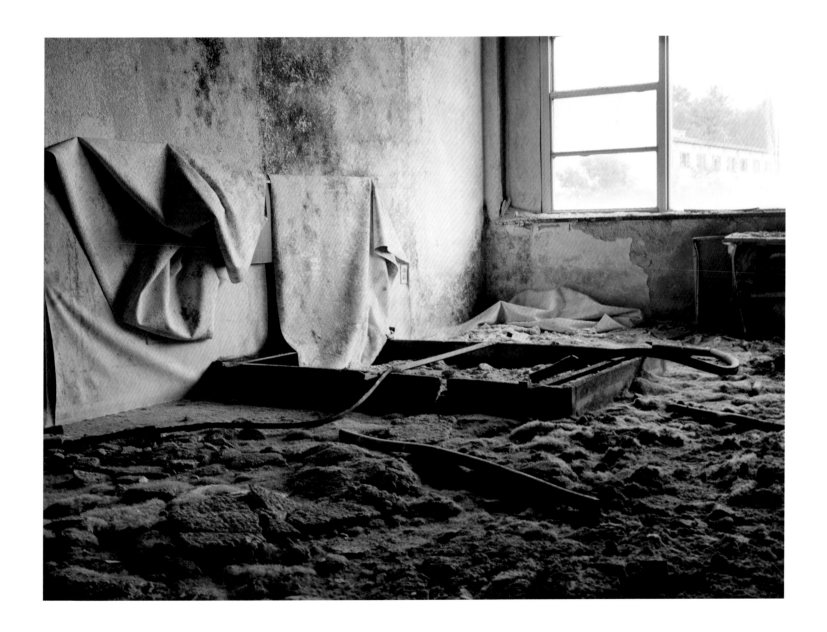

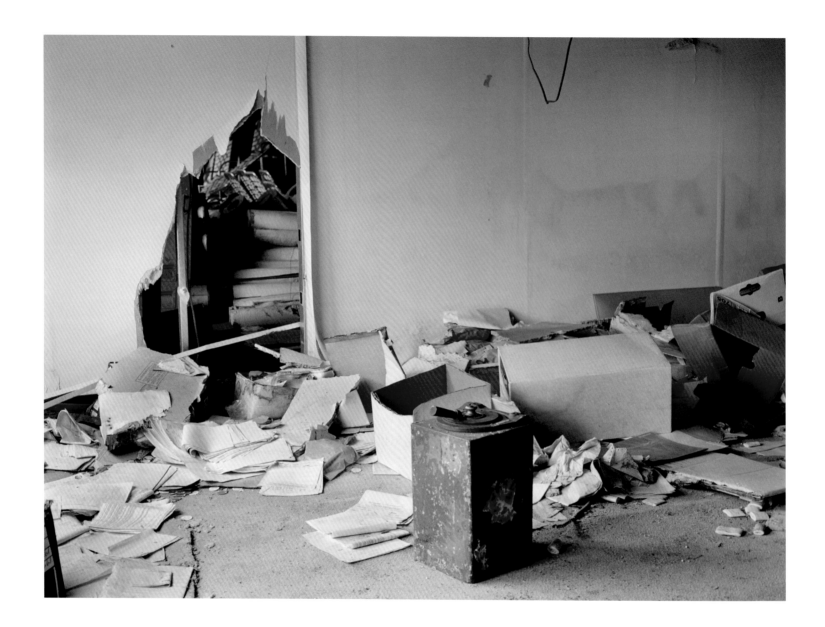

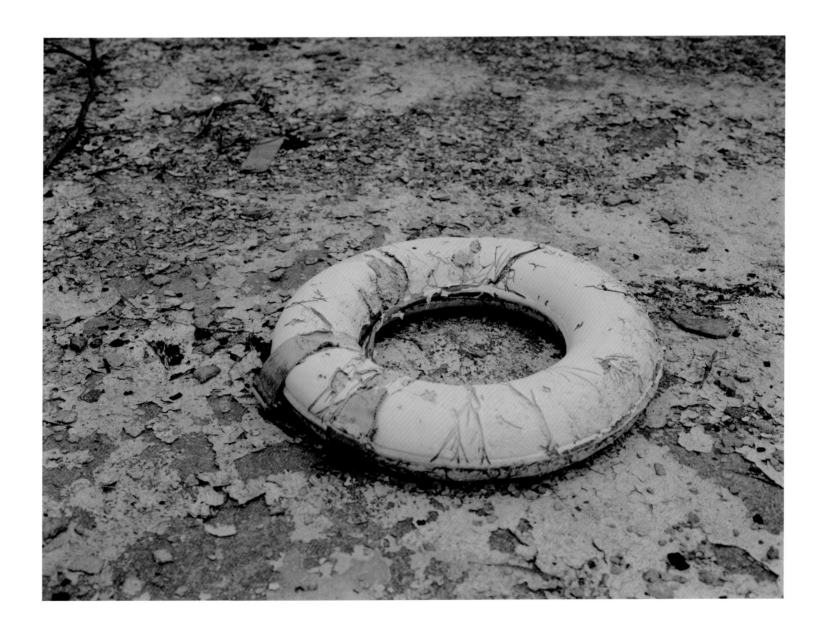

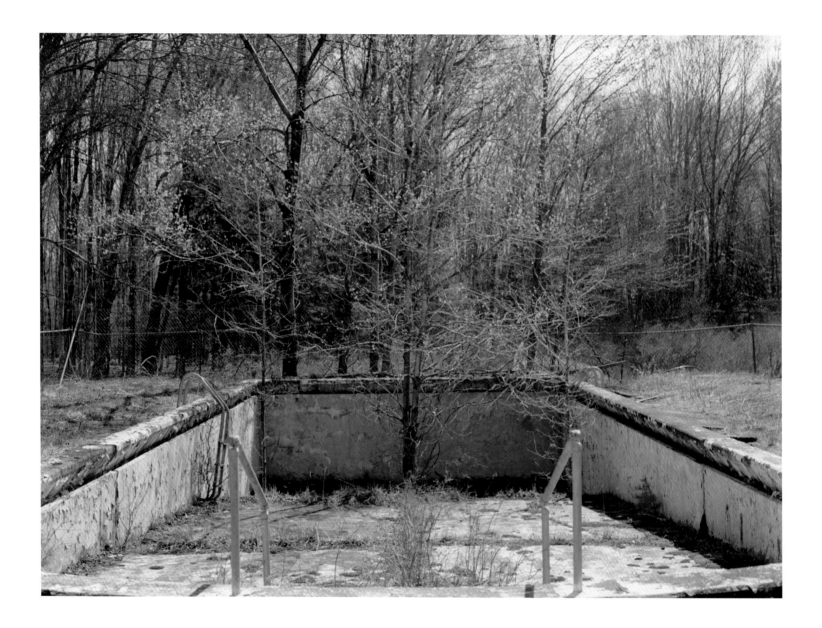

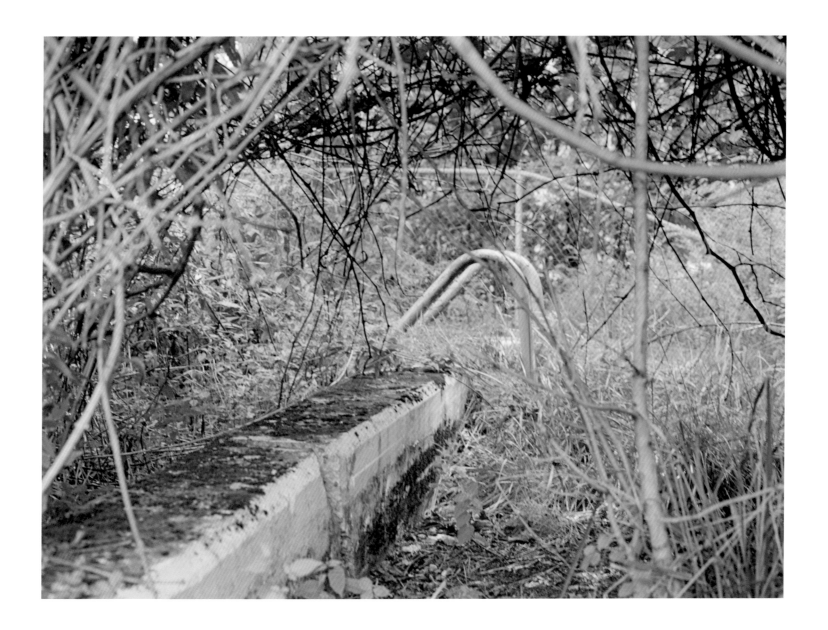

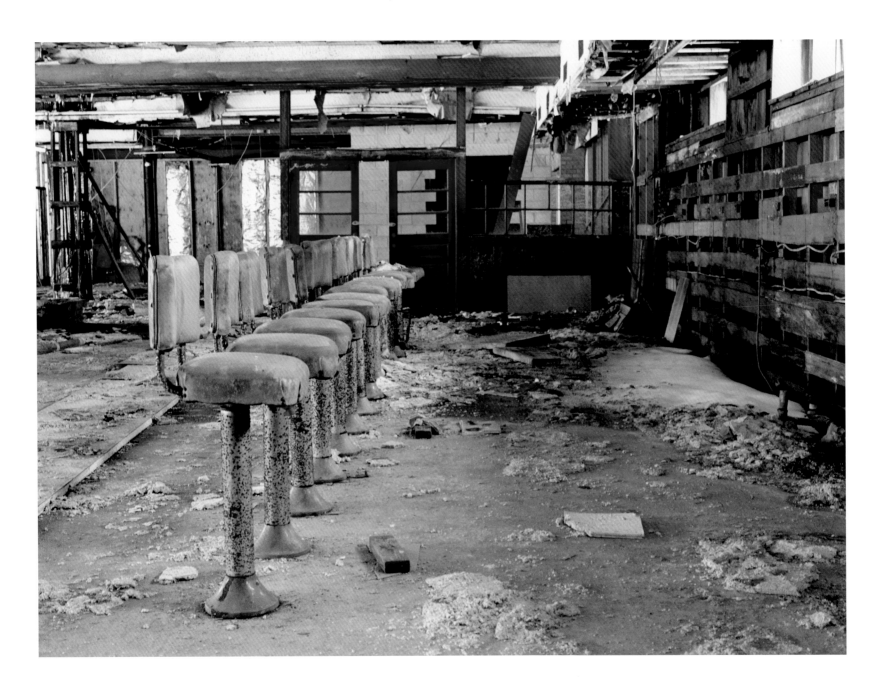

NOTES ON THE PHOTOGRAPHS

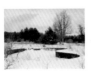

Postcard, ca. 1960, by Bill Bard Associates. Indoor pool, Laurels Hotel and Country Club on Sackett Lake, Monticello, New York (p. 30)

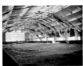

Undated postcard by Steingart Associates, South Fallsburg, New York. "New Artificial Year Round Indoor-Outdoor Skating Rink," Pines Hotel, South Fallsburg, New York (p. 32)

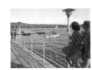

Postcard, ca. 1965, by Bill Bard Associates. Lakefront promenade, Laurels Hotel and Country Club on Sackett Lake, Monticello, New York (p. 34)

Indoor pool, 2010, Laurels Hotel and Country Club on Sackett Lake, Monticello, New York (p. 31)

Indoor-outdoor skating rink, 2010, Pines Hotel, South Fallsburg, New York (p. 33)

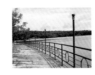

Lakefront promenade, 2011, Laurels Hotel and Country Club on Sackett Lake, Monticello, New York (p. 35)

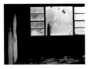

Guest room, Grossinger's Catskill Resort and Hotel, Liberty, New York (p. xii)

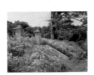

Stairs, Tanzville Hotel, Parksville, New York (p. 38)

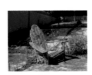

Outdoor pool, Vegetarian Hotel, Woodridge, New York (p. 40)

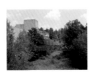

Entrance, Grossinger's Catskill Resort and Hotel, Liberty, New York (p. 37)

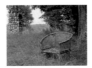

Chair, Tamarack Lodge, Greenfield Park, New York (p. 39)

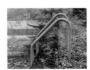

Outdoor pool, Lesser Lodge, Livingston Manor, New York (p. 41)

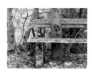 Outdoor pool, Lewinter's, Monticello, New York (p. 42)

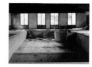 Guest room, Grossinger's Catskill Resort and Hotel, Liberty, New York (p. 50)

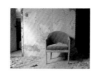 Indoor pool, Palms Country Club, Fallsburg, New York (p. 57)

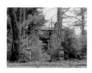 Entrance, Lewinter's, Monticello, New York (p. 43)

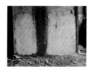 Outlet, Grossinger's Catskill Resort and Hotel, Liberty, New York (p. 51)

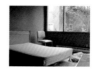 Guest room, Tamarack Lodge, Greenfield Park, New York (p. 58)

 Poker chips and cards, Grossinger's Catskill Resort and Hotel, Liberty, New York (p. 44)

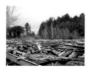 Ice skating rink, Pines Hotel, South Fallsburg, New York (p. 52)

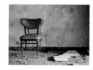 Chair, Pines Hotel, South Fallsburg, New York (p. 59)

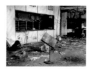 Lower lobby, Pines Hotel, South Fallsburg, New York (p. 45)

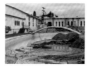 Outdoor pool, Pines Hotel, South Fallsburg, New York (p. 53)

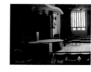 Stardust Room, Nevele Grande Hotel, Ellenville, New York (p. 60)

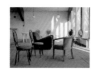 Ski chalet, Nevele Grande Hotel, Ellenville, New York (p. 47)

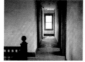 Hallway, Lennon Hotel, Liberty, New York (p. 54)

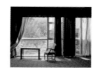 Lobby, Homowack Lodge, Spring Glen, New York (p. 61)

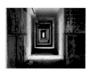 Hallway, Grossinger's Catskill Resort and Hotel, Liberty, New York (p. 48)

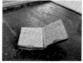 Prayer book, Homowack Lodge, Spring Glen, New York (p. 55)

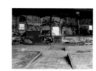 Black Magic Showroom, Commodore Hotel, Swan Lake, New York (p. 62)

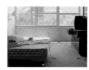 Guest room, Homowack Lodge, Spring Glen, New York (p. 49)

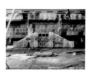 Lobby, Grossinger's Catskill Resort and Hotel, Liberty, New York (p. 56)

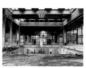 Indoor pool, Grossinger's Catskill Resort and Hotel, Liberty, New York (p. 63)

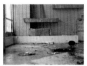 Indoor pool, Pines Hotel, South Fallsburg, New York (p. 64)

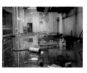 Kitchen, Pines Hotel, South Fallsburg, New York (p. 65)

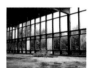 Indoor pool, Grossinger's Catskill Resort and Hotel, Liberty, New York (p. 67)

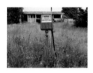 Fuel pump, Tamarack Lodge, Greenfield Park, New York (p. 68)

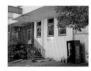 Esther Manor, Monticello, New York (p. 69)

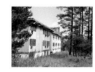 Young's Gap Hotel, Parksville, New York (p. 70)

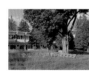 Chairs, Esther Manor, Monticello, New York (p. 71)

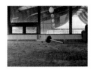 Ski chalet, Nevele Grande Hotel, Ellenville, New York (p. 72)

 Stairs, Pines Hotel, South Fallsburg, New York (p. 73)

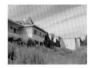 Paramount Hotel, Parksville, New York (p. 74)

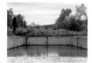 Outdoor pool, Paramount Hotel, Parksville, New York (p. 75)

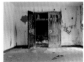 Persian Room, Pines Hotel, South Fallsburg, New York (p. 77)

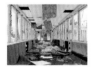 Overpass, Pines Hotel, South Fallsburg, New York (p. 78)

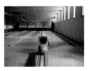 Bowling alley, Homowack Lodge, Spring Glen, New York (p. 79)

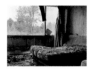 Guest room, Tamarack Lodge, Greenfield Park, New York (p. 80)

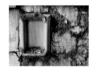 Soap dish, Grossinger's Catskill Resort and Hotel, Liberty, New York (p. 81)

 Log book, Concord Hotel, Kiamesha Lake, New York (p. 82)

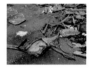 Chairs, Commodore Hotel, Swan Lake, New York (p. 83)

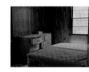 Bedroom, 4 Corners Bungalow Colony, Kiamesha Lake, New York (p. 85)

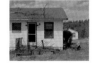 Bungalow, Breezy Corners, Monticello, New York (p. 86)

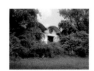 Palms Country Club, Fallsburg, New York (p. 87)

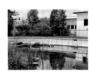
Outdoor pool, Pines Hotel, South Fallsburg, New York (p. 88)

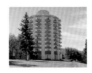
Nevele Grande Hotel, Ellenville, New York (p. 96)

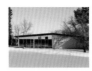
Ice arena, Kutsher's Hotel and Country Club, Monticello, New York (p. 103)

Outdoor pool, Pines Hotel, South Fallsburg, New York (p. 89)

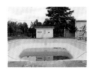
Outdoor pool, Paul's Hotel, Swan Lake, New York (p. 97)

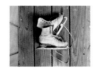
Ice skates, Homowack Lodge, Spring Glen, New York (p. 104)

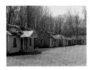
Bungalows, White Swan Bungalow Colony, White Lake, New York (p. 90)

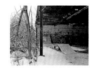
Black Magic Showroom, Commodore Hotel, Swan Lake, New York (p. 98)

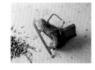
Ice skate, Homowack Lodge, Spring Glen, New York (p. 105)

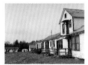
Bungalows, Breezy Corners, Monticello, New York (p. 91)

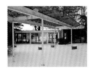
Patio, Kutsher's Hotel and Country Club, Monticello, New York (p. 99)

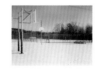
Basketball courts, Kutsher's Hotel and Country Club, Monticello, New York (p. 107)

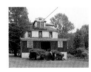
Rosemond Hotel, Woodridge, New York (p. 92)

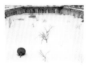
Outdoor pool, Grossinger's Catskill Resort and Hotel, Liberty, New York (p. 100)

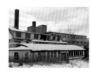
Laundry building, Grossinger's Catskill Resort and Hotel, Liberty, New York (p. 108)

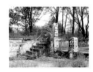
Outdoor pool, Commodore Hotel, Swan Lake, New York (p. 93)

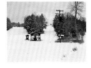
Ski hill, Concord Hotel, Kiamesha Lake, New York (p. 101)

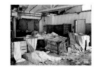
Laundry building (interior), Grossinger's Catskill Resort and Hotel, Liberty, New York (p. 109)

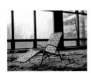
Indoor pool, Grossinger's Catskill Resort and Hotel, Liberty, New York (p. 95)

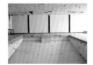
Indoor pool, Homowack Lodge, Spring Glen, New York (p. 102)

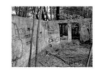
Le Roy Hotel, Loch Sheldrake, New York (p. 110)

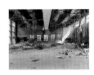 Fur Workers Resort, White Lake, New York (p. 111)

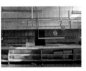 Kitchen, Nevele Grande Hotel, Ellenville, New York (p. 112)

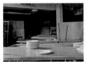 Plates, Nevele Grande Hotel, Ellenville, New York (p. 113)

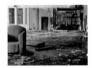 Upper lobby, Pines Hotel, South Fallsburg, New York (p. 114)

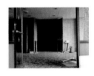 Stardust Room, Kutsher's Hotel and Country Club, Monticello, New York (p. 115)

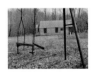 Abel's Bungalow Colony, South Fallsburg, New York (p. 116)

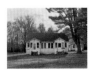 Cooper's Sunrise Bungalow Colony, Rock Hill, New York (p. 117)

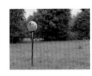 Pines Hotel, South Fallsburg, New York (p. 118)

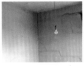 Lennon Hotel, Liberty, New York (p. 119)

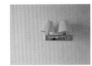 Guest room, Paramount Hotel, Parksville, New York (p. 120)

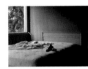 Guest room, Tamarack Lodge, Greenfield Park, New York (p. 121)

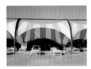 Lounge chairs, Nevele Grande Hotel, Ellenville, New York (p. 122)

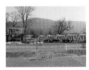 Outdoor pool, Nevele Grande Hotel, Ellenville, New York (p. 123)

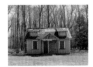 Bungalow, White Swan Bungalow Colony, White Lake, New York (p. 124)

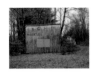 Handball court, Echo Mountain, Monticello, New York (p. 125)

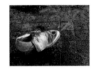 Indoor pool, Grossinger's Catskill Resort and Hotel, Liberty, New York (p. 126)

 Golf shoe, Grossinger's Catskill Resort and Hotel, Liberty, New York (p. 127)

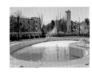 Outdoor pool, Brown's Hotel, Liberty, New York (p. 128)

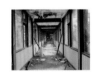 Hallway, Grossinger's Catskill Resort and Hotel, Liberty, New York (p. 129)

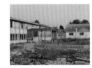 Kutsher's Hotel and Country Club, Monticello, New York (p. 130)

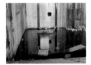 Indoor pool, Grossinger's Catskill Resort and Hotel, Liberty, New York (p. 131)

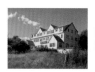 La Minette, Loch Sheldrake, New York (p. 133)

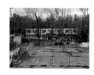 Patio, Pines Hotel, South Fallsburg, New York (p. 140)

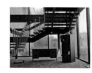 Kutsher's Hotel and Country Club, Monticello, New York (p. 148)

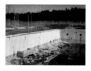 Outdoor pool, Laurels Hotel and Country Club on Sackett Lake, Monticello, New York (p. 134)

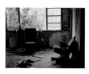 Guest room, Grossinger's Catskill Resort and Hotel, Liberty, New York (p. 141)

 Grossinger's Catskill Resort and Hotel, Liberty, New York (p. 149)

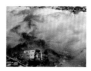 Outdoor pool, Laurels Hotel and Country Club on Sackett Lake, Monticello, New York (p. 135)

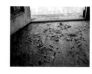 Feathers, White Lake Mansion House, White Lake, New York (p. 143)

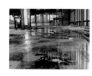 Indoor pool, Grossinger's Catskill Resort and Hotel, Liberty, New York (p. 150)

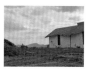 Revolution Room, Breezy Corners, Monticello, New York (p. 136)

 Bird, Tamarack Lodge, Greenfield Park, New York (p. 144)

 Outdoor pool, Rosemond Hotel, Woodridge, New York (p. 151)

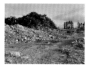 Concord Hotel, Kiamesha Lake, New York (p. 137)

 Bones, Grossinger's Catskill Resort and Hotel, Liberty, New York (p. 145)

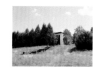 Fur Workers Resort, White Lake, New York (p. 153)

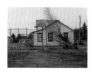 Basketball court, Breezy Corners, Monticello, New York (p. 138)

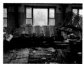 Lounge chairs, Grossinger's Catskill Resort and Hotel, Liberty, New York (p. 146)

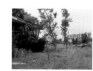 Tamarack Lodge, Greenfield Park, New York (p. 154)

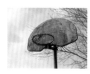 Basketball net, Breezy Corners, Monticello, New York (p. 139)

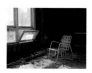 Grossinger's Catskill Resort and Hotel, Liberty, New York (p. 147)

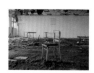 Lobby, Esther Manor, Monticello, New York (p. 155)

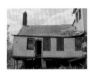
Bungalow, Lewinter's, Monticello, New York (p. 156)

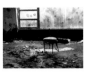
Upper lobby, Pines Hotel, South Fallsburg, New York (p. 164)

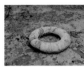
Outdoor pool, Commodore Hotel, Swan Lake, New York (p. 171)

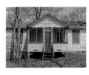
Bungalow, Brentwood Cottages, Liberty, New York (p. 157)

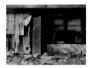
Wedgewood Room, Pines Hotel, South Fallsburg, New York (p. 165)

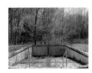
Outdoor pool, White Swan Bungalow Colony, White Lake, New York (p. 172)

Ice skating rink (exterior), Nevele Grande Hotel, Ellenville, New York (p. 158)

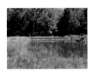
Outdoor pool, Heiden Hotel, South Fallsburg , New York (p. 166)

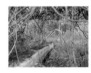
Outdoor pool, Perlin's Bungalow Colony, Glen Wild, New York (p. 173)

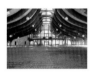
Ice skating rink (interior), Nevele Grande Hotel, Ellenville, New York (p. 159)

Tennis courts, Laurels Hotel and Country Club on Sackett Lake, Monticello, New York (p. 167)

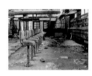
Coffee shop, Grossinger's Catskill Resort and Hotel, Liberty, New York (p. 175)

Outdoor pool, Laurels Hotel and Country Club on Sackett Lake, Monticello, New York (p. 160)

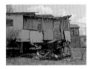
Bungalow, Brentwood Cottages, Liberty, New York (p. 168)

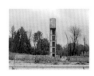
Guest building, Tamarack Lodge, Greenfield Park, New York (p. 161)

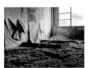
Guest room, Grossinger's Catskill Resort and Hotel, Liberty, New York (p. 169)

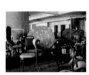
Dining room, Pines Hotel, South Fallsburg, New York (p. 163)

Office, Grossinger's Catskill Resort and Hotel, Liberty, New York (p. 170)

ACKNOWLEDGMENTS

DEEP GRATITUDE TO THE FOLLOWING INDIVIDUALS WHO HAVE HELPED TO MAKE this project a reality, whether by accompanying me on a photo shoot, allowing me access to hotels or bungalow colonies, or sharing your knowledge of a hotel, bungalow colony, or of the Borscht Belt more generally. You have all played a part in this long and fascinating journey: Andrew Liff, Sam Hellman, Alan Grant, Eric Garchik, Samantha Garchik, James Gorman, Steven Vegliante, Steve Proyect, Chris Hummel, Henry Zabatta, Ken Cogswell, Mike McNamara, John Conway, Lois Di Stefano, Alan Barrish, Phil Brown, Michael Summa and the Fallsburg Police Department, Dr. Phil Brown, Abby Dan, Amy Goodstein, Lazell "Duke" Neals, Louis Inghilterra, Rachel Weiner, Erika Schmidt, J. J. Pavese, Brian Rourke, Zinnia Konviser, Jeff Richmond, Jillian Scheinfeld, Allison Scheinfeld, Barry Scheinfeld, Eric Atkins, Martin Gottesman, Jeremy Levner, Howard Ingber, Gabrielle Ingber, Brian Fleischman, Allan Wolkoff, Vivian Liff, Moose Liff, Jared Swift, Harriet Ehrlich, Michael R. Treanor, Michael Novison, Rita Sheehan, Olivier Gibbons, Vivien Marinaro, Mark Brinn, Raymon Elozua, and Scott Coleman.

Thank you to the following individuals whose research or writing inspired the making of these photographs: Max Kozloff, Beaumont Newhall, Susan Sontag, Mark Klett, Robert Polidori, Robert Ginsberg, Annette Kuhn, Lucy Lippard, Rebecca Solnit, Dylan Trigg, Alan Weisman, Phil Brown, John Conway, Irwin Richman, Allan Sekula, and William Cronon.

Thank you to the individuals, institutes, and organizations that have supported, advised, and exhibited this work: Dr. Jacob Wisse, Susan Bronson, Phyllis Galembo, Gayle Rothschild, Dr. Carol McCusker, Susan Seelig, Yona Verwer, Richard Keely, David Hewitt, Seth Mallios,

Zachary Levine, Dr. Jo-Anne Berelowitz, Kim Stringfellow, Stefan Kanfer, Yeshiva University Museum, the Center for Jewish History, the Lower East Side Jewish Conservancy, and the National Yiddish Book Center.

I extend collective recognition to all those (extended family, friends, locals, tourists, and strangers alike) who have lived in, worked in, passed through, or made memories in the Borscht Belt.

Additional love and appreciation to my grandmothers, Ruth Scheinfeld and Harriet Moskowitz, and to the memory of my grandfathers, Jack Scheinfeld and Benjamin Moskowitz, who all spent their summers in "the country." Eternally-lasting love to my great-grandmother, Ada Freed.

To my family—Joan, Barry, Allison and Jillian—thank you for your love and support and for always encouraging me to pursue my passions.

To Arthur Ollman, thank you for giving me the advice that compelled me to start this project, for challenging me, and for seeing it through to the very end.

To Michael McGandy, thank you for seeing the potential in this project. I am forever grateful.

To Sara Ferguson, thank you for your keen eye and swift editing. It is so very appreciated.

To Scott Levine, book designer and former Kutsher's guest, thank you for your vision, which facilitated my own. It was a pleasure to work with you.

To everyone else at Cornell University Press, you're an amazing bunch. Thank you.

To my close friend and fellow photographer Rizzhel Javier, the inspiration your work and friendship provide me is invaluable. Love you, photo-sis.

To Jenna Weissman Joselit, thank you for your patience, guidance, and eloquent words.

To Lee Jaffe, who gave me one of the best gifts I've ever received, the Pentax 645 that I used to make these photographs, thank you.

To Sam McCabe, I am grateful to the universe and to all the forces that brought us together. Timing is everything, and you're the one I want to go through time with.

All scans for this book were made by Icon (Los Angeles) or L&I (New York). Special thanks to Bonny Taylor and Paul Batoon at Icon and Jack at L&I. Thank you to Ben Pease of Pease Press Cartography for the map of the Catskills resorts. Editing and layout assistance were provided by Professor Arthur Ollman with additional input by Walter Briski, Jr.

BIOGRAPHIES

JENNA WEISSMAN JOSELIT, the Charles E. Smith Professor of Judaic Studies and Professor of History at The George Washington University in Washington, D.C., is an historian of daily life, especially that of America's Jews. The author of *The Wonders of America* and *A Perfect Fit* as well as a forthcoming book on America's relationship to the Ten Commandments, she also writes for *The Forward*, where her monthly column is now in its sixteenth consecutive year of publication.

STEFAN KANFER is a contributing editor to *City Journal*. He writes extensively on a wide range of political, social, and cultural topics. Kanfer's 2015 *City Journal* feature, "City Lights," discussed the long line of literary personalities who made New York City their home, ranging from Washington Irving to Edith Wharton to Norman Mailer. Kanfer is the author of more than a dozen books, among them *The Last Empire*, the story of the De Beers diamond company; *Stardust Lost*, about the triumph and tragedy of the Yiddish Theater in America; and *A Summer World: The Attempt to Build a Jewish Eden in the Catskills, from the Days of the Ghetto to the Rise and Decline of the Borscht Belt*. Kanfer wrote and edited at *Time* for more than twenty years, during which he was a cinema and theater reviewer and essayist and, for a decade, senior editor of the magazine's book review section. Kanfer was installed as a Literary Lion at the New York Public Library, has been a writer in residence at the City University of New York, a visiting professor at SUNY-Purchase and Wesleyan University, and is the only *Time* writer to win the Penney-Missouri School of Journalism Prize and the Westchester Writers Prize.

MARISA SCHEINFELD was born in Brooklyn, New York, in 1980 and raised in the Catskills. She received a BA from the State University at Albany in 2002 and an MFA from San Diego State University in 2011. Her work is highly motivated by her interest in ruins and the histories that lie within them. Marisa's work has been exhibited nationally and internationally and is among the collections of Yeshiva University Museum at the Center for Jewish History, the National Yiddish Book Center, the Simon Wiesenthal Center, and the Edmund and Nancy K. Dubois Library at the Museum of Photographic Arts. This is her first book.